THE PRIVATE
LIFE OF A
MASTERPIECE

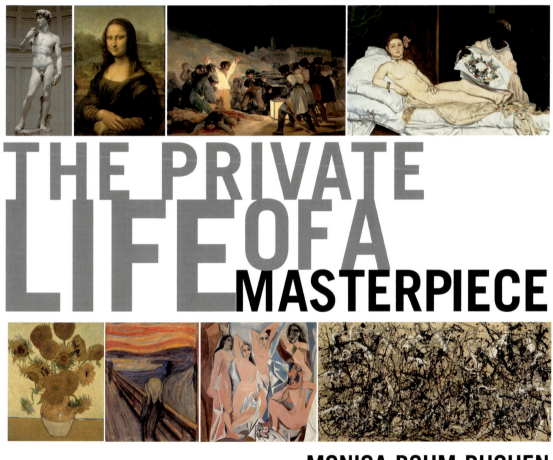

THE PRIVATE LIFE OF A MASTERPIECE

MONICA BOHM-DUCHEN

In loving and admiring memory of Claire Duchen

The original idea for this book was conceived by Jeremy Bugler of Fulmar TV & Film Ltd

This book was published to accompany the television series *The Private Life of a Masterpiece*, made by Fulmar TV & Film Ltd, first broadcast on BBC 2 in 2001.
Executive Producer: Jeremy Bugler

Published by BBC Worldwide Ltd
Woodlands, 80 Wood Lane, London W12 0TT

First published in 2001
Copyright © Monica Bohm-Duchen 2001
The moral right of the author has been asserted

ISBN 0 563 53767 1

Commissioning Editor: Emma Shackleton
Project Editor: Patricia Burgess
Copy Editor: Diana Davies
Art Director: Linda Blakemore
Designer: Paul Vater
Picture Researchers: Sophie Hartley, Miriam Hyman

Set in Garamond and Trade Gothic
Printed and bound in Great Britain by Butler & Tanner Ltd, Frome and London; Colour separations by Radstock Reproductions Ltd, Midsomer Norton; Jacket printed by Lawrence Allen Ltd, Weston-super-Mare

ACKNOWLEDGEMENTS

I am indebted to Jeremy Bugler of Fulmar Television & Film, who devised the concept on which this book is based, and to Ian Jones, who shared his research with me. Thanks also to Ian and to Judith Winnan for their comments on the Michelangelo and Munch chapters. I should like to thank the staff of the Tate Gallery and Westminster Central Reference Libraries for their willingness to offer practical help. Sophie Hartley has proved, once again, an extremely efficient picture researcher and a pleasure to work with, as have Trish Burgess, Miriam Hyman and Emma Shackleton of BBC Worldwide, my copy editor Diana Davies and the designer Paul Vater. I am grateful to my friend Anna Moszynska for her interest in the project, and small but invaluable words of guidance. Special thanks must go to Valerie Holman, whose intervention caused this enjoyable commission to come my way, and to my research assistant, Sarah Weatherall, without whom I would have been hard pressed to meet an alarmingly tight deadline. And, of course, to my husband, Michael, and children, Hannah and Benjamin, thanks for their tolerant understanding of the pressures this entailed. My mother, Dorothy Bohm, as ever, offered much-appreciated moral and practical support.

CONTENTS

INTRODUCTION

As a form of relaxation during the course of working on this book, I happened to be reading Michael Frayn's entertaining novel *Headlong* (1999), in which a maverick art historian is convinced he has discovered a long-lost masterpiece. The following passage immediately struck me as being wonderfully relevant to my own enterprise:

There are some paintings in the history of art that break free, just as some humans do, from the confines of the particular little world into which they were born... They step out of their own time and place, and find some kind of universal and enduring fame. They become part of the common currency of names and images and stories that a whole culture takes for granted. It happens for good reason and for bad, and for no discernible reason at all. It's always happened... But now that images can be reproduced so easily and so accurately, now that mass tourism and universal education have filled the great galleries of the world with holidaymakers and schoolchildren...some of these images have become even more pervasive.

Two of the works of art to which Frayn alludes – 'It happened with one faintly smiling Tuscan woman... It happened with a vase of Provençal sunflowers...' – do indeed feature in this volume. That the others do not is a salutary reminder that the eight masterpieces on which I focus could well be supplemented by others; that ultimately the selection represents my personal conviction that these clamoured for attention more loudly and insistently than any other possible candidates for inclusion. As will become evident, for all the diversity of the works scrutinized, no attempt has been made to achieve a fair distribution of images over the centuries, or indeed over the map of the world. Perhaps only the choice of the *David*, the *Mona Lisa* and *The Scream* will go completely unchallenged. Yet my other choices, too, I believe, although less instantly and universally recognizable, are powerful icons of a more specific kind.

Taking my cue from the programmes made by Fulmar Television & Film for the BBC on Michelangelo's *David* and Munch's *The Scream* (first screened on British television in October 2001), my brief has been to write a 'biography' of each work of art – the essential concept of the series. I focus on a certain number of extremely famous works of Western art and examine them in detail from as many angles as possible. Thus, I have looked not only at their origins, evolution and context, but also at their rich and varied 'afterlife'. In so doing, I have aimed to bring to light unfamiliar facts and to provide fresh insights, not only into the works of art in question, but also into the role of art in Western society. (For, unlike Frayn, I believe that one can go some way at least to account for the process whereby such works become 'part of the

common currency…that a whole culture takes for granted'.) As the title of my book suggests, I have tried to meld the private and the public aspects of each work into a thought-provoking, illuminating and sometimes surprising whole. The process has been a fascinating one, which has led me in often unexpected directions and revealed sometimes startling connections. Although aimed primarily at the lay reader, the end result will, I hope, also be of interest to students and specialists.

In this day and age, few people should need reminding how gender-specific the notion of a 'masterpiece' is. (One need only consider how very different – almost comical – are the connotations of a 'mistresspiece'.) After all, some thirty years have passed since Linda Nochlin wrote her seminal essay, provocatively entitled 'Why have there been no great women artists?' Although the responses to this question have been varied and sometimes contradictory, there is now a general consensus that this is probably the wrong question to ask, since it was above all the social, economic and sexual constraints facing women through the centuries that militated against them turning to art as a career – let alone becoming 'great'. So, despite my own strong feelings on the subject, I have had to acknowledge that although there are plenty of impressive works of art produced by female artists, virtually no artworks by women have attained a truly iconic status in the wider world. (One notable exception, I would argue,

is Judy Chicago's *Dinner Party* of the mid-1970s, which may one day feature in a sequel to this volume.) On the other hand, it has seemed important to illuminate the gender politics at work in the production, iconography and reception of works by the male artists selected for this book, and – by extension – to cast a questioning look at the very notion of genius and the concept of a masterpiece.

That most of the works featured originally met with a mixed, if not downright negative reaction, and have exerted little direct artistic influence should not in the end surprise us. However hard to define, the force of genius is rarely a comfortable one, and its cultural products, of their very nature, are likely to disturb the status quo. However diverse, works of this power and originality seem, moreover, to exert an aura inimical to would-be imitators. As we will see, their influence has for the most part been both more oblique and more pervasive.

Monica Bohm-Duchen
March 2001

MICHELANGELO
DAVID 1501–4

Breathtaking in size and execution, Michelangelo's *David* was the largest sculpture of a naked man produced since classical antiquity. Ostensibly a celebration of an Old Testament hero, its allusion to triumph over unequal

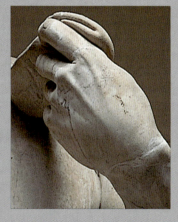

odds was seen as symbolically appropriate of the new Florentine republic's struggle against the Medicis and its other political enemies. The statue, which embodies the religious and the secular, the physical and the spiritual, arrogance and humility, has transcended its immediate historical context to become an icon of faith in human beauty.

▶ *David*
1501–4
Michelangelo Buonarroti
MARBLE
410 CM HIGH (WITHOUT BASE)
GALLERIA DELL'ACCADEMIA, FLORENCE

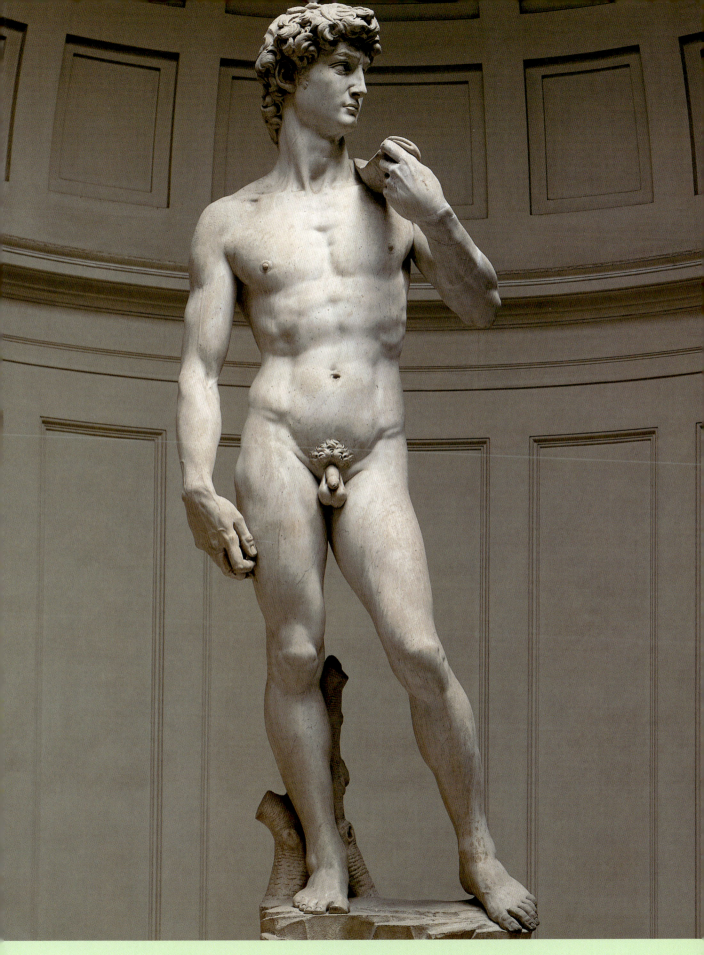

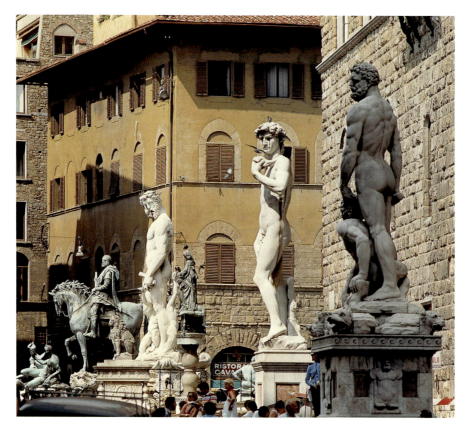

◂ Replica of *David* in the Piazza della Signoria, Florence. Bandinelli's *Hercules and Cacus* is on the right

'Without any doubt this figure has put in the shade every other statue, ancient or modern, Greek or Roman... To be sure, anyone who has seen Michelangelo's *David* has no need to see anything else by any other sculptor, living or dead.' GIORGIO VASARI, 1550/68

Even allowing for the purple prose that characterizes much of Vasari's (unauthorized, and frequently inaccurate) biography of the artist whom he regarded almost as a deity, it would hardly be an exaggeration to claim that *David* is probably the most famous naked man in the world. Certainly, it would be hard to think of any other sculpture that has been so frequently reproduced – and so bowdlerized in the process. For a start, few tourists realize, as they gaze reverently at the giant marble statue in the Piazza della Signoria in Florence (above), that this is not actually the original sculpture. The latter is, in fact, housed in the Galleria dell'Accademia, while another

MICHELANGELO BUONARROTI

version, made of bronze, graces the Piazzale Michelangelo. Few tourists, conversely, can fail to notice the plethora of cheap, crude replicas of the work in all sizes and materials (page 13), available at virtually every street corner. Lifesize copies, of varying quality, can be found as far afield as London, Japan, California and Las Vegas. More recent marketing strategies have ensured that *David*'s likeness also appears on scarves, ties, T-shirts, aprons (right) and party games, and even – in blatantly tongue-in-cheek fashion – on fridge magnets (page 14), where his female counterpart is Marilyn Monroe.

But what of the 'true' story behind this most famous and most reproduced of sculptures? The history of the marble block from which the *David* was carved by Michelangelo Buonarroti between 1501 and 1504 goes back much further, to 1464. At this juncture Florence was already a thriving city-state, ruled by the Medici since the mid-1430s, its wealth founded on the early capitalism of the banks and trade guilds. Rich and ambitious patrons of the arts abounded, dominated by the Medici family itself. Cosimo de' Medici died in this year, passing power first, but only briefly, to his son Piero, and then to his twenty-year-old grandson, Lorenzo, soon to be dubbed 'Il Magnifico', in tribute both to his political acumen and, above all, to his enlightened patronage of the arts.

The crowning glory of the city was the vast cupola of the cathedral (Duomo) of Santa Maria del Fiore, designed by Filippo Brunelleschi and begun in 1420, a feat of engineering that few people had believed was technically possible (page 28). The cathedral board, however, was piqued that Milan had stolen a march on Florence with the richness and diversity of the statuary adorning its cathedral. Plans to commission a series of twelve colossal sculptures of biblical prophets for Florence's cathedral had so far yielded only two figures for the buttresses of the building: one by Donatello, created at the very start of the fifteenth century, and the other by his assistant, the minor but well-respected artist Agostino di Duccio, completed in 1464. (Both sculptures are now lost.)

The Overseers of the Office of Works or Operai, dominated by members of the influential Wool Guild, therefore decided to commission Agostino di Duccio to carve another large Old Testament figure to add to the cathedral buttresses. In late 1464, a massive block of white marble, probably the largest ever, was hewn out of the Polvaccio quarry, near Carrara (now popularly known as the 'quarry of Michelangelo'), or one nearby, for the purpose. The marble would almost certainly have been blocked out at the quarry by a skilled craftsman, working to di

▲ A *David* apron in an Italian souvenir shop

Duccio's specifications, in order to reduce its size and weight prior to its transportation to Florence.

White marble – the material out of which most antique sculptures and monuments were carved – had been quarried in the Carrara area (page 17), some seventy miles north-west of Florence as the crow flies, since the days of ancient Rome. So prized was it that the Roman historian Pliny boasted that this marble was of a purer white than that of the Greek quarries of Paro. In the second half of the thirteenth century, with the stirrings of a new interest in classical culture, there was an increasing demand for white statuary marble for the new cathedrals of Pisa, Siena and Florence. Yet it was only in the sixteenth century, due in large measure to the fame of Michelangelo himself, who remained faithful to the medium throughout his long life, that white marble became the accepted material for virtually all large-scale, quality carving. Until the early sixteenth century, white marble sculptures were hardly known outside Italy, but in the course of that century, its use spread from Italy to France and later, to Spain, The Netherlands, England and beyond. Ultimately, the medium would become an integral part of neo-classical thinking about art.

It seems that Agostino di Duccio got as far as beginning to shape the legs, feet and chest of his figure, roughing out some drapery and possibly gouging a hole between the legs. For reasons that remain somewhat unclear, however, his association with the massive block of marble ceased on the death of his master Donatello in 1466. Ten years later, another Florentine artist, Antonio Rossellino, was commissioned to take up where di Duccio had left off. This too proved unfruitful. His contract was apparently terminated without recriminations, and the block remained unworked and neglected, exposed to the elements in the yard of the cathedral workshop, for a further twenty-five years – much to the concern of the Duomo authorities, since a piece of marble this size would have been extremely costly. Not only was the block huge, but the amount of labour, time and danger involved in quarrying and transporting it to Florence in the days before mechanization would have been immense. The marble, after all, had to be painstakingly hauled down the mountain by ropes and pulleys, transferred to an ox-drawn cart, and finally loaded on to a barge to be taken up the River Arno.

In 1500, an inventory of the cathedral workshops described the piece as 'a certain figure of marble called *David*, badly blocked out and supine'. A document of 2 July 1501 records that the Operai were now determined to find an artist capa-

ble of turning the problematic piece of marble into a finished work of art. They therefore ordered that it should be raised 'on its feet' so that 'masters experienced in this kind of work' might examine it and express an opinion. Leonardo da Vinci and Andrea Sansovino were apparently consulted; but in the event it was the twenty-six-year-old Michelangelo who convinced them that he alone deserved the commission.

Born on 6 March 1475 in the small hilltop town of Caprese (now called Caprese Michelangelo in his honour), Michelangelo was the second son of Lodovico Buonarroti, a scion of an old family fallen on harder times.

Lodovico's appointment as mayor of two modest Tuscan towns ensured that the honour of the family could be maintained. Although his social standing was thus higher than that of many other artists of the time, Michelangelo – and his biographers – would later claim for his family a greater nobility than it actually possessed, in keeping with the social aspirations of the man who saw himself as the equal of popes and princes. He was raised on the family farm in Settignano, a hilltown south-west of Florence famous for its pietra serena stone and its stonecarvers; his wet-nurse was the wife of a mason, and Michelangelo later claimed to have

▲ A 'Diva David' fridge magnet, sold with several changes of clothes, is one of many commercial products inspired by Michelangelo's statue.

▶ *Bacchus*
1496–7
Michelangelo Buonarroti
MARBLE
203.2 CM HIGH (WITHOUT BASE)
MUSEO NAZIONALE DEL BARGELLO, FLORENCE

imbibed the skills of a stoneworker at her breast. Although more than accomplished in the fields of painting and architecture (not to mention poetry), he always saw himself primarily as a sculptor, regarding that medium as the noblest of them all – in defiance of the prevailing view that the heavy manual labour sculpture entailed rendered it inferior to the art of painting. This was clearly a view his own family shared: he was apparently beaten as a boy for wanting to become a painter, but when he later announced his wish to be a sculp-

tor they were more outraged still.

His early apprentice years were spent in nearby Florence, first in the studio of the painters Davide and Domenico Ghirlandaio and then, until his death in 1492, under the beneficent patronage of Lorenzo de' Medici. So precocious – and arrogant – was the young man that a fellow pupil in the Ghirlandaio studio called Pietro Torrigiano punched his nose so hard that he virtually flattened it; in later years Torrigiano would boast that he had left his signature on the great Michelangelo's face. He fared less

well after Lorenzo's death, since the latter's successor, Piero de' Medici, showed little of the same warmth or interest in the young artist. In 1493, at the age of eighteen, he was given special dispensation to study the anatomy of dissected corpses at the monastery of Santo Spirito, in exchange for which he carved a crucifix for the monastery. Although he would give up dissection due to its adverse effect on his digestive system, its importance to the artist was confirmed by the fact that he took it up again in later life at the Santa Maria Nuova Hospital in Florence.

The fall of the Medici in 1494, and consequent fear of the approaching French army, caused the nineteen-year-old Michelangelo to flee the city. Working mainly in Venice, Rome, Siena and Bologna, where he produced the small carving of *St Proclus* of 1494–5 (page 18), which, although relatively crude, prefigures the *David* in its scowling intensity and *contrapposto* – or twisting – stance, he returned to Florence in 1501, quite possibly because rumours of the impending commission had already reached him. Although very early works, such as the *Madonna of the Stairs* and the *Battle of the Centaurs*, produced when he was a mere teenager, had already shown him to be a sculptor of considerable skill, even virtuosity, his first mature masterpiece, the exquisite *Pietà* of 1498–9, now in St Peter's in

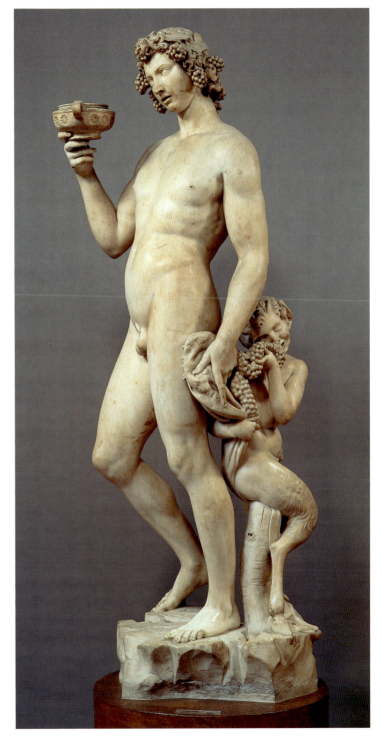

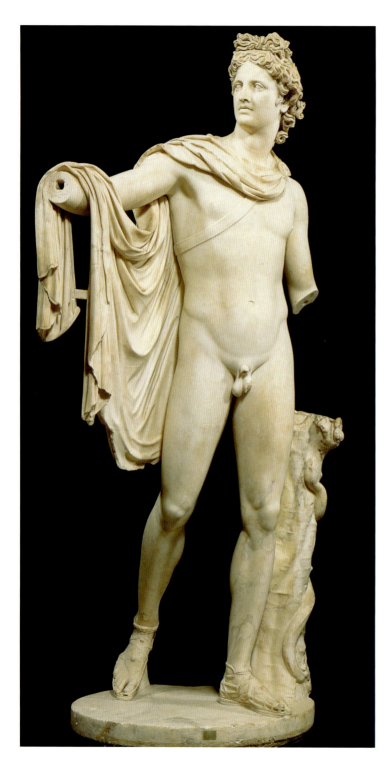

Rome, definitively established his reputation as an independent master. An inscription on the Virgin's sash reads: 'Michelangelo Buonarroti the Florentine made this' – evidence of a pride in his native city that would no doubt have endeared him to its civic authorities. Another work of this first Roman period is the curiously unsettling *Bacchus* of 1496–7 (page 15), over 2 metres high, which, although very different in physique and mood to the *David*, to a limited extent anticipates the pose of that work. In Rome, too, he would have had direct access to works of classical antiquity, such as the famous *Apollo Belvedere* (left), excavated in that city in 1479, which would so profoundly influence his own art.

In Siena he left behind him a huge unfinished commission for fifteen statues of saints for the Piccolomini altar in the cathedral there. With only five of these completed when he abandoned the project in favour of the *David*, the Piccolomini family claimed that the sculptor owed them one hundred ducats as compensation for breach of contract. They would have to wait over sixty years for the money, since they were paid only after Michelangelo's death in 1564, out of the artist's estate, as stipulated in his will – evidence, presumably, of a guilty conscience on this matter. This was an early instance of a recurring feature in a long and intense-

ly productive career, in which the artist would constantly overstretch his resources, unable to turn down new commissions even when previous commitments should have made him hesitate.

The artist's Florentine reputation, in spite of his seven-year absence from that city, was already considerable. Not only would the cultured élite of Florence have been aware of his success in other Italian centres, but the fact that in 1492 he had carved an over-lifesize figure of Hercules (now lost) out of a weathered block of marble, which had remained in Florence, also gave him the right credentials for undertaking the creation of another monumental hero out of less than perfect materials. (In later life, by contrast, Michelangelo would prove extremely fussy about the quality of the marble on which he was prepared to work, spending significant amounts of time reconnoitring and supervising

workmen in the Carrara quarries.) Another very practical reason for his being granted the commission for the *David* may well have been that he was the only artist who claimed he could create a freestanding figure out of the block as it stood, without incurring further costs by adding extra pieces of marble, as Sansovino, for example, had proposed. In any event, with the production of an impressive small wax maquette, Michelangelo won the day.

Politically, Florence in 1501 was a radically different place from the Florence he had left behind in 1494. With the fall of the Medici in that year, life in the city had been dominated by the powerful presence of the Dominican friar Savonarola, whose passionate sermons exhorted the citizens of Florence to mend their evil, impure ways. Michelangelo would have been familiar with his ideas, since the monk had in

◀ *Apollo Belvedere*
c. 350 BC
ROMAN COPY OF GREEK ORIGINAL
MARBLE
223.5 CM HIGH
VATICAN MUSEUMS, ROME

◀ A Carrara marble quarry and some of its workers in the days before the extraction process was mechanized

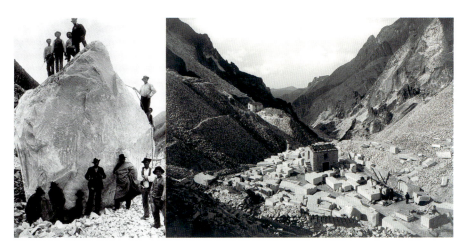

▲ *St Proclus*
1494–5
Michelangelo
Buonarroti
MARBLE
58.4 CM HIGH
(WITHOUT BASE)
SHRINE OF ST
DOMINIC, BOLOGNA

Pope and hanged as a heretic. A new but weak republican regime was now in force, governed by a large and unwieldy central assembly known as the Grand Council or Signoria. Externally, it was kept busy defending itself from assaults by the armies of the exiled Piero de' Medici and Cesare Borgia, illegitimate son of Pope Alexander VII, from the south, while simultaneously attempting to win back the rebellious city of Pisa in the north. This entailed an almost continuous alliance with the French monarchy, a policy that – in the turbulent and fickle political climate of the times – involved alternately opposing and appeasing the Papacy. In 1501, in an attempt to stabilize the internal political situation, Piero Soderini, a patrician grandee who had shown some sympathy for the broader constitution, was appointed *gonfaloniere* (head of state, literally 'standard bearer') for life, in emulation of the Venetian doge.

On 16 August 1501, Michelangelo was given the official contract to embark on the daunting but profoundly challenging new task that – despite the artist's lack of direct political involvement with the new republic – would inevitably take on wider political implications. This, after all, was David, the youthful hero (the young Florentine republic), armed only with a humble sling, who vanquished the giant Goliath (the powerful forces opposed to the republic) against all the odds. As

fact been active in the city for some years prior to this. Ironically, for an artist so enamoured of the physicality of the human body, the ageing Michelangelo came to be increasingly preoccupied by Savonarola's rabid rejection of all things worldly, and claimed he could still hear the friar's voice ringing in his ears. In 1498, however, Savonarola was excommunicated by the

Vasari put it, David was 'a symbol of liberty…just as David had protected his people and governed justly, so whoever ruled Florence should vigorously defend the city and govern it with justice'. The religious aspects of the story, of the monotheistic Israelites triumphing over the idolatrous Philistines – so crucial to its significance in the Old Testament context – were completely overlooked in all this. The statue, the contract specified, was to be completed within two years from September, and the artist would be paid a generous monthly salary of six gold florins, rather than the usual fixed fee on delivery of the work. In marked contrast to the Sienese contract for the Piccolomini altar (and, indeed, most of his subsequent contracts), this one was notable for its brevity and latitude. As we have seen, the subject had already been identified as a David, but beyond that, the artist was given a free hand.

Michelangelo set to work in a specially constructed wooden shed near the Duomo. On 9 September, in a symbolically dramatic public display, a few hammer blows removed a 'certain knot' from the chest of the rudimentary figure already blocked out by his two predecessors – evidence, presumably, that the figure had been intended to wear a cloak and, equally, of his own intention to create an unclothed hero. He would almost certainly have made sketches

from the life, probably using *garzoni* or studio boys as his models, which may well have included alternative ideas for the pose, including the more traditional one of depicting David with the severed head of Goliath at his feet. (The narrow dimensions of the block, however, would have severely limited his options.)

▶ *Continued on page 22*

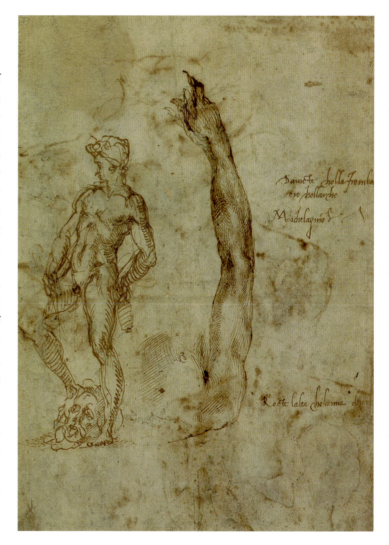

▲ Studies for bronze *David* with autograph inscriptions *c.* 1502
Michelangelo Buonarroti
PEN AND INK
26.7 X 19.7 CM
MUSEE DU LOUVRE, PARIS

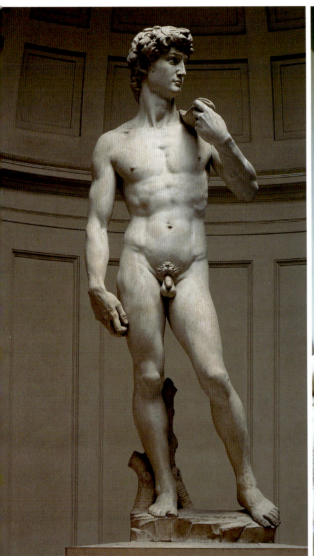
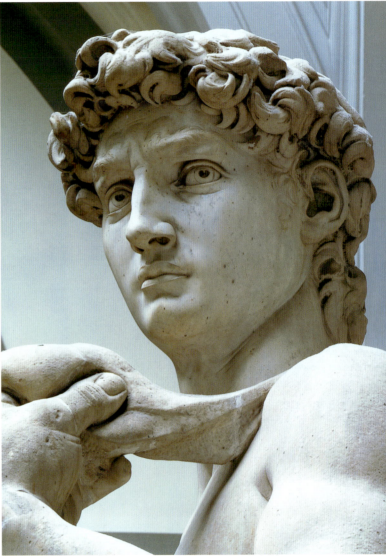

DAVID MICHELANGELO BUONARROTI

Michelangelo faced a huge technical challenge in carving a monumental standing figure out of a massive but extremely shallow piece of marble. The size of the block may also have determined the pose of the figure, since there was no room to show David in the traditional manner, standing triumphantly on Goliath's severed head.

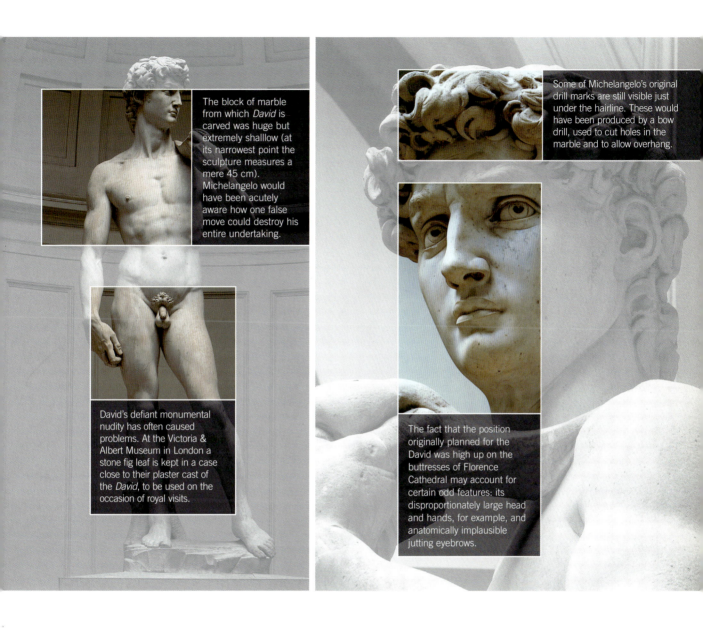

The block of marble from which *David* is carved was huge but extremely shalllow (at its narrowest point the sculpture measures a mere 45 cm). Michelangelo would have been acutely aware how one false move could destroy his entire undertaking.

David's defiant monumental nudity has often caused problems. At the Victoria & Albert Museum in London a stone fig leaf is kept in a case close to their plaster cast of the *David*, to be used on the occasion of royal visits.

Some of Michelangelo's original drill marks are still visible just under the hairline. These would have been produced by a bow drill, used to cut holes in the marble and to allow overhang.

The fact that the position originally planned for the David was high up on the buttresses of Florence Cathedral may account for certain odd features: its disproportionately large head and hands, for example, and anatomically implausible jutting eyebrows.

At this relatively early stage of his career, Michelangelo probably carried out more of the rough work than he was prepared to do in later years, but skilled assistants would almost certainly have knocked off the excess marble for him. After sketching the frontal plane on the block, he began carving, employing three grades of chisel: a sharp-pointed *subia* was used to break off large chunks of stone; a claw chisel, called a *gradino*, was used for more delicate work; and a very fine *scalpello* was used to bring the statue near completion. The final smoothing was done with a rasp.

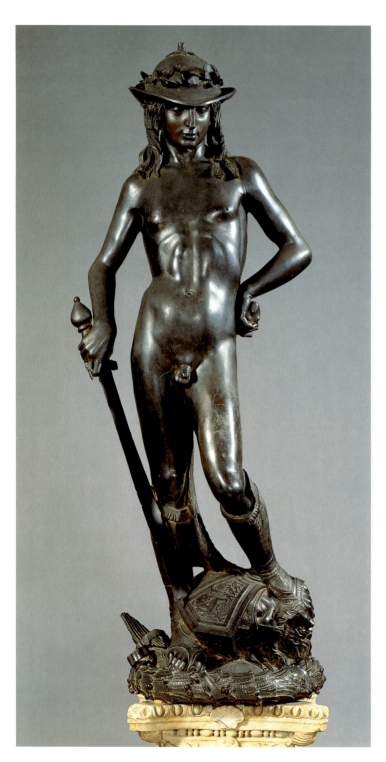

▶ Little is known about Michelangelo's preliminary work for the statue, so there was great excitement in 1987, when a small stucco torso appeared. Several experts were convinced it was a preparatory model for the *David*, but it was soon revealed to be an embarrassing fake. Values in the region of $50–$80 million had already been mooted.

Skilled assistants probably knocked off the excess marble, getting the block to within a few inches of the final surface; although since this was a relatively early work, Michelangelo may well have done more of the rough work than he would have been prepared to do in later years. Sketching the frontal plane on the block, he began the carving from the front, employing three grades of chisel: a sharp pointed one (known as a '*subia*'), to break away large pieces of stone; a claw chisel (or '*gradino*'), for more delicate work; and a finer chisel still (known as a '*scalpello*') to get the statue to its almost completed state, ready for smoothing and burnishing with a rasp. It is possible too that he employed a simple but effective method for helping him gauge what action was needed next: a clay model of the sculpture would have been placed in a bath of water, lying face up, so that as the water was allowed to drain away, the features emerged on the plane on which he had to carve them. The magnificent unfinished *Slaves* (page 34) that Michelangelo

produced some twenty years after the *David* give some inkling of how the latter may have emerged out of the massive block of marble.

One should remember that, contrary to the mythical proportions he acquired, Michelangelo was physically a small man – little over 1.55 metres tall – which must have made his task even harder. He would certainly have needed three levels of scaffolding; and seeing the statue in its entirety while actually at work on it would have been impossible. The block was far too large to be tilted, so would have been worked on upright. Leonardo da Vinci has given us a vivid description of a sculptor at work, in which one can almost hear the fastidious distaste in his voice: 'The marble dust flours him all over so that he looks like a baker, his back is covered with a snowstorm of chips…' Given the shallowness of the block, Michelangelo would have been only too well aware of how easily one false move could destroy the entire undertaking. Scarcely pausing to eat or drink, let alone wash, he would often sleep in the workshop fully clothed, with his boots still on, ready for action on the following day.

Vasari's claim that 'working on it continuously, he brought it to perfect completion, without letting anyone see it' cannot be entirely true, since in February 1502 the overseers decided that the sculpture was already half-finished, and that its maker should be paid 400 gold florins. That it was now popularly, and for obvious reasons, known as '*il gigante*' (the giant) was rather ironical: in the Old Testament, it was Goliath, after all, not David, who was the giant. It was at this point, it seems, that they decided that such an impressive work would be utterly wasted high up on the cathedral buttresses, although its final position was not yet determined. By April 1503, moreover, the Board of Works was so happy with the statue's progress that it commissioned the artist to produce twelve apostle figures for the Duomo, one a year for the next twelve years. The Wool Guild even began to build him a new house and studio in the centre of the city, as an incentive to work on this mammoth project. However, the building was hardly beyond the foundations stage before Michelangelo broke the contract. The only work that he produced for them – ironically, after the contract had already been cancelled – was the superb, unfinished *St Matthew* of *c.* 1505.

In the meantime, to Michelangelo's annoyance, work on the marble *David* was interrupted by a commission for another David, a bronze version after the earlier sculpture by Donatello (opposite). This was for the current favourite of the French king Charles VIII, the general Pierre de Rohan,

◄ *David*
c. 1440
Donatello
BRONZE
158 CM HIGH
MUSEO NAZIONALE
DEL BARGELLO,
FLORENCE

Maréchal de Gié, who had occupied the Medici Palace in 1494 when the French invaded the city, and admired the sculptural riches of Florence. Keen to maintain the French alliance, the Signoria decreed in 1502 that Michelangelo should respond to hints dropped by Florentine ambassadors to the French court that de Rohan would greatly appreciate a copy of the Donatello *David*. In the event, by the time the work was actually cast, in 1508, the maréchal had fallen from favour, so the gift was made instead to the French secretary of finance, its subsequent history untraceable beyond the seventeenth century. However, two preliminary pen and ink sketches for the work have survived (page 19), which – as one might expect – indicate a male body far more muscular and energetic than the original, rather effete and self-consciously elegant Donatello figure. The right arm, moreover, is closer in pose to the marble *David* than to the Donatello sculpture.

Interestingly, the two drawings are accompanied by two short texts, one of them reading 'David, with his sling, I, with my bow – Michelangelo'. If, as seems reasonable, one assumes the artist to be referring to the drill operated by means of a bow that would have been one of the tools of his trade, it becomes clear that he is drawing an analogy between two different kinds of weapons, both leading to victory, albeit in very different fields. (The bow drill would have been used to cut holes – between the arms and the body of the figure, for example – and to allow overhang, as under the hair, where the drill marks are still visible.) Just as the youthful David would slay Goliath and defeat the Philistines, so would the young Michelangelo become the conquering hero of Renaissance Florence. Yet the fact that in the marble *David* (and in contrast to the Donatello, and, indeed, most other renderings of the subject), the figure is depicted tensed before the moment of battle rather than resting after his victory, suggests another affinity, a shared feeling of uncertainty in the face of a formidable task. (Only in the later, quintessentially Baroque rendering of the same subject by Gianlorenzo Bernini (opposite) would David be depicted actually in the act of slaying his opponent.)

Before the marble *David* reached completion in mid-1503, its maker had also embarked on several other major commissions, not only for the bronze *David* already discussed, but also for the *Bruges Madonna*, and the *Taddei*, *Pitti* and *Doni Tondi*. (The first of these was a freestanding marble piece, the next two, marble reliefs, and the last, a painting.) These were almost certainly the most productive years of Michelangelo's long career: at one point he was either work-

ing on, completing, or had commissions for no fewer than forty separate works.

On 23 June 1503, the feast day of St John the Baptist, patron saint of Florence, a door was opened up in the structure Michelangelo had had erected around his sculpture for the sake of privacy, to enable the public to view the work for the first time. By the middle of that summer, the *David* was effectively finished. On 25 January 1504, a special meeting or *pratica*, as it was called, was held in a room of the Opera del Duomo to discuss the siting of the magnificent new work. Remarkably, the minutes of this meeting have survived, enabling us to reconstruct it in almost uncanny detail. Although he would later claim to have been present, and that, indeed, his own republican convictions helped win the day, we know from this source that Michelangelo was in fact conspicuous by his absence. The gathering included many of the great artistic luminaries of the day, including Leonardo da Vinci and Filippino Lippi, as well as numerous civic dignitaries. Opinions largely centred on where the statue would look best and be least vulnerable to damage.

Only one or two members of the meeting still considered placing the sculpture on the cathedral buttresses as a viable option. Not only was the *David* too outstanding an achievement to be relegated to a position some 12 metres in the air, where no one would be able to see it properly; but its size and weight would clearly present grave, if not insurmountable, technical problems. Moreover, its evident power as a symbol for the young Florentine repub-

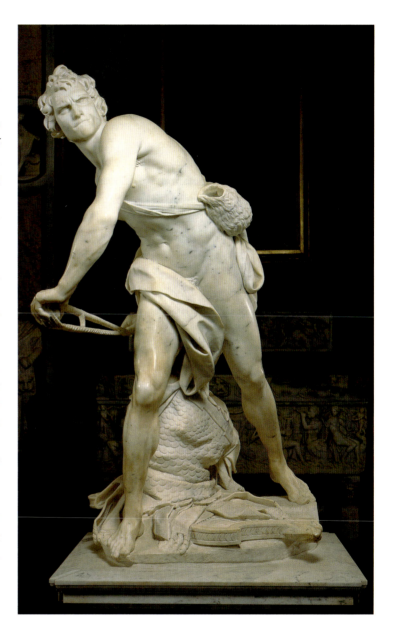

▲ *David Slaying Goliath*
1623
Gianlorenzo Bernini
MARBLE
170 CM HIGH
GALLERIA BORGHESE, ROME

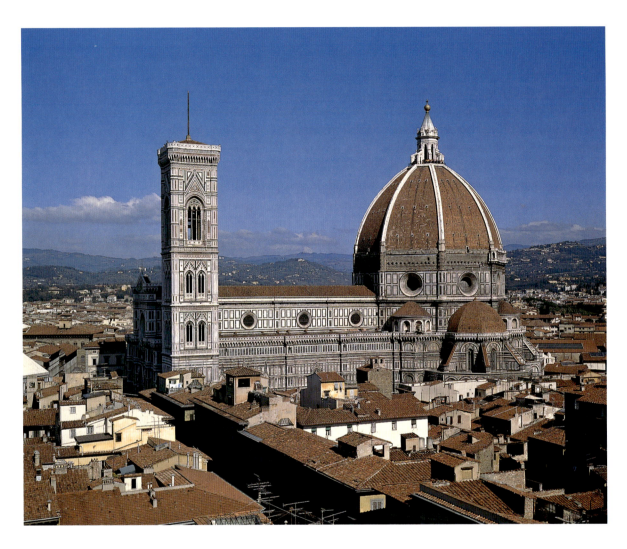

▲ Florence
Cathedral

low height, such as the cut-away triangles in the eyes to indicate lustre, were added. A quite possibly apocryphal anecdote related by Vasari tells how Soderini, the Florentine head of government, arrived on the scene one day to inspect the statue. When he suggested that the *David*'s nose could do with some improvement, Michelangelo complied by pretending to work on it, dropping marble dust as he did so in order to look convincing. Soderini was apparently well pleased with the result.

The final touches were added: the tree stump and sling strap were gilded, and a garland of golden leaves (which has long since disappeared) placed around the figure's head. A second garland of twenty-eight copper fig leaves, to hide its genitals, may have been added at the decree of the cathedral committee. (One should recall that at

the time of its creation, *David* was the largest freestanding marble sculpture of a nude figure, male or female, to have been produced since classical antiquity. In the medium of bronze, Donatello's 1.5-metre *David* (see page 22) remained anomalous, although small statuettes of heroes such as Hercules and David were rather more common. And after all, surely the biblical David would not have fought Goliath stark naked.) On 5 September Michelangelo was paid the balance of his salary. The public unveiling of the statue took place on 8 September 1504, the day of Soderini's official investiture as *gonfaloniere*, thus making explicit the *David*'s role as a republican symbol.

The positioning of the *David* at street level meant that several features of the monumental figure, which would barely have been noticeable had the sculpture been sited high up on the cathedral buttresses (some of which may indeed have been created with that position in mind), now became more conspicuous. Notable among them were the unusual shallowness of the block out of which the statue had been carved; the impeccably groomed pubic hair and surprisingly small penis; the prominent veins and exaggeratedly furrowed brow (which juts out in an anatomically impossible fashion); the disproportionately large head and hands (particularly the right one); and last but by no means least, the giant

stature of the work as a whole. Some commentators have felt that the size of the *David*'s head and hands lends the work an aura of adolescent awkwardness; more to the point, I would suggest, is the fact that the biblical David was sometimes referred to by the Latin term *manu fortis* (with a strong hand), in reference to the strength and manual dexterity required to use a sling effectively.

In the wake of *David*'s public success, Soderini was determined to persuade its maker to create a companion piece. Although Michelangelo did get as far as producing wax models for a Hercules and a Samson, it was ultimately a minor – and now little-known – artist called Baccio Bandinelli who carved the marble block that had been earmarked for Michelangelo into a *Hercules and Cacus*, finally completed in 1534. A comparison between the two works, which still stand close to each other in the piazza (page 10), serves only to highlight Michelangelo's genius. The Renaissance sculptor and goldsmith Benvenuto Cellini, for example, derisively dismissed Bandinelli's statue as 'an old sack of melons'.

As many had anticipated, the exposure of the *David* to the elements led in due course to problems, starting in 1512, when its base was struck by lightning, which may explain the presence of numerous defects in the marble, and the fact that it came to lean precarious-

ly forward. A further mishap occurred in 1527, when violent conflict between supporters of the Medici and supporters of the republic led to serious damage to the statue. Pro-Medici rioters outside the Palazzo della Signoria were apparently being pelted by those inside, when a bench hurled out of the building by the republicans shattered the arm of the *David*, breaking it into several pieces. According to Vasari, there were three fragments, which he and another young nobleman risked life and limb to rescue three days later. Cynically, some have seen this emphasis on the religiously significant number three as part of Vasari's apotheosis of his hero, and quite in keeping with his claim that Michelangelo had 'worked a miracle in restoring to life something [i.e. the marble block] that had been left for dead'. In fact, X-rays have since shown that the arm was actually damaged in many more places, that the fingers were smashed and that extensive pinning had taken place to repair the damage (which was only undertaken several years later).

The first instance of the *David*'s adaptability as a political symbol came in the 1530s, when the Medici regained power in Florence, making the Palazzo della Signoria, now renamed – more neutrally – the Palazzo Vecchio, their power base. Viewed as a *persona non grata* by the Medici, and with a death warrant issued against him (he had,

after all, designed fortifications to defend the city against the Medicean armies), Michelangelo had once again to flee the city, this time for good. His *David*, however, remained imperviously in place, guardian of the palace and, by extension, of the Medici dynasty.

In the eighteenth century, the statue began increasingly to attract the interest of travellers on the Grand Tour, although Rome, treasure house of classical antiquities, still took precedence over Renaissance Florence at this juncture. By 1800, the civic authorities were seriously concerned about the physical condition of the *David*. Three hundred years of exposure to rain, wind, storms and sun had taken their toll – in addition to which, a gutter from the Palazzo Vecchio had been allowed to leak on to the statue, causing further damage. The first 'modern' restoration of the *David* took place in 1813, carried out by Stefano Ricci, who replaced the middle finger of the right hand, broken off in an unknown incident, and applied a protective substance to the surface of the sculpture, which was designed to act as a barrier against the elements. In the process, the statue acquired an unnatural whiteness much favoured by neoclassical artists of the period.

In 1843, however, the benefits of this treatment were cancelled out by the notoriously insensitive restoration undertaken by Costoli, who scraped the

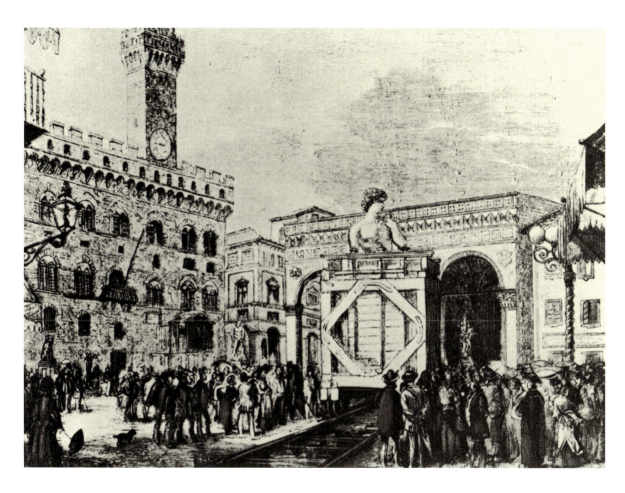

▲ A contemporary print showing *David* being transferred from the Piazza della Signoria to the Accademia in 1873

statue clean with wire wool, erasing a great deal of detail and aggravating surface weaknesses. The chisel marks on the top of *David*'s head, made by the first sculptor to tackle the marble, and intentionally left behind by Michelangelo to demonstrate that he had indeed made use of every inch of the block, were now removed. Costoli repaired the little toe of the right foot – not very effectively, it seems, since it required further attention just eight years later. It was at this time that strategies to secure the now alarmingly angled statue (it leaned forward a full half metre) were discussed: one proposal was that the carved tree trunk should be extended up the *David*'s back to provide extra support.

During the course of the nineteenth century, in the Italy of the Risorgimento (literally, resurrection), the statue became a potent symbol of the fledgling nation's struggle for independence from France and Austria. The Piazza della Signoria became a gathering place for supporters of the republican movement, and guards were placed at the foot of the statue to prevent it being

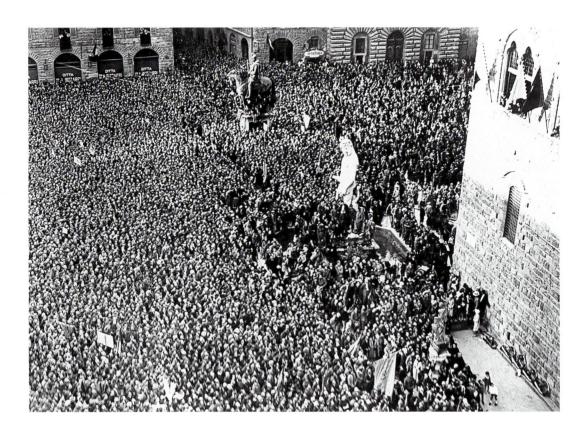

▲ A fascist rally
in the Piazza
della Signoria
during the 1930s

used as a focal point for speech-makers and insurrectionists. In the age of Italian unification, it came to embody the 'Spirit of the Italian People', nobly triumphing against the odds. As the importance of the *David* in the Italian popular imagination increased, so too did demands for its relocation to a less vulnerable site.

In 1854, it was finally decided that the *David* should indeed be moved; but as had happened in the early sixteenth century, no one could decide where it should go. In the meantime, a plaster cast was made of the work, causing further damage to it. This copy was placed in the Loggia dei Lanzi so as to gauge the suitability of that location: thus, for a while, not just one, but two Davids graced the piazza. After four months, it was decided that the *David* was too dominant a presence in the Loggia; other locations – the Loggia del Mercato Vecchio, the Loggia degli Uffizi – were also, for reasons of light or context, rejected. Eventually, in 1866, the plaster copy was installed in the National Museum of the Bargello, where a wall had to be demolished to let it into the building.

In 1871, the original sculpture, supported with wood and metal, was boxed up *in situ* in the Piazza della Signoria, to protect it from the elements. It thus

remained hidden from public view for nearly two years, until, on 30 July 1873, it was transported to the Galleria dell'Accademia – where it has remained to this day. Contemporary illustrations (page 31) show the statue, which was initially hauled up within its box on a purpose-built frame, being pushed through the streets of Florence on specially constructed railway tracks, escorted by a sizeable crowd.

Since, after twenty years of wrangling, the specially designed semi-circular tribune intended to accommodate the *David* in the Accademia had still not been constructed, the statue was left in its box, where – to add insult to injury – lack of ventilation caused a violet fungal growth to break out on its surface. Apart from one week in 1875 when it was put on public display as part of the celebrations to mark the 400th anniversary of Michelangelo's birth, the statue disappeared from public view for the best part of a decade. In partial compensation, a third *David*, this time cast in bronze, known locally as the 'Moorish' David, and flanked by copies of the famous 'times of day' figures from the Medici tombs in the church of San Lorenzo, was installed as part of a new monument to their creator in a square overlooking the city, duly renamed the Piazzale Michelangelo. A sound and light performance apparently accompanied the unveiling of the work.

The new tribune of the Accademia (designed to allow a support to be run from the rear wall to the back of the statue) finally opened to the public in 1883, to a mixed reception. Some felt that placing *David* in an interior diminished the work; and, indeed, in a literal sense, this was true, since it now had a different pedestal, 60 cm lower than the original one, which had been too large to fit into the new space. In the meantime, the outdoor site formerly occupied by the *David* remained empty. Certain Italian artists argued that a modern work should take its place; others, including the poet Gabriele D'Annunzio, advocated the return of the original *David*, suggesting that since it had, after all, been designed for an exterior setting, it should be allowed to weather with dignity in the open air. Ultimately, it was decided to commission yet another copy of the *David*, which was placed in the Piazza della Signoria in 1910. The conspicuous stains visible today on this marble copy all too vividly testify to the damage wrought by twentieth-century pollution.

In the 1930s, the piazza became a favourite place for Fascist rallies at which Benito Mussolini addressed tens of thousands of people from a window in the Palazzo Vecchio. Film stills from the period (opposite) show how people climbed up on to the base of the new *David*, propping themselves against his legs so as to obtain a clearer view of Il

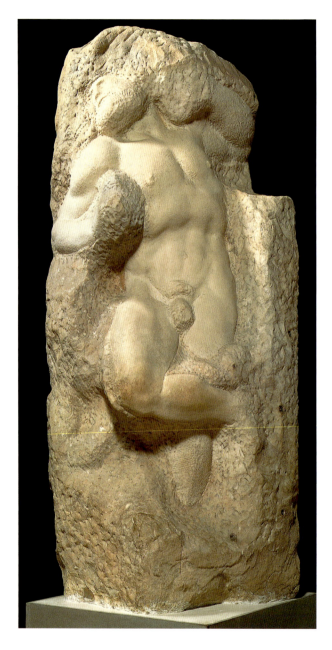

▲ *The Awakening Slave*
1520s (?)
Michelangelo Buonarroti
MARBLE
269.6 CM HIGH
GALLERIA DELL'ACCADEMIA, FLORENCE

▶ *David*
before 1476
Andrea del Verrocchio
BRONZE
126 CM HIGH
MUSEO NAZIONALE DEL BARGELLO,
FLORENCE

Duce. Ironically for a nice Jewish boy, *David*'s Aryan looks found favour with Fascist aesthetic ideology.

With the advent of the Second World War and the threat of air-raids on Florence, those artworks that were readily movable were evacuated from the city. The *David*, together with most of the other statues in the Accademia, including Michelangelo's *Slaves* (left), were wrapped in protective sheeting, then bricked up in rounded silos, from which they emerged unscathed at the end of the war.

The history of Michelangelo's *David* since 1945 has been rather less colourful. Better cared for than ever before, defects such as the lean have been corrected, while X-rays and ultraviolet scans have enabled scholars and conservators to gauge the extent of the damage and repairs to the sculpture over the centuries. In 1991, a disaffected and mentally unhinged artist called Pietro Cannato attacked the left foot of the statue with a hammer, with the result that for a time it was protected by a full-length glass barrier. (This was in due course replaced by smaller protective screens.) The most recent development is a meticulous digital scan of the statue undertaken in 1999 by a team from Stanford University in California, which will ultimately lead to a 3D computer model of the work, intended to provide hitherto undreamt-of technical

insights. Indeed, it has already revealed that the *David* has a squint, only obvious, however, if the head of the figure is viewed straight on – which of course, as its creator knew full well, it never would be.

Even in today's purportedly liberal climate, the defiant nudity of Michelangelo's monumental figure can sometimes cause problems. A *Daily Star* newspaper article of 1986, for example, revealed how the plaster cast housed in London's Victoria and Albert Museum, often giggled at by embarrassed schoolgirls, was supplied with a 30-cm-high stone fig leaf (page 37), stored in a nearby glass case, in anticipation of a visit to the museum by Diana, Princess of Wales. In 1987, a photographer called Lea Andrews slyly poked fun at the conventions of masculine representation when he produced a naked portrait of himself holding a reproduction of the middle section of the *David* over his genitals (page 36); astonishingly, the commercial distributors of the poster for the exhibition in Cambridge, England, aptly titled *Imposters*, in which the work featured, refused to accept it until the image was overprinted with a fig leaf. When, in 1995, moreover, Florence offered a copy of the *David* to Jerusalem, in honour of the 3000th anniversary of the conquest of the city by the biblical King David, it was rejected by the authorities on the

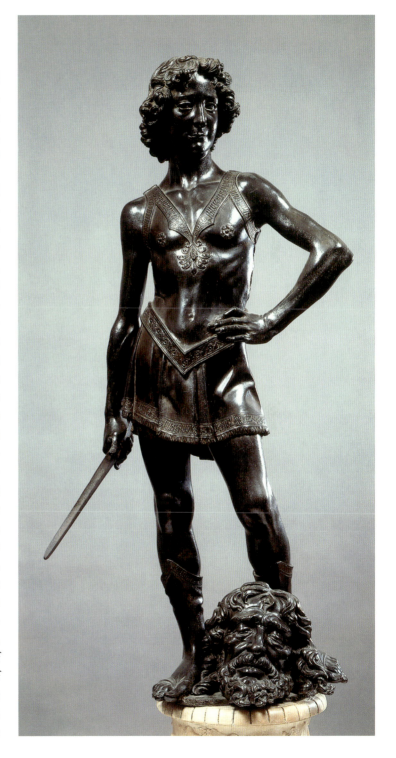

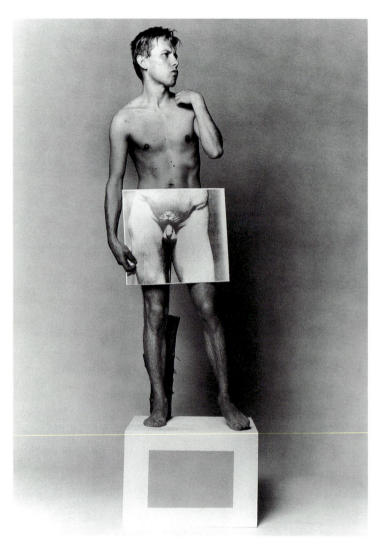

which led him to place sixteen snow-white replicas of it on classical columns in the driveway of his Los Angeles mansion (popularly known as the 'House of David', opposite), led to a public outcry.

The details of Michelangelo's own sexuality remain open to debate, although there is little doubt that he was homosexually inclined. However, the distinction between heterosexuality and homosexuality was by no means as clearly defined in those days as it is now. Indeed, it seems that in sixteenth-century Florence, between one-half and two-thirds of all men had experienced some form of homosexual relationship before they were thirty years old. Although common, it was against the law, and such affairs were hence conducted in secret. For the most part, however, it was young boys (of the kind immortalized in Donatello's *David* (page 22) who were the object of erotic interest, which makes it unlikely that the muscular youth represented by Michelangelo would have been viewed in the same light. In more recent years, on the other hand, the *David* has become a gay icon *par excellence*, his pose and physique emulated in numerous gay magazines. Similarly, with the rise of feminism in the 1970s, women have felt freer to express their unabashed admiration for the sculpture's magnificent physique.

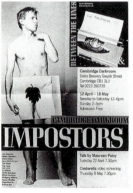

grounds that it would cause offence to the ultra-orthodox Jewish community. (A copy of Andrea del Verrocchio's earlier *David* (page 35), respectably covered in a tunic, although far more camp in pose and expression than Michel-angelo's, was accepted in its place.) And even in contemporary California, rock musician Norwood Young's obsession with the *David*,

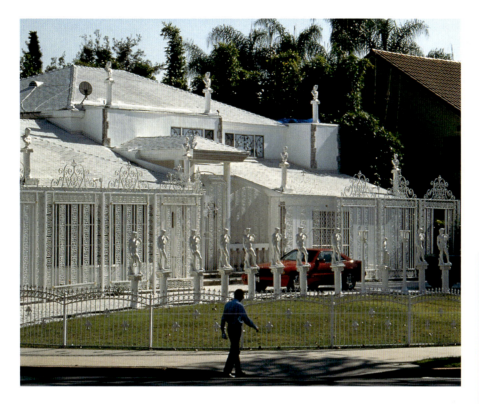

◀ (left and below)
Norwood Young's
'House of David'
LOS ANGELES

▲ The stone fig leaf that V & A
curators still deem necessary
to cover *David*'s modesty
during royal visits
VICTORIA & ALBERT MUSEUM, LONDON

Yet it is surely not just the physical beauty of the *David* that explains its enduring power and appeal to the over one million tourists who every year queue up outside the Accademia to experience the original sculpture for themselves. Might it perhaps have something to do with its distinctive and unusual blend of confidence and vulnerability, the human and the superhuman, the religious and the secular, physicality and spirituality? Perhaps one should let Michelangelo himself have the last word: 'If man's divine part has well conceived someone's face and gestures, it then, through that double power, using a slight and lowly model, gives life to stones – and this is not the result of mere craftsmanship.'

◀ (opposite, top)
Form and Content
1986
Lea Andrews
PHOTOGRAPH
PRIVATE COLLECTION

◀ (opposite, bottom)
Poster for 'Impostors'
exhibition, Cambridge
Darkroom
1987

LEONARDO DA VINCI

MONA LISA *c.1503–6(?)*

Virtually nothing is known with any certainty about this most famous and widely reproduced of all paintings. The inscrutable expression of its subject has led to a wealth of speculation, but the painting retains its aura, despite being endlessly plagiarized by other artists and used for a variety of

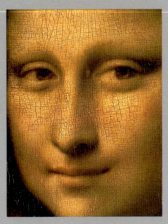

commercial purposes. The beautiful image was innovative in many ways, not least in its use of recently developed oil paints and a new line-softening technique called *sfumato*. But Leonardo's greatest achievement was in creating a portrait that appeared to represent a living, breathing person – a mysterious woman who haunts us still.

▶ *Mona Lisa*
c. 1503–6 (?)
Leonardo da Vinci
OIL ON PANEL
77 X 53 CM
MUSÉE DU LOUVRE, PARIS

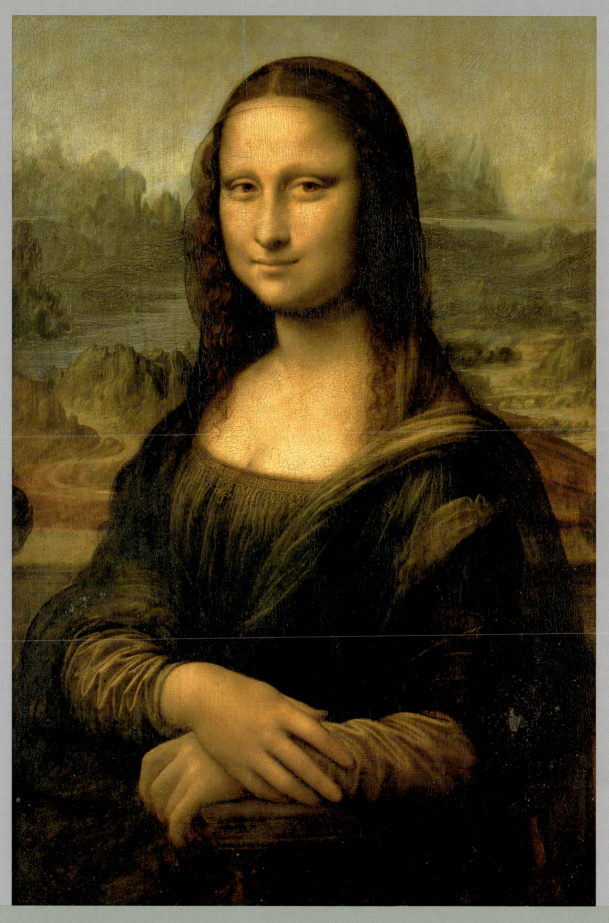

'It provokes instant shocks of recognition on every continent from Asia to America, reduces the Venus of Milo and the Sistine Chapel to the level of merely local marvels, sells as many postcards as a tropical resort, and stimulates as many amateur detectives as an unsolved international murder mystery.' ROY McMULLEN, 1976

At the heart of any attempt to understand the *Mona Lisa* lies a paradox: that this most famous of all works of art is also the one about which we know virtually nothing with any certainty. Perhaps, then, as an antidote to all the extravagant words that have been penned about it over the centuries, one should start with a down-to-earth description of its verifiable physical and technical aspects.

The painting popularly known as the *Mona Lisa* is executed in oil on panel, the latter being a single, thin, fine-grained piece of white poplar, the wood support particularly favoured by Italian artists of the early Renaissance. The panel currently measures 77 x 53 cm – first-time viewers of the work often comment that they are surprised how small it is – but we know from early copies that the original composition clearly included two classical columns, which are now barely hinted at on either side of the painting. It appears that the sides of the panel were trimmed by a few inches, probably in the early seventeenth century by an unthinking framer. The panel itself may have been prepared in the complicated and painstaking way recommended in Leonardo da Vinci's *Trattato della Pittura* (Treatise on Painting). According to the *Trattato,* the first coat to be applied would have been of mastic, turpentine and white lead or lime; this would have been followed by two or three coats of a solution of alcohol and arsenic or mercury chloride, and a well rubbed-in layer of boiled linseed oil; these in turn would have been followed by a coat of varnish and white lead. Once the surface of the panel was completely dry, it might have been washed with urine (sometimes used to remove any traces of grease), and finally pumiced until it resembled a sheet of ivory. X-ray and other tests conducted at the laboratories in the Louvre reveal that the pigments used were suspended in a very fluid oil medium and that the picture was built up by a series of thin colour washes, very much in the manner of those pioneers of the oil painting

medium, the Flemish painters of the fifteenth century.

There are no contemporary accounts of Leonardo at work on the *Mona Lisa* itself, but the following firsthand description by the writer Matteo Bandello of the artist at work on his famous fresco of the *Last Supper* suggests that progress would have been slow:

Many a time I have seen Leonardo go early in the morning to work on the platform…and there he would stay from sunrise until darkness, never laying down the brush, but continuing to paint without eating or drinking. Then three or four days would pass without his touching the work, yet each day he would spend several hours examining it and criticizing the figures to himself. I have also seen him, when the fancy took him, leave the Corte Vecchia where he was at work on the stupendous horse of clay [his ultimately unrealized monument to Ludovico Sforza, ruler of Milan], and go straight to the Grazie [the monastery of Santa Maria delle Grazie in Milan]. There, climbing on to the platform, he would take a brush and give a few touches to one of the figures: and then suddenly he would leave and go elsewhere.

The device of placing a portrait high against a landscape backdrop, which to us now seems entirely conventional, was, in Leonardo's day, something of a

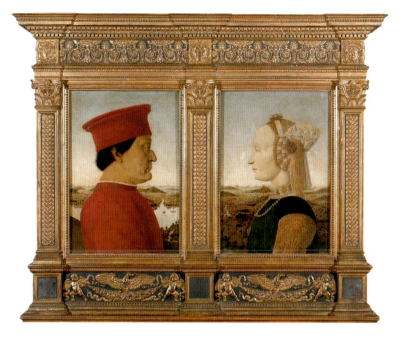

▲ *Montefeltro Diptych* c. 1472 Piero della Francesca UFFIZI GALLERY, FLORENCE

rarity. A notable Italian precursor in this respect (which Leonardo would have encountered at first hand when he visited Urbino in 1502) was Piero della Francesco's memorable *Montefeltro Diptych* of *c.* 1472 (above); but a comparison of the two works reveals more differences (above all, in the rendering of the heads) than similarities. In fact, the use of a landscape background had originated in the Low Countries, as witnessed in paintings by Jan van Eyck and Hans Memling. The blue-green crags are reminiscent both of certain Flemish compositions, and – more intriguingly – of oriental scroll painting. Landscape and figure are united in the *Mona Lisa* by a mysterious fluidity, in

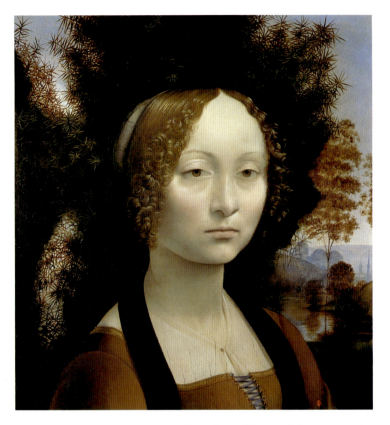

▲ *Ginevra de'*
Benci (detail)
c. 1475/6
Leonardo da Vinci
OIL ON PANEL
38.8 X 36.7 CM
NATIONAL GALLERY OF
ART, WASHINGTON DC

the workings of the earth and of the human body, drawing on the well-established Renaissance conceit of microcosm and macrocosm: 'By the ancients man has been called the world in miniature, and certainly this name is well bestowed, because, inasmuch as man is composed of earth, water, air, and fire, his body resembles that of the earth...' More specifically, his observation that 'the motion of the surface of the water... conforms to that of the hair' is borne out in the painting by the way the delicate cascades of the woman's hair evoke the ripple and flow of water (see also page 165), an analogy underscored by the little rivulets of drapery falling from her gathered neckline and the spiral folds of the veil across her left breast. In compositional terms, one might also note the way the curve of the road on the left-hand side of the picture echoes that of her neckline, while the bridge on the right continues the curve of the material draped over her left shoulder.

Above all, figure and background are united by the distinctive, quintessentially Leonardesque manner in which they are painted. This is normally referred to by a term Leonardo himself liked to use: namely, *sfumato*. Italian for 'misty' or 'smoky', the term denotes a particularly subtle form of *chiaroscuro*, that is, a very gradual tonal transition from light to dark, a subtle modelling of form that encourages the use of a limited range of

confirmation of Leonardo's own conviction that 'Everything proceeds from everything else and everything becomes everything, and everything can be turned into everything else.' Space in the painting is strangely condensed. One is barely aware, for example, of the chair on which the woman sits, while the dramatic linear perspective beloved of so many Renaissance artists has been eschewed in favour of what da Vinci himself dubbed 'aerial perspective', the use of progressively hazier contours and lighter colours to create a highly atmospheric illusion of spatial recession.

The artist himself wrote passionately about the analogies to be drawn between

muted colours, eliminates sharp contours and virtually dispenses with line. Made technically possible by the introduction of oil paints in the fifteenth century, the technique was developed largely by da Vinci himself. In the artist's own words: 'the boundaries of bodies are the least of all things… Wherefore, O painter, do not surround your bodies with lines.' It is in large measure this elimination of hard edges around the eyes and mouth that enabled the artist to achieve the haunting ambiguity and mobility of expression that has become the painting's hallmark.

That the *Mona Lisa* is by Leonardo's own hand – one of a mere handful of authenticated finished works by him that have survived – has never been seriously questioned. Like all Leonardo's work, however, the *Mona Lisa* is neither signed nor dated. To this day, the date of the painting and the identity of the sitter remain unverifiable; there are no extant sketches or related drawings, no evidence of a commission or record of payment, no mention of it anywhere in its maker's voluminous notebooks and only very few in contemporary documents.

The best-known contemporary account is the detailed description of the work by Giorgio Vasari in his *Lives of the Artists*, first published in 1550, thirty-one years after Leonardo's death, which for the first time identifies the sitter by name:

For Francesco del Giacondo, Leonardo undertook to execute the portrait of his wife, Mona Lisa. He worked on this painting for four years, and then still left it unfinished; and today it is in the possession of King Francis of France, at Fontainebleau… The eyes had their natural lustre and moistness, and around them were the lashes and all those rosy and pearly tints that demand the greatest delicacy of execution. The eyebrows were completely natural, growing thickly in one place and lightly in another and following the pores of the skin. The nose was finely painted, with rosy and delicate nostrils as in life. The mouth, joined to the flesh-tints of the face by the red of the lips, appeared to be living flesh rather than paint. On looking closely at the pit of her throat one could swear that the pulses were beating… [While] he was painting Mona Lisa, who was a very beautiful woman, he employed singers and musicians or jesters to keep her full of merriment and so chase away the melancholy that painters usually give to portraits. As a result, there was a smile so pleasing that it seemed divine rather than human; and those who saw it were amazed to find that it was as alive as the original.

Who, then, was Mona Lisa? Mona (more accurately, Monna, short for Madonna, the Italian equivalent of My Lady or Madame – *mona* is in fact a

► *Continued on page 46*

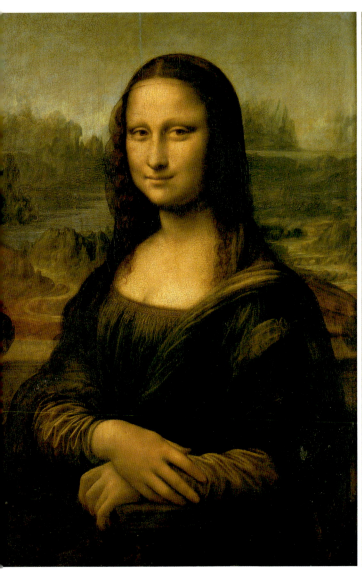

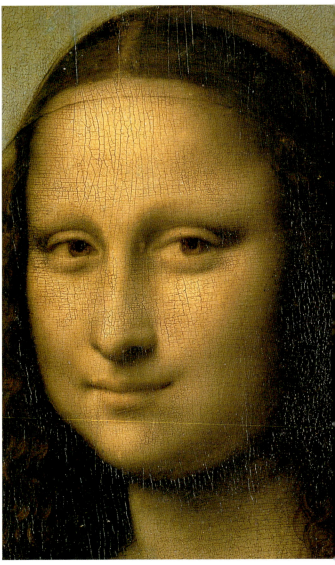

MONA LISA LEONARDO DA VINCI

This classic painting was originally a highly innovative work of art: it used oil paint rather than tempera, employed a new line-softening technique called *sfumato*, and placed the portrait against a landscape background. Leonardo's genius lay in fusing its parts into a fluid and mysterious whole.

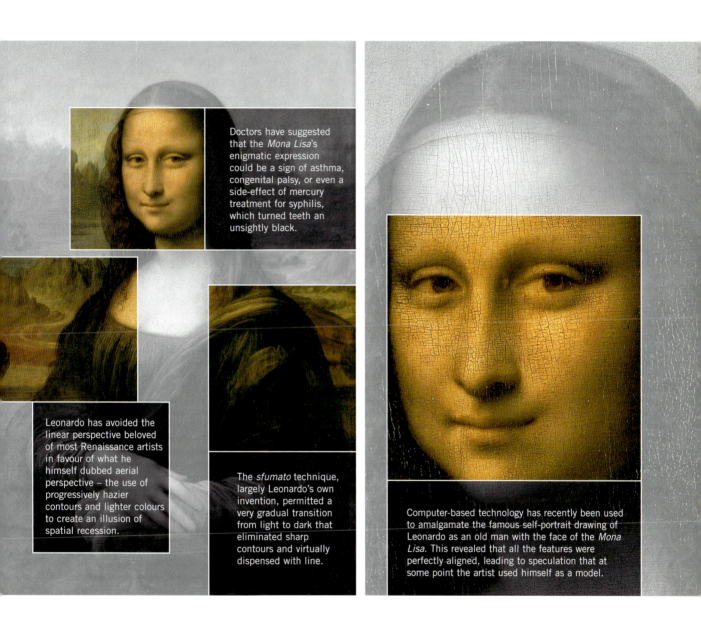

Doctors have suggested that the *Mona Lisa*'s enigmatic expression could be a sign of asthma, congenital palsy, or even a side-effect of mercury treatment for syphilis, which turned teeth an unsightly black.

Leonardo has avoided the linear perspective beloved of most Renaissance artists in favour of what he himself dubbed aerial perspective – the use of progressively hazier contours and lighter colours to create an illusion of spatial recession.

The *sfumato* technique, largely Leonardo's own invention, permitted a very gradual transition from light to dark that eliminated sharp contours and virtually dispensed with line.

Computer-based technology has recently been used to amalgamate the famous self-portrait drawing of Leonardo as an old man with the face of the *Mona Lisa*. This revealed that all the features were perfectly aligned, leading to speculation that at some point the artist used himself as a model.

In keeping with Italian Renaissance studio practice, it is likely that Leonardo employed assistants to create a smooth white surface on the wood panel and to prepare the pigments he used to paint on it. Given the panel's small size, however, it is unlikely that anyone but Leonardo worked on the painting itself. Following an initial charcoal drawing, the basic forms of the composition would probably have been blocked in with green or brown underpainting, and the surface slowly built up with a sequence of thin colour washes and glazes.

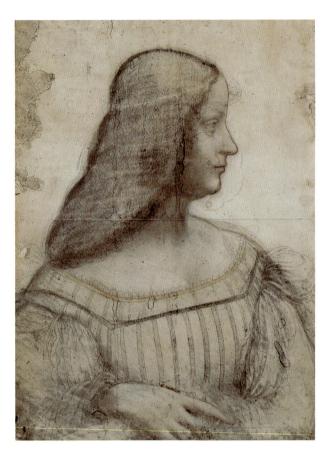

▲ *Isabella d'Este*
c. 1500 (1502?)
Leonardo da Vinci
BLACK AND RED CHALK
AND YELLOW PASTEL
CHALK
63 X 46 CM
MUSEE DU LOUVRE,
PARIS

▶ dialect word for the female private parts) Lisa was, it seems, Lisa Gherardini, the young wife of Francesco di Bartolommeo di Zanobi del Giacondo, a rich silk merchant closely associated with the republican government of Florence. The marriage took place in 1495, when Lisa was a mere sixteen years old; her new husband was nineteen years her senior, and already twice a widower. Yet there is no documentary evidence whatsoever to confirm that Francesco del Giacondo ever commissioned a portrait of his wife (although there is, by contrast, a con-

fusing earlier reference to a – now untraceable – portrait by Leonardo of Francesco himself), or that he ever paid the artist or took delivery of the painting. One of the few things we do know for sure is that da Vinci kept the painting with him until his death at Clos-Lucé, near Amboise, France, in 1519.

Then there is the matter of the painting's title. Known in English as the *Mona Lisa*, in France she goes by the name of *La Joconde*, and in Italy, *La Giaconda* – literally, the Jocund or Smiling Woman. Is this a reference to Lisa's family name, or to the smile that is the sitter's trademark? Or both? After all, Leonardo had already made witty visual references to names in his portraits: most famously perhaps, in the beautiful *Ginevra de' Benci* of c.1475/6 (page 42), in which the inclusion of a juniper tree (*ginepro* in Italian) alludes to the young woman's first name. Eloquent and persuasive as Vasari's description of the work is, we need to remember that he was only six years old when Leonardo and his portrait left Italy for good, and that it is therefore almost impossible that he ever saw the painting at first hand. For all that, the name Mona Lisa has stuck.

If not Lisa, who might the sitter have been? Needless to say, art historians – and others, less expert – have had a field day. Some claim she is Isabella d'Este, ruler of Mantua, who knew Leonardo

well in Milan, and whose court Leonardo visited in 1499. In that year he apparently drew two sketches of her in chalk, charcoal and pastel, both now lost; and in 1502 he produced a preparatory drawing or cartoon (left), presumably for a portrait in oils, but which bears only a minimal resemblance to the woman depicted in the *Mona Lisa*. Others hold out for Costanza d'Avalos, Duchess of Francavilla, who ruled over a tiny court on the island of Ischia and, like Isabella d'Este, prided herself on being a lavish patron of the arts. Support for this view comes from the solitary and inconclusive fact that she is mentioned in a contemporary poem as having been painted by Leonardo 'under the lovely black veil'.

In fact, the earliest probable reference to the work was penned in 1517 by Antonio de' Beatis, a member of the entourage of the Cardinal of Aragon, when he visited Leonardo at the manor house of Clos-Lucé and noted the existence of a portrait of a 'certain Florentine lady, made from nature at the instigation of the late Magnificent Giuliano de' Medici'. This clearly plays havoc both with the claim that the portrait was commissioned by Francesco del Giacondo and with the traditional dating of the work to 1503–6, since Giuliano de' Medici (brother of Pope Leo X) was the artist's patron considerably later, principally in Rome, between 1513 and 1516.

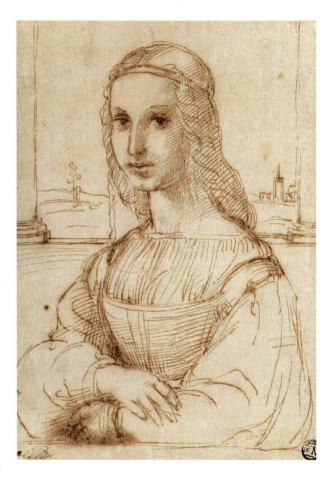

▲ *Florentine Portrait*
c. 1504
Raphael
INK
22.5 X 15.9 CM
MUSEE DU LOUVRE,
PARIS

Explanations, or rather attempts at explanations, proliferate: the sitter was Giuliano's mistress (was she even, conceivably, Lisa del Giacondo herself?); the reason that Giuliano never took possession of the painting was that he became a respectable married man in 1515, and died not long after. Were there perhaps two authentic portraits – one painted earlier for Francesco del Giacondo, another somewhat later for Giuliano de' Medici? The case for the existence of more than one version of the painting is strengthened not only by

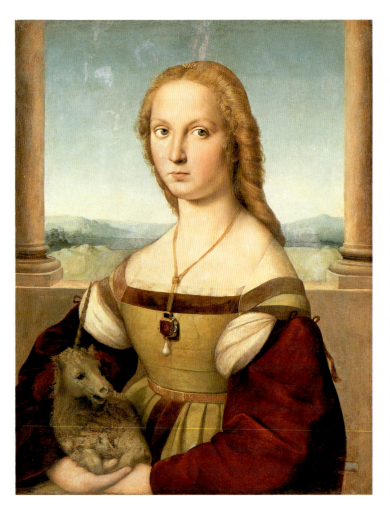

▲ *Lady with*
a Unicorn
1505–6
Raphael
OIL ON PANEL
66 X 51 CM
GALLERIA BORGHESE,
ROME

the fact that Leonardo is known to have produced two versions of several of his works (most famously *The Virgin of the Rocks*), but also by the fact that numerous later copies of the painting portray a significantly younger face than the one today in the Louvre. The argument for a later dating of the painting runs aground when faced with the evident influence of the *Mona Lisa* and her pose on the young Raphael in Florence around 1506: not only in a drawing

(page 47), but also in more assured and accomplished works, the *Lady with a Unicorn* (left), *Maddalena Doni* and even (although the sitter is a man) the *Portrait of Baldassare Castiglione*. In the absence of concrete evidence, however, the most plausible explanation may well be that the painting was begun in Florence between 1503 and 1506, taken by Leonardo on his travels and completed later, probably in Rome between 1513 and 1516. (The virtuoso use of veiled glazes in the painting, a hallmark of Leonardo's late style, lends weight to this theory.)

The mystery surrounding the true identity of the sitter has led to yet more fanciful speculations. It has been suggested that the reason that no single model can be identified is that no single model was used; that the portrait is generic rather than specific (and indeed, just a few years later, portraits of beautiful women by artists such as Titian and Palma Vecchia were regarded, and valued, precisely in this light). The most radical – and high-tech – of these surmises came in 1992 from an American computer graphics consultant called Lillian Schwartz. Using computer-based technology, she amalgamated the famous self-portrait drawing of Leonardo as an old man with the face of the *Mona Lisa*. Finding that all the features were perfectly aligned, she concluded that although the artist may well

have started working on a portrait of a now unknown woman, he later used himself as a model. As further 'proof' of her argument she cites the verbal connection between the artist's name, Vinci, and *vinco*, the Italian word for 'osier', the species of willow used in basketry – in reference to the knotted patterns, resembling basketwork, on the bodice of the sitter's dress.

Far-fetched as all this may seem, it does, however, draw attention to the sexual ambiguity of the sitter. The mysterious half-smile features prominently not only in Leonardo's other images of women (for example, the *Madonna and Child with St Anne* of *c.* 1508–18, but also in supposedly male but actually disturbingly androgynous figures (most notably, *St John the Baptist* of *c.* 1510–15 (page 50). The artist's own homosexuality naturally adds fuel to these speculations. A tantalizing addendum to all this is the fact that one conspicuous precedent for the smile is the bronze statue of *David* by Andrea del Verrocchio (page 35), who had been Leonardo's teacher, and who – legend has it – may have used his young apprentice as a model for the head.

There are, of course, numerous other possible artistic precedents for the enigmatic smile. Ancient Far Eastern art, and the smile of the Buddha in particular, has been cited, as has archaic Greek sculpture (right). Closer in time

and place to Leonardo are the smiles to be found on the faces of medieval angels, most famously those gracing the façades of Gothic cathedrals such as Reims which filtered into early Renaissance art as well. Those less interested in purely art-historical explanations have sought the answer elsewhere – with wildly contradictory, and sometimes amusing, results. Whereas Vasari, as we have seen, described the smile as 'divine rather than human', the French thinker Hippolyte Taine, who, like most of his nineteenth-century contemporaries, revelled in the ambiguity of *La Joconde*'s facial expression, saw it as 'doubting, licentious, Epicurean, deliciously tender, ardent, sad'. In the twentieth century, novelist Lawrence Durrell identified it as 'the smile of a woman who has just eaten her husband', Kenneth Clark called it 'worldly, watchful and self-satisfied', and feminist writer Camille Paglia believed that 'What Mona Lisa is ultimately saying is that males are unnecessary'. Surrealist artist Salvador Dali attributed the 1956 attack on the painting by a young Bolivian to the smile: 'Subconsciously in love with his mother, ravaged by the Oedipus complex', the young man, Dali claimed, was 'stupefied to discover a portrait of his own mother, transfigured by the maximum female idealization. His own mother, here! And worse, his mother smiles ambiguously at

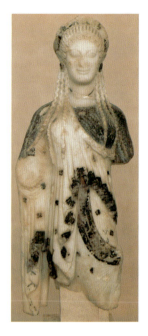

▲ Inscrutable smiles featured on many ancient statues, such as this *kore* (maiden) from the island of Chios *c.* 650 BC
ACROPOLIS MUSEUM, ATHENS

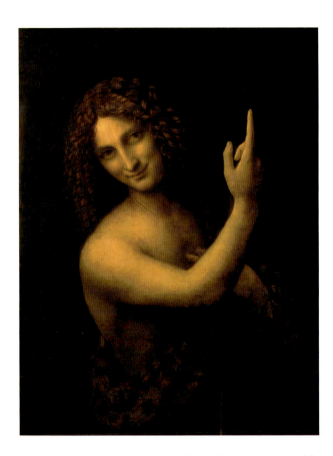

Vinci, and his family. The *Mona Lisa*, Freud concludes, comprises 'the most perfect representation of the contrasts dominating the love-life of the woman, namely reserve and seduction, most submissive tenderness and the indifferent craving, which confront the man as a strange and consuming sensuality'.

In recent, more prosaic times, physiological explanations – hardly more plausible and equally unverifiable – have been brought to bear on the painting. Does asthma account for the sitter's closed lips and strange, asymmetrical expression? Or was it rather the fact that she was undergoing mercury treatment for syphilis, which would have turned her teeth an unsightly black? According to a Danish doctor, she had congenital palsy, which affected the left side of her face and explains the unusually large hands, which were characteristic of palsy sufferers. An Italian doctor claimed that she suffered from bruxism, an unconscious habit of grinding the teeth during sleep or periods of mental stress. A French orthopaedic surgeon has concluded that her half-smile was the result of semi-paralysis either from birth or from a stroke; one indication of this, he has argued, is that her right hand looks relaxed, while the left is inexplicably tensed. Or is she, more straightforwardly, merely expressing the mysterious contentment of pregnancy? In fact, a more convincing, if still only partial, explana-

him… Attack is his one possible response to such a smile.'

Much of this smacks of Freudian analysis, and Dali would undoubtedly have been familiar with Sigmund Freud's famous text of 1910, entitled *Leonardo da Vinci and a Memory of His Childhood*. In this, Freud goes to great (and sometimes improbable) lengths to prove that the woman's expression resembled the smile of the artist's mother, Caterina, of whom we know almost nothing except that she was a farmer's daughter who abandoned her illegitimate son to the care of his father, the notary Ser Piero di Antonio da

tion of her pose and expression can be found in fifteenth- and sixteenth-century manuals on etiquette, in which a half-smile and clasped hands are consistently seen as markers of female respectability and social standing.

If the origins of the *Mona Lisa* remain shrouded in mystery and speculation, the fate of the painting after its creator's death in 1519 is easier to establish. Although, it is true, there is no documentary evidence to establish whether King François I, at whose court at Amboise Leonardo had found employment since 1517, bought the painting – either directly from the artist or, after his death, from his younger assistant (and lover?) Francesco Melzi – or was given it as a gift, it would remain in the possession of the kings of France until the French Revolution. At first, it seems, it hung in the Appartement des Bains at the Palace of Fontainebleau. This was a splendid suite of rooms akin to the baths of Imperial Rome, sumptuously decorated by the Italian Mannerist artist Primaticcio and his pupils with stucco nymphs and *risqué* mythological murals. The rooms were further adorned with easel paintings by well-known Italian artists, such as Perugino, Raphael and Andrea del Sarto. Indeed, it has been said, with some justification (especially since the place often functioned as a semi-public art gallery), that the Louvre was actually born in a bathroom.

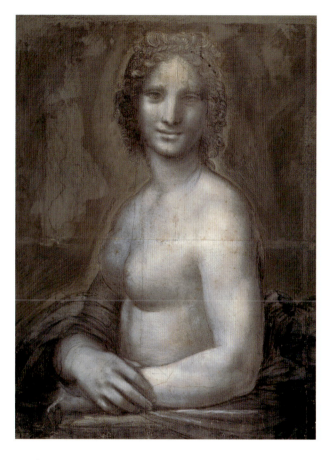

The *Mona Lisa* spawned copies of itself from the very start. Soon, prompted perhaps by the unashamedly erotic ambience in which the painting hung, nude versions also began to proliferate, although the earliest of these works (above) probably pre-dates the artist's arrival in France. It has been suggested that Leonardo himself produced an image of an unclothed Mona Lisa, either as a pendant (or companion piece) to the clothed one (anticipating Goya's *Naked* and *Clothed Majas* by some three hundred years) or – more plausibly – as a preliminary study for

▲ *Nude Giaconda*
c. 1513
Follower of Leonardo
CHALK
32 X 22 CM
MUSEE CONDE,
CHANTILLY

the extant painting, on which these later naked versions may have been based. Since no evidence of such an image exists, however, it seems just as likely that these later artists were knowingly exploiting the latent sexuality of the original work for their own lascivious purposes. That by the early seventeenth century many viewers saw the original image as erotically charged is confirmed by the words of Père Dan, author of a guidebook to Fontainebleau, who in 1642 protested that the clothed *Mona Lisa* was not only 'first in esteem, a marvel of painting', but also a depiction of 'a virtuous Italian lady and not of a courtesan, as some people believe'.

By the end of the sixteenth century, the unusually high humidity of the Appartement des Bains was beginning to have an adverse effect on the paintings hanging there. Indeed, the varnish referred to by the collector and antiquarian Cassiano del Pozzo in 1625 ('The dress is black, or dark brown, but it has been treated with a varnish which has given it a dismal tone, so that one cannot make it out very well') may well have been applied to protect the painting from moisture. Accordingly, the *Mona Lisa*, plus all the other easel paintings, was transferred to a specially conceived Cabinet des Tableaux, in a part of the château known henceforth as the Pavillon des Peintures.

In 1625 the Duke of Buckingham made a spirited, but ultimately unsuccessful, attempt on behalf the English king Charles I to persuade King Louis XIII (who showed little interest in art) to part with the *Mona Lisa*. In the 1650s the painting was transferred, with the bulk of François I's collection of Italian art, to the Louvre, which, after a period of neglect, was again being favoured by Louis XIV as a royal residence. By 1695 the painting was hanging in the Petite Galerie at Versailles; in 1706 it was back in Paris, as part of the Cabinet des Tableaux at the Tuileries Palace. In 1709 it was once more at Versailles, and was still there in 1720. Inventories of 1760, 1784 and 1788 confirm that the painting spent much of the second half of the eighteenth century in one of the dimly lit small rooms of the Direction des Bâtiments (the rough equivalent of a modern ministry of fine arts) in Paris.

With the fall of the monarchy in 1789, the *Mona Lisa*, and the rest of the royal collection, officially became the property of the French nation. In practice, the painting continued for some years to be seen by only a few people, mostly government officials and their friends. Napoleon Bonaparte, whose bedroom at the Tuileries Palace had been graced by 'Madame Lisa' (as he liked to call her) since 1800, only agreed

to her removal to the Louvre in 1804. There she would remain for the rest of the century – except for a brief period during the Franco-Prussian War of 1870 and the ensuing Paris Commune when the painting was moved for safekeeping to the Arsenal at Brest – from the very start one of its star attractions.

The nineteenth century without doubt represents the apogee of the *Mona Lisa*'s reputation. Not only was the painting on view to the general public for the first time, but Romanticism, the cultural tendency that dominated much of that century, with its love of mystery, suggestiveness and decadence, found in the *Mona Lisa* all these qualities – and more. Although artists such as Jean-Baptiste Corot (page 54) kept up the tradition of paying visual homage to Leonardo's painting, the real mythologizers were largely literary people. For French writer Arsène Houssaye, writing in the middle of the century, even the yellowish varnish that discoloured the painting's surface lent it an extra aura of mystery: 'Mona Lisa of the sweet name, bathed in the tawny light of amber... do not ask who she is, ask rather who she is not, this young girl who is so ignorant, as full of grace as the Galatea of the poem, and yet a woman, with six thousand years of experience, a virgin with an angelic brow who knows more than all the knowing rakes of Boccaccio!' And

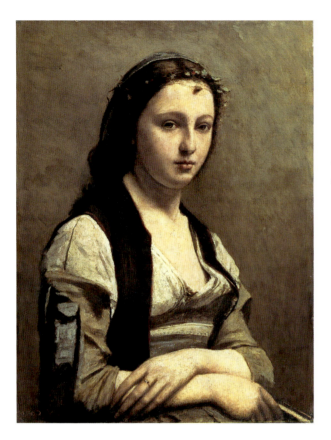

▲ *Woman with a Pearl*
1868
Jean-Baptiste Corot
OIL ON CANVAS
70 X 55 CM
MUSEE DU LOUVRE,
PARIS

in 1858 the French writer and poet Théophile Gautier wrote the following:

We have seen these faces [of Leonardo] before, but not upon this earth: in some previous existence perhaps, which they recall to us vaguely. How can we explain otherwise the singular charm, almost magic, which the Mona Lisa exercises on even the least enthusiastic natures? Is it her beauty? Many faces by Raphael and other painters are more correct. She is no longer even young; her age must be that loved by Balzac, thirty years; through the subtle modelling we divine the beginnings of fatigue, and life's finger has left its imprint on the peachlike cheek. Her costume, because of the darkening of the pigments, has become almost that of a widow; a crêpe veil falls with the hair along her face; but the expression, wise, deep, velvety, full of promise, attracts you irresistibly and intoxicates you, while the sinuous, serpentine mouth, turned up at the corners, in the violet shadows, mocks you with so much gentleness, grace and superiority, that you feel suddenly intimidated, like a schoolboy before a duchess.

Most famous of all perhaps is the passage penned by the English writer Walter Pater in the *Fortnightly Review* of 1869, and later reprinted in his book *The Renaissance* (1873):

Hers is the head upon which all 'the ends of the world are come', and the eyelids are a little weary. It is a beauty wrought from within upon the flesh, the deposit, little cell by cell, of strange thoughts and fantastic reveries and exquisite passions. Set it for a moment beside one of those white Greek goddesses of antiquity, and how they would be troubled by this beauty, into which the soul with all its maladies has passed… She is older than the rocks among which she sits; like the vampire, she has been dead many times, and learned the secrets of the grave; and has been a diver in deep seas…

It was often as much the persona of the artist – perceived as polymath, magus or

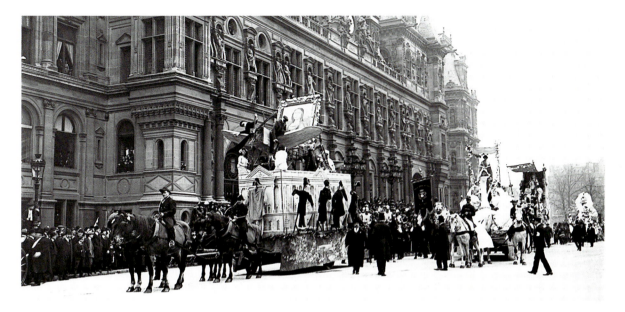

▲ A float in the Paris mid-Lent parade, showing the *Mona Lisa* taking off from the Louvre in a plane 1912

seer – as of the sitter that elicited such extreme and fervent responses. That Leonardo da Vinci himself was seen as a prodigiously talented, larger-than-life figure worthy of the utmost reverence is borne out by pictorial representations of the artist, such as Ingres's historically inaccurate *Death of Leonardo* of 1818 (page 52) and Aimée Brune-Pagés's *Leonardo Painting the Mona Lisa* of 1845, both paintings popularized by their reproduction in graphic form.

Probably the most audacious and brazen art theft of all time took place in Paris in 1911. On 20 August of that year, among the usual Sunday throng at the Louvre were three Italians, Vincenzo Perugia and the Lancelotti brothers. The former was well acquainted with the layout and workings of the great museum. In late 1910, the directors of the Louvre, prompted by a number of attacks on works of art, had made

the difficult and controversial decision to encase in protective glass some of their most valuable holdings – including, needless to say, the *Mona Lisa*. Four experienced workmen – one of whom was Vincenzo Perugia – were hired to build a suitable case for the precious painting. Like many museums past and present, the Louvre permitted the copying of works of art, with the proviso (as a guard against possible forgery) that the copy should not be the same size as the original. It even provided a space in which copyists could store their materials overnight. It was here on the night of 20 August that Vincenzo and his two accomplices hid.

At that time, the Louvre was closed to the public on Mondays, chiefly to allow for the carrying out of essential maintenance work. Early that Monday morning, the three men donned the regulation workers' tunics which they had

brought with them and which, in those days of minimal security, would allow them complete freedom of movement within the museum, and emerged cautiously from their hiding-place. Waiting for a quiet moment, it was all too easy for Perugia to remove the *Mona Lisa* from the Salon Carré, the large and magnificent gallery where it hung, and, aided by a series of lucky breaks, carry it out of the museum and into the street. Astonishingly, it would be another twenty-seven hours before anyone in the Louvre realized that their most famous painting was missing. Hard as it is now to imagine, at that time the disappearance of a painting from a wall was rarely a matter for concern, since paintings were frequently taken off to be photographed or examined without prior notification. Indeed, the very thought of the *Mona Lisa* being stolen was almost

inconceivable: Théophile Homolle, director of France's national museums (until forced to resign as a result of the furore surrounding the theft), had declared in 1910: 'Steal the *Mona Lisa*? You might as well pretend that one could steal the towers of the Cathedral of Notre-Dame.'

It seems likely that the mastermind behind the theft was not one of the three perpetrators, but a shadowy South American aristocrat who called himself the Marqués Eduardo de Valfierno, about whom to this day we know very little. Leaving his three accomplices in complete ignorance of his grand plan, he had arranged with an extremely skilful French art restorer and forger named Yves Chaudron that the latter should produce not one but six exact copies of the *Mona Lisa*, in advance of the robbery. His plan, which he duly put into action once the theft had successfully taken place, was to sell all six copies – each one, of course, purporting to be the original – to already primed and complicitous buyers, five in North and one in South America, individuals whom Valfierno himself once referred to as 'horny-handed and well-heeled men lacking in any background of culture, or knowledge of art'. Having made his fortune once and for all, Valfierno saw the fate of Leonardo's masterpiece as being of little consequence. Thus it was that the original *Mona Lisa* ended

▼ 'Her Return' – a postcard marking the return of the *Mona Lisa* to the Louvre in 1914

up hidden for over two years in a trunk specially constructed for it by Perugia in his dingy living quarters just a stone's throw from the Louvre.

In the meantime, once the theft was discovered on 22 August 1911, the whole of Paris, France and the Western world reacted with incredulity and indignation. In French newspaper headlines, words like 'unimaginable', 'unbelievable', 'inexplicable', 'frightening' loomed large. An article in *Le Figaro* went as follows: '*La Joconde* by Leonardo da Vinci has disappeared. This surpasses the imagination. Such an occurrence appears at first so enormous that one is tempted to laugh about it as though it were a bad joke... But since it has disappeared, perhaps forever, one must speak of this familiar face, whose memory will pursue us, filling us with regret in the same way that we speak of a person who died in a stupid accident.' When the Louvre reopened to the public a week later, thousands of Parisians filed into the Salon Carré to stare at the vacant space on the wall, in front of which one anonymous mourner had placed a bunch of flowers. A curious reporter ascertained that many of these people had never actually seen the painting, but came nevertheless to look at where it had once hung.

As the investigation of the theft got under way, rumours proliferated. Everyone had their own pet theory. In a political climate of French–German hostility, accusations fuelled by nationalistic prejudice reared their head. Substantial financial rewards for information leading to the return of the painting were offered. The newspaper *Le Matin* even went so far as to offer five thousand francs to any occultist, medium or clairvoyant who could help recover the *Mona Lisa* 'by means of the Beyond'. All to no avail.

One of the strangest episodes surrounding the notorious theft involved the young poet Guillaume Apollinaire and Pablo Picasso, and led to their being temporarily implicated in the scandal. The exact degree of their complicity is hard to establish, but it seems that a slightly mad young Belgian called Géry Pieret, who had worked briefly as Apollinaire's secretary and general assistant, 'removed' two small Iberian heads from the Louvre, which he then offered to Picasso. According to Picasso's then mistress, Fernande Olivier, Pieret did not divulge where he had got them from, but said only that 'they should not be exhibited too conspicuously'. As discussed on pages 192–4, it was carvings such as these that were to play such an important part in the evolution of Picasso's epoch-making painting *Les Demoiselles d'Avignon*.

Soon after, Pieret left France to seek his fortune in Mexico. Returning to Paris in 1911, he was apparently about

▲ French new year greetings card, 1914. The message reads: '*La Joconde* is receiving visitors every day except Mondays'

to resume his larcenous visits to the Louvre, when the much-publicized theft of the *Mona Lisa* put an abrupt end to his ambitions. Panicking, Pieret rashly sold one of his stolen statues, plus a full confession, to *Paris-Journal*. Not surprisingly, Apollinaire and Picasso also panicked. Not only had they knowingly received stolen goods, but both men were non-French nationals, aliens sub-ject to deportation. Olivier recounts how they determined to throw the statuettes into the River Seine in the middle of the night, but after two hours of indecision, were unable to bring themselves to do so. In the end, they handed them over to *Paris-Journal*, in return for a guarantee of anonymity. The newspaper, naturally, was more than delighted to have a fresh scoop.

In the event, however, the police were hot on their trail. Desperate for results, they were all too eager to assume that Pieret and his accomplices were also connected with the theft of the *Mona Lisa*. Apollinaire was arrested in early September and imprisoned for five days; Picasso was brought in for questioning soon after, but was never officially charged. Both men pleaded innocence with regard to the painting; according to Fernande Olivier, they 'wept before the judge, who was quite paternal and had some difficulty in maintaining his judicial severity in the face of their childish grief'. All charges against Apollinaire were finally dropped in January 1912. But at least, as he remarked to friends, he could claim the dubious distinction of being the only person formally arrested in France in connection with the theft of the *Mona Lisa*.

By the spring of 1912, most Parisians had resigned themselves to the likelihood that the *Mona Lisa* was gone for

▼ *Replica of*
LHOOQ
1919
Marcel Duchamp
'ASSISTED READY-MADE'
19.7 X 12.4 CM
PHILADELPHIA
MUSEUM OF ART

good. In confirmation of this, the traditional mid-Lent parade of that year included a float displaying a giant mock-up of the painting taking off in an aeroplane from the roof of a cardboard Louvre (page 55). By the end of 1912, the directors of that museum, having kept *La Joconde*'s place in the Salon Carré empty for over a year, finally admitted defeat, and hung Raphael's *Portrait of Baldassare Castiglione* there in its stead. The vogue for music hall and theatrical stars posing as Mona Lisa began to fade. Sales of song parodies, postcards and souvenirs (these included Giaconda radiator caps for motorists and a Giaconda-patterned tussore silk, marketed – with a pun on the words 'tussor/tu sors' – as *le tussor du Louvre*) gradually declined, but far-fetched rumours continued to circulate.

And then, in December 1913, events took an unexpected turn. Vincenzo Perugia, apparently quite forgotten by Valfierno, got tired of waiting for the instructions – and the fortune – the latter had promised him. He therefore decided to take matters into his own hands. Travelling to Florence on 10 December with a wooden trunk in tow, he installed himself in a small run-down hotel (subsequently renamed the Giaconda) under the name Vincenzo Leonard, and proceeded to pay a visit to Alfredo Geri, one of the best-known antique

▲ *Giaconda
with Keys*
1930
Fernand Léger
OIL
91 X 72 CM
MUSEE NATIONALE
FERNAND LEGER, BIOT

dealers in the city. Perugia had written to Geri in November, describing himself as an Italian citizen who had been 'suddenly seized with the desire to return to his country at least one of the many treasures which, especially in the Napoleonic era, had been stolen from Italy'.

After his arrest and subsequent imprisonment, Perugia stuck obstinately – and astutely – to the notion of himself as a passionate (if historically misinformed) Italian patriot, acting without accomplices, as justification for his crime. With time his arguments grew increasingly garbled and inconsistent,

and he also spoke of how he had fallen 'a victim to her smile'. Perugia was tried in early June 1914, and initially sentenced to one year and fifteen days. This was reduced after an appeal to a mere seven months, and because he had already been in prison for seven months and nine days, he was released on the spot. Clearly, the whole affair had become something of an embarrassment to the authorities. Not surprisingly, it has since provided the raw material for several colourful films and novels.

Italy, needless to say, rejoiced at the return of the painting. However, there was little doubt that the *Mona Lisa* would be sent back to France; ironically, the episode seems actually to have strengthened cultural ties between the two countries. Before its return, the painting was displayed with due pomp and circumstance at the Uffizi Gallery in Florence: on the morning of 14 December, when members of the general public were first allowed in, an estimated 30,000 over-excited individuals pushed and shoved to catch even a brief glimpse of Italy's most famous expatriate.

Six days later, the new director of the Louvre, Henri Marcel, personally escorted the painting to

▼ *Use a Rembrandt as an Ironing Board (Marcel Duchamp)* 1964
Daniel Spoerri
ASSEMBLAGE
ARTURO SCHWARTZ
COLLECTION, MILAN

Rome, where it was displayed first at the Borghese Gallery, and then at the Villa Medici and the Farnese Gallery. Its last Italian port of call was the Brera Museum in Milan. Everywhere, the painting was greeted with scenes of near-hysteria.

At the very close of 1913 the *Mona Lisa* once more crossed the French border. For the first few days of the new year, it was on view at the Ecole des Beaux-Arts in Paris; an admission fee was charged, the proceeds of which went to Italian charities. Then, on 4 January 1914, in an emotional ceremony, the painting resumed its old place in the Salon Carré at the Louvre. Over the next two days, more than 100,000 people flocked there to welcome it home. Popular songs were once again adapted, this time to celebrate her return, and postcards, often wittily, served the same purpose (pages 56 and 57). One sobering ditty, however, presaged the coming war: 'It's me, I'm the *Giaconda*/Wait for the varnish to fall/Wait for the end of the world/I'll smile under the bombs.'

Although the public at large remained uncritical, the veneration with which the *Mona Lisa* had hitherto been regarded by artists, writers and intellectuals came in the years following the theft of the painting and the First World War to be replaced by a distinct irreverence. This may have been due in part to the almost

farcical nature of the whole theft episode, but it was also thoroughly in keeping with the iconoclastic attitude to society's most sacred cows so characteristic of the Dada and Futurist movements, and, indeed, of avant-garde art generally. In 1915, for example, the Italian writer Ardengo Soffici wrote in his diary: 'In the tram omnibus, I see written on a wall in large white letters against a blue background "Giaconda. Italian Purgative Water". Further down there is the stupid face of Mona Lisa. At last something like good art criticism is getting under way, even in Italy.' Most famously, in 1919 Marcel Duchamp took it upon himself to doctor a cheap reproduction of the hallowed image by adding a moustache, a goatee and the letters LHOOQ (page 58). When said out loud in French, these innocent letters become distinctly less innocent: *elle a chaud au cul* – 'she has a hot arse'. For all the subversiveness of the gesture, Duchamp astutely homed in on the sexual ambiguities inherent in the original.

In 1924 Fernand Léger expressed a sentiment shared by many artists when he proclaimed: 'The Italian Renaissance – the *Mona Lisa*, the sixteenth century – is regarded by the whole world as a zenith, a summit, an ideal to be attained… *This is the most colossal error that could be committed…*' Six years later he painted his *Giaconda with Keys* (page 59), in which the modern, func-

▲ *Mona Lisa: Thirty Are Better Than One*
1963
Andy Warhol
SILKSCREEN INK ON
SYNTHETIC POLYMER
PAINT ON CANVAS
319.4 X 208.6 CM
COURTESY OF BLUM
HOLMAN GALLERY,
NEW YORK

tional beauty of a bunch of keys is juxtaposed with the 'decadence' of the *Giaconda*, which is further debunked by the presence of a can of sardines. Both Duchamp's and Léger's works can nevertheless be construed as a kind of perverse homage.

Scholars and critics seemed to confirm the painting's apparent decline in status.

In 1916, the art critic Bernard Berenson, who some years earlier had hailed the *Mona Lisa* as possibly the world's finest example of 'tactile values', made a complete volte-face when he declared: 'What I really saw in the figure of Mona Lisa was the estranging image of a woman…a foreigner with a look I could not fathom, watchful, sly, secure, with a smile of anticipated satisfaction and a pervading air of hostile superiority', and admitted that when he heard about the theft, 'I heaved a sigh of relief… She had simply become an incubus, and I was glad to be rid of her.' A 1929 article in *Contemporary Review* by Percy Dearner ran as follows:

▼ US Marine Corps guards with fixed bayonets protect the *Mona Lisa* in Washington, DC 1963

Perhaps the visitors to the Louvre who are escorted round the Salon Carré by the representatives of a tourist agency do really believe that Mona Lisa has 'learned the secrets of the grave and has been a diver in deep seas'; but the rest of us know that [Leonardo] was just experimenting in dimples with his beloved chiaroscuro, and we remember that the unfathomable smile about which everyone has written so ecstatically was probably evoked on the face of a rather stupid woman by the efforts of the artist to drag her out of her lethargy.

In 1936, during the heady days of the French Popular Front, Léger, who was a staunch Marxist, persuaded the fine arts administrator to keep the Louvre open late for the benefit of factory employees: 'He opened [the museum] in the evening, and the workers came. But there you are, they saw only one picture. They had to line up in front of the *Mona Lisa*, for it was the star, as in the movies. Consequently the results were nil.' During the Second World War, the *Mona Lisa*, together with other treasures from the Louvre, was stored outside Paris as a precaution against bomb damage. Even in these most unlikely of circumstances, the myth survived: art historian Germain Bazin, then curator of the museum depot, later recalled that 'German soldiers in full flight [during 1944] stop and pound on the door…and ask as an ultimate, supreme

favour that we let them see the *Mona Lisa* before they left'.

Since 1945 artists have continued to draw inspiration from the *Mona Lisa*, albeit in ambivalent fashion. The most thought-provoking examples hail from the 1960s, the heyday of Pop Art, with its indebtedness to Dada, its cynicism, its interest in popular culture and mass communication. In his *Use a Rembrandt as an Ironing Board (Marcel Duchamp)* of 1964 (page 60), Daniel Spoerri wittily extended Duchamp's concept of a 'reciprocal ready-made' to embrace Duchamp's own adaptation of the *Mona Lisa* (page 58). Better known is Andy Warhol's ambiguous homage to the painting, in the form of two screen prints, both of 1963 (page 61), which, through endless replication, reduce the priceless masterpiece to the status of a Campbell soup can. As in the case of Warhol's double-edged tributes to Marilyn Monroe, modern reproductive techniques, originally intended to celebrate their subject, ultimately render it meaningless. At first glance Tom Wesselman's inclusion of the *Mona Lisa* in at least two works in his *Great American Nude* series (above) also reduces the original painting to the level of cultural wallpaper. Yet they too pay homage to it in an oblique and sardonic way. Op artists and, more recently, digital artists have also frequently used the familiar image as the basis for their technical experiments.

▲ *Great American Nude No. 35*
1962
Tom Wesselman
MIXED MEDIA CONSTRUCTION, ACRYLIC, ENAMEL AND COLLAGE ON COMPOSITION BOARD
122 X 153.4 CM
COURTESY OF FRANCES AND SYDNEY LEWIS, RICHMOND, VIRGINIA

In 1962, for the first and only time, the *Mona Lisa* travelled to the United States. This was a classic, if unacknowledged, example of culture being put at the service of a wider political agenda. Not only had an aeroplane carrying American tourists from Atlanta to Paris recently crashed at Le Bourget airport, but US–French relations were distinctly strained by General de Gaulle's decision to pursue a military defence policy independent of NATO. What better time, then, for a munificent gesture of goodwill on the part of the French government, spearheaded by the newly appointed Minister of Cultural Affairs, André Malraux? In mid-December 1962, therefore, the painting set sail – in a first-class cabin all to itself – from Le Havre to New York. On landing, the *Mona Lisa* was loaded into a specially sprung van which, escorted by other

▶ *Mona Lisa*
shop, Tokyo
1974

vehicles carrying Secret Service agents, made its way to Washington DC. The convoy passed through the Lincoln and Baltimore Harbor tunnels, which were cleared of other traffic for the duration. On 8 January 1963, two thousand elegantly attired luminaries – including President Kennedy and his First Lady – attended the opening ceremony at the National Gallery of Art. At one point, the conservator sent by the Louvre was so anxious about the possible damaging effects of the strong TV lights, that she stepped over the protective velvet cord to check the temperature-humidity recorder. One of the US Marines guarding the work (page 62) suspected foul play and immediately lunged at her, ripping her gown with his bayonet. Fortunately, a Secret Service man came swiftly to her rescue. During the twenty-seven days that the painting was on view in Washington (with the gallery

open in the evenings for the first time in its history), 674,000 visitors – more than half the gallery's usual attendance figures for an entire year – waited patiently, often for up to two hours, for their turn to catch a brief glimpse of the *Mona Lisa*. Between 6 February and 4 March it was on view at the Metropolitan Museum of Art in New York, where severe weather conditions failed to deter 1,077,521 people from queuing to see it.

Many of these people had never before visited an art gallery; indeed, in Washington one man asked a guard what the grand building was used for when the *Mona Lisa* wasn't there. More people came to see it, commented John Walker, Director of the National Gallery, 'than had ever attended a football game, a prize fight, or a world series'. Attendance figures were not the most important thing, however, as

Walker was careful to stress in his speech at the closing of the New York exhibition. What was far more significant was that the *Mona Lisa* 'acted as a catalytic agent… This great painting stirred some impulse toward beauty in human beings who had never felt that impulse before.' To what extent this was true, or whether the public's motives were closer to those of fans attending a celebrity pop concert, will never be known. In any event, few people took heed of the Italian Prime Minister's pointed reminder, at a press conference, that the creator of the *Mona Lisa* was not in fact French but Italian. After all, the painting had been in France since 1517, and had not the French, ever

since the days of François I and Louis XIV, effectively become the cultural heirs of Renaissance Italy?

All this paled, however, beside the frenzy that accompanied the painting's trip to Japan in 1974. At Tokyo's National Museum, some 1.5 million visitors were hustled past the painting for the briefest of looks. Dozens of bars and nightclubs changed their name to Mona Lisa, at least one of them staging a Mona Lisa nude revue. By ringing a certain number, one could hear a recording of the lady herself saying, in Italian, how happy she was to be in Japan. Local girls took to wearing dark dresses with long sleeves, and to parting their hair in the middle; one model

◀ A London estate agency uses the *Mona Lisa* to help sell its properties

▶ A trade union poster uses the *Mona Lisa* to protest against rising prices in Japan 1974

even resorted to plastic surgery so as to attain a more convincing look. The country's largest trade union, moreover, put up posters in which a non-smiling Mona Lisa, shopping basket on her arm, joined in the protest against rising prices (above).

In Moscow, where the painting was put on view at the Pushkin Museum that same year, the response was rather more muted. Yet even here, several members of the public deposited poems in front of the painting, almost as if it were a religious icon. And when the show closed, a woman from the provinces sent three roubles to the museum, with the request that roses be bought for the lady before she boarded the plane back to Paris.

Her image continues to be used for every conceivable purpose: as a point of departure – reverent or otherwise, subtle or crude – for contemporary artists and would-be artists; to make political points (Monica Lewinsky as the Mona Lisa and so on); to advertise everything and anything, from anti-dandruff shampoo to estate agents (page 65). Collectors of 'Giacondiana' – and there are plenty of them, as an organization calling itself the Friends of the *Mona Lisa* testifies – have catalogued some four hundred advertisements incorporating the image, and at least sixty-one products called after it, in fourteen different countries.

Yet against all the odds, the aura of the original painting appears to persist. Few first-time tourists to Paris, even those otherwise uninterested in the visual arts, would dream of omitting to pay homage to the *Mona Lisa*. And so it is that, rain or shine, patient queues of diligent visitors to the Louvre continue to snake their way around the enormous forecourt. Once finally in front of the painting, they are unlikely to get more than a tantalizing glimpse(right). The sheer number of viewers, the small size of the original, and the fact that it is firmly encased in a box of bullet-proof glass (a gift from the Japanese on the occasion of the painting's visit to their country) all militate against an intimate encounter. The box is kept at a constant temperature of 20 °C (68 °F) and 55 per cent humidity, which are maintained by means of a built-in air conditioner and

4 kg of silica gel. Once a year, the box is opened and the painting receives a thorough check-up. In the late 1990s the possibility of removing the centuries-old layers of varnish that are now so intrinsic a part of the painting's appearance was mooted, to considerable controversy and debate. To date, no action has been taken on this front, and the *Mona Lisa*, for all its discoloration and craquelure, remains in remarkably good condition. At the time of writing, there are plans to display the world's most famous painting in a room of its own, to be paid for to the tune of over $4 million by a Japanese TV network.

The million-dollar question, of course, remains: how on earth does one account for the almost mythical status and apparently undiminished power of Leonardo's *Mona Lisa*? Few people would deny that it possesses an almost uncanny allure. Nor, if they stopped to think about it, would they question the technical prowess with which its haunting beauty is conveyed, or its rare ability to combine in a single image the sensual and the spiritual, the Christian and the pagan, the particular and the universal. But is this enough? On one level, the fact that the painting is famous for being famous feeds on itself. On another, it is surely the ultimate inscrutability of the image, the fact that in the end we know so very little about it and can thus read so very much into it, that continues to feed the imagination and tantalize the intellect.

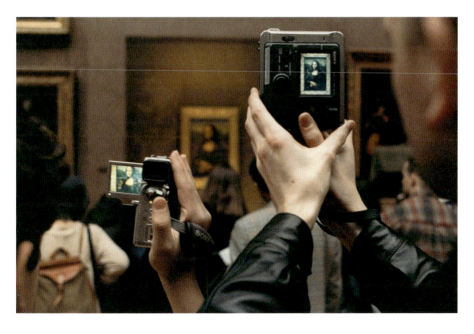

◄ Tourists try to catch a glimpse of the *Mona Lisa* at the Louvre

FRANCISCO DE GOYA

THE THIRD OF MAY 1808 1814

A far cry from the classical subject matter that still dominated much of European art in the early nineteenth century, this powerful painting was a delayed yet direct response to specific historical events – the occupation of Spain by French troops, which led to popular insurrection and a bloody and divisive war. On another level, Goya's dramatic and emotional depiction of man's inhumanity to man remains disturbingly contemporary, and its message continues to resonate down the centuries.

▶ *The Third of May 1808*
1814
Francisco de Goya
OIL ON CANVAS
266 X 345 CM
MUSEO DEL PRADO, MADRID

'*The Third of May* belongs with that very restricted group of works that leave aesthetics, art and art history far behind to become instead archetypal images that condition the very tenor of existence after their completion.'

FRED LICHT, 1979

Goya's famous painting is an unforgettable distillation of the cruelty of modern warfare, of confrontation between dehumanized perpetrators and all-too-human victims. The former, seen only from the back, are rendered anonymous and all the more menacing by their collective concentration on the job in hand. The latter, although endowed with greater individuality, are also anonymous, poignantly unheroic in their fear and incredulity. Although the central figure is imbued with the aura of a Christian martyr, and the indistinct shape to the far left of the composition might just be construed as a grieving madonna and child, there is no assurance of redemption here. Soon this man too will be a crumpled, bleeding heap, and the next man will take his place, and then the next, and then the next. A deliberately limited palette, consisting primarily of blacks, greys, olive greens, browns and ochres brushed into a terracotta ground, dramatically accentuates the pale yellow of the lantern, the red of spilt blood and the whiteness of the victim's shirt. A barren hill, a shadowy building and an inky sky provide a spatially compressed, symbolically appropriate and psychologically suggestive backdrop. For all the sense of inevitability, the tension is almost unbearable.

So intensely immediate is the impact of Goya's painting that it comes as a shock to realize that far from being created on the spot or even soon after the event, it was produced a full six years later. Many biographies of the artist have perpetuated the myth that the sixty-two-year-old Goya watched the shootings of 3 May 1808 through a telescope from the window of the Quinta del Sordo (House of the Deaf Man), the walls of which he would later cover with his terrifying 'Black Paintings'. We now know this to have been physically impossible (he only moved to that house in 1819). But the artist was an inveterate prowler and roamer of the streets, and even if he did not actually witness these particular killings at first hand, the titles of several of the prints in his blood-curdling *Disasters of War* series ('*I saw it –*', '*That also –*') suggest

that he did indeed see enough atrocities 'in the flesh' to enable him to reconstruct the events of 3 May with frightening conviction. One might even speculate that his inability to hear (a serious illness had left him completely and permanently deaf at the age of forty-seven) only sharpened his already impressive visual faculties.

Yet for all its apparent veracity, this is by no means a realistic recreation of the scene. In strictly practical terms, no firing squad – even in the early nineteenth century – would shoot at point-blank range, or leave the prisoners unbound and without blindfolds. The force of the musket-balls, moreover, would cause the victims to reel backwards rather than keel forwards; consider too how disproportionately huge the central figure would be were he to rise from his kneeling position. The buildings in the background are left deliberately vague, and cannot readily be identified. The use of perspective is inconsistent, since we view the murdered figure in the foreground from above, yet our eye level for the rest of the painting is calculated more or less along the central horizontal axis. The lighting too is inconsistent. As Picasso commented:

The black sky isn't a sky, it's blackness. As for the lighting, there are two types. One that we don't understand. It illumines everything like moonlight: the sierra, the belfry, and the men shooting, who should not be lighted from behind. But it sheds far more light than the moon. It hasn't the same colour. Then there's the huge lantern on the ground, right in the middle. And what does that illumine? The guy raising his arms, the martyr. If you look at it carefully, you'll see that it sheds light only on him. The lantern is Death. Why? No one knows. Not even Goya. But what Goya knew was that it had to be just like that.

As Picasso implies, none of this matters: on the contrary, it is precisely the liberties that Goya takes with 'reality' that contribute to the painting's emotional and symbolic power.

One recent visitor to the Prado Museum in Madrid, where the picture is given pride of place, was apparently informed by a guard that Goya had used his own blood to paint the bloody areas of the canvas. So apparently spontaneous and unpolished (and, indeed, so modern) is the artist's handling of paint, so rawly evocative of fear and freshly spilt blood, that it seems almost sacrilegious to dwell on the aesthetic or technical aspects of the work. Yet it would be foolish to underestimate the importance of Goya's artistry, his knowing manipulation of composition, colour and brushstroke in creating a work in which beauty and terror, art and atrocity are utterly

inextricable. Indeed, the painting is disturbingly modern in the complex questions it raises about the aestheticization of horror.

The seeming ahistoricity and the undoubted contemporary relevance of *The Third of May 1808* should not, however, blind us to the fact that on another level it was very much a response to, and the product of, a particular set of historical circumstances. In the end, these are not any victims, or any perpetrators, but recognizably French infantrymen taking aim at Spanish insurgents on the hill of Príncipe Pío in Madrid (the present-day district of Moncloa). Whether or not the artist was actually there, he was unquestionably a patriotic Spaniard whose political and cultural sympathies with France rendered his own position in the turmoil of those times exceedingly complicated.

So what exactly were the historical events that provide a necessary context for a deeper understanding of this extraordinary painting? To appreciate the significance of the events of 3 May 1808, one needs to go back in time, not only to the uprising of 2 May which caused such brutal reprisals, but at least to the previous decade. By the 1790s, the Spanish golden age epitomized by the reign of Philip II in the sixteenth century was no more than a memory. By contrast, Spain in the late eighteenth century was, to put it bluntly, a mess. To the rest of Europe and above all to France, she was backward, corrupt, barely civilized. Internally, factionalism and unrest were rife. Charles IV had succeeded his father Charles III to the Spanish throne in 1788. One of his first acts was to extend the powers of the Inquisition to restrict the circulation of subversive revolutionary material from France. His queen, María Luisa, soon formed an intimate (rumour had it, far too intimate) relationship with the powerful but unpopular prime minister Manuel Godoy, who came to exert a disproportionate influence on royal policy. Indeed, the three of them together acquired the unflattering nickname of the 'Unholy Trinity'. Yet, for all the vain stupidity of the royal couple (so vividly evoked in Goya's portraits of them), Godoy himself was a complex individual who prided himself on being a munificent patron of the arts and, although fickle in his foreign alliances, responded to the winds of change from France, opening himself up to more democratic and libertarian ideas. Ironically, it was these ideas that made him more hated than ever by most of the Spanish population. Capitalizing on these sentiments for his own ends, Crown Prince Ferdinand (depicted in blue, second from the left, in the group portrait, opposite) secretly plotted the overthrow of his parents and the royal favourite,

◄ *The Family
of Charles IV*
1800–1
Francisco de Goya
OIL ON CANVAS
280 X 336 CM
MUSEO DEL PRADO, MADRID

The people represented (from left to right) are: the Infante Don Carlos María Isidro; Crown Prince Ferdinand; Doña María Josefa, the king's sister; an unidentified young woman; the Infanta María Isabel; Queen Maria Luisa; the Infante Francisco de Paula Antonio; King Charles (Carlos) IV; Don Antonio Pascual, the king's brother; the Infanta Carlota Joaquina; Don Luis de Borbón, Prince of Parma and his wife, the Infanta Doña María Luisa Josefina, holding their son. Goya stands at his easel, in the background on the left.

first by allying himself with the British and then with Napoleon Bonaparte.

Thus, when Napoleon decided to march into the Iberian peninsula at the end of 1807, initially with a view to establishing French control over Portugal, he was astutely taking advantage – for his own imperialist reasons – of Spain's internal crisis. On 17 March 1808 the so-called Mutiny of Aranjuez brought the reign of Charles IV, María Luisa and Godoy to an abrupt and dramatic close. A mob stormed Godoy's residence at Aranjuez, found him hiding (so the story goes) in a rolled-up carpet and took him prisoner. Popular unrest accompanied by cries for the abdication of the king and queen reached fever pitch. In the hope of saving Godoy's skin and their own (remembering no doubt the fate that had not so long ago been meted out to their cousins Louis XVI and Marie Antoinette), they conceded the throne to their son. The new king, Ferdinand VII, entered Madrid in triumph on 24 March, uncomfortably aware no doubt that the mob was now the real wielder of power.

Napoleon's troops, who had entered Spain on Godoy's invitation as the allies of Charles IV, were made equally welcome by Ferdinand. Indeed, a decree of 2 April 1808 ordered Spaniards to accord them due respect and obedience. But public suspicions were aroused

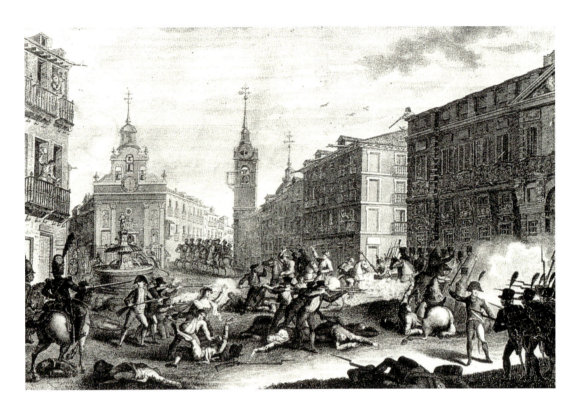

when, in late April, Napoleon invited not only Ferdinand but also his parents, Godoy and other members of the royal household to Bayonne, near the French–Spanish border. Those suspicions proved well-founded: Spain's rulers were now in effect Napoleon's prisoners. It was thus easy enough for Bonaparte to 'persuade' Ferdinand to hand the crown back to his father, who promptly abdicated in favour of Napoleon. Charles and María Luisa, guaranteed a respectable annual income, obligingly went into exile in Italy, while Ferdinand was kept for six years under military guard in a French château.

Meanwhile, back in the Spanish capital, rumours of plans to evacuate the remaining members of the royal family to Bayonne spread like wildfire. The exact details of what took place on 2 May 1808 are surprisingly difficult to establish, since no unbiased account of events exists. As a crowd gathered outside the palace that morning, it witnessed carriages waiting to carry away the Infantes [Princes] Antonio and Francisco de Paula, and María Luisa, Queen of Etruria (all of whom feature in Goya's group portrait of *The Family of Charles IV*, page 73). It seems that the mob tried to prevent the queen's departure by cutting the reins of her carriage, and some sixty to seventy people stormed the palace in an attempt to rescue the two infantes. French troops,

who had been forewarned of possible disturbances, were summoned to control the situation. Although the Spanish soldiers had been given orders not to enter the fray, two artillery officers, Velarde and Daoiz, disobeyed, and provided the insurgents with arms. There ensued a ferocious orgy of slashing, disembowelling and butchery. In the mêlée the officers met their deaths, becoming the only two nameable martyrs of the day. Fighting continued until the early afternoon, when an uneasy truce was attained with the co-operation of the Spanish municipal government.

Municipal forces also helped round up the insurgents, many of whom were executed that afternoon, during that night and into the next day at points throughout the capital, including the Prado, the park of Buen Retiro and in the vicinity of the headquarters of Marshal Joachim Murat, the French general-in-chief, near the hill of Príncipe Pío. About one hundred Spaniards were put to death. A rare eyewitness report by a certain Juan Suárez, who was led out to be shot but managed to escape, runs as follows: '…already on my knees, I too expected to receive the bullets, when I found myself able to slip out of my bonds, fling myself on to the ground and then roll down a narrow ditch. When I got up, bruised, they fired shots at me and even tried to follow me, cutting off my retreat; but I, more agile, gained the wall, which I jumped, and succeeded in taking refuge in the church of San Antonio de la Florida.' (This was the church built in the 1790s by Charles IV on the other side of the hill, for which Goya had painted frescoes depicting the life of St Anthony of Padua, and in which the artist's body now lies.)

Spanish accounts of these ugly events have, not surprisingly, tended to emphasize the nobility and patriotism of the Spaniards, and the cruel brutality of the French. Clearly the latter were far from blameless. Indeed, we know that Napoleon had issued written instructions just a week earlier ordering that 'If the rabble stirs let it be shot down', and that Murat (whom Napoleon would later describe as 'a hero but a beast') proclaimed in no uncertain terms: 'The populace of Madrid, led astray, has given itself to revolt and murder. French blood has flowed. It demands vengeance.' However, the image of the masses as both well-dressed and well-behaved, perpetuated by the Spanish in written accounts and popular prints alike, belies the historical likelihood that the crowd was indeed a rabble of questionable integrity and included many from outside Madrid, loiterers and transients, even escaped prisoners spoiling for a fight.

▶ *Continued on page 78*

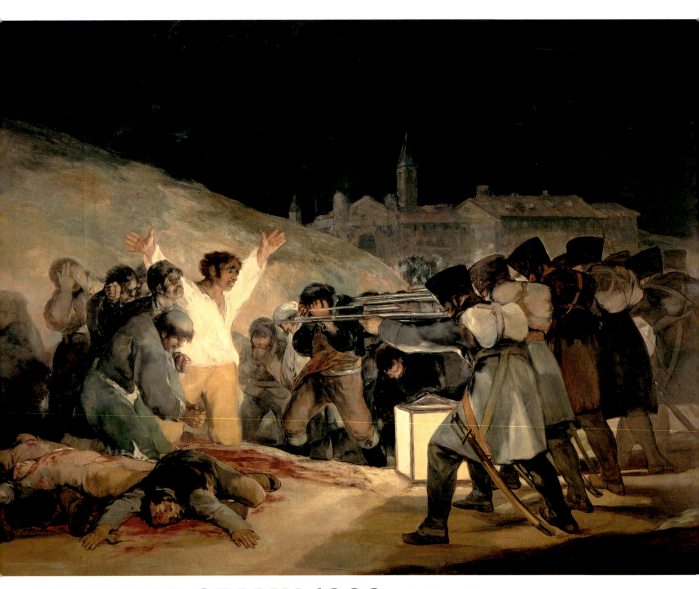

THE THIRD OF MAY 1808 GOYA

For all the emotional intensity and apparent spontaneity of Goya's painting, it was actually created a full six years after the events depicted in it. The artist offered the work to King Ferdinand VII as a tribute to the Spaniards who had died in the Peninsular War, hoping also to curry favour with the newly reinstated monarch.

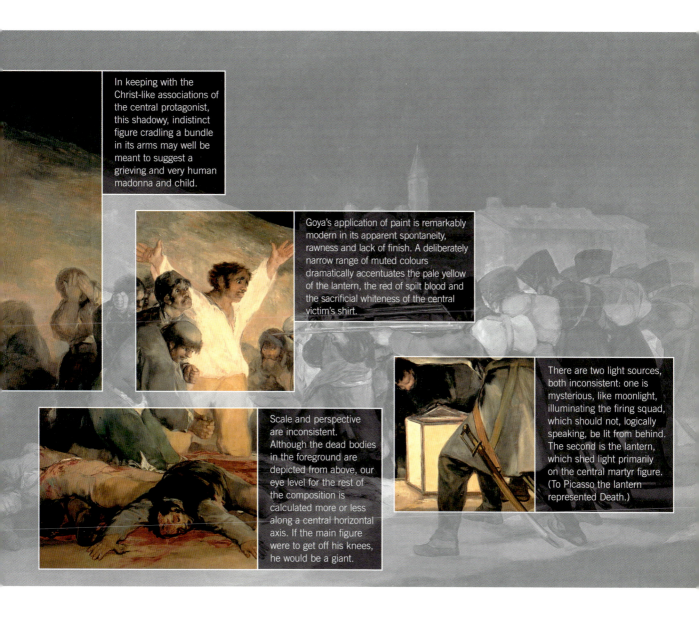

In keeping with the Christ-like associations of the central protagonist, this shadowy, indistinct figure cradling a bundle in its arms may well be meant to suggest a grieving and very human madonna and child.

Goya's application of paint is remarkably modern in its apparent spontaneity, rawness and lack of finish. A deliberately narrow range of muted colours dramatically accentuates the pale yellow of the lantern, the red of spilt blood and the sacrificial whiteness of the central victim's shirt.

There are two light sources, both inconsistent: one is mysterious, like moonlight, illuminating the firing squad, which should not, logically speaking, be lit from behind. The second is the lantern, which shed light primarily on the central martyr figure. (To Picasso the lantern represented Death.)

Scale and perspective are inconsistent. Although the dead bodies in the foreground are depicted from above, our eye level for the rest of the composition is calculated more or less along a central horizontal axis. If the main figure were to get off his knees, he would be a giant.

As far as we know, Goya did not employ studio assistants at this point in his career. According to his only surviving son, he often painted a work in a single session that might last up to ten hours. He avoided the afternoon light, but worked late into the night by using candles precariously attached to his hat. Only two related sketches for the work have survived, and these may not even be by Goya's own hand. Similar motifs appear in some of his *Disasters of War* etchings, but it is not known if these were made before or after the painting.

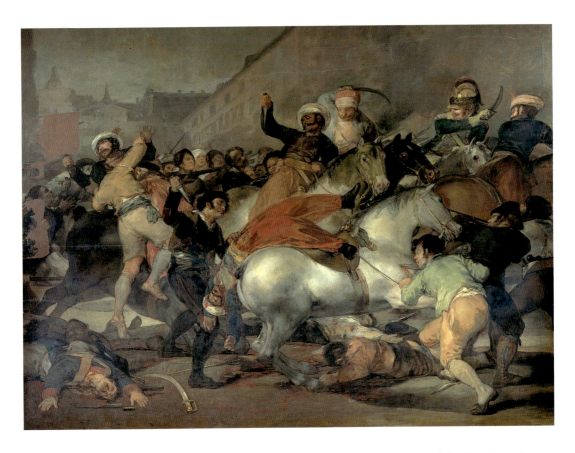

▶ When Goya came to commemorate the battle between Spanish insurgents and Napoleon's famous Turkish body-guards, the Mamelukes, in Madrid's main square, the Puerta del Sol, in the companion piece to *The Third of May 1808* known as *The Second of May 1808* (above), his uncompromising depiction of the populace as violent, aggressive and anarchic may well have been closer to the truth than most Spaniards would have cared to admit. *The Second of May 1808* certainly stands in marked and uncom-fortable contrast with other – distinctly more idealized – images commemorating the event (page 74). The contrast with more conventional 'high art' renderings of battle scenes (opposite) is also striking. In the centre of Goya's composition where traditionally one would expect the conquering hero, we find only the white rump of a horse and the bloodied corpse of a fallen Mameluke. Chaos, brutality and anonymity prevail. True, the figure just left of centre who brandishes the dagger that killed the Mameluke pro-vides a focus of sorts, but he remains unnamed and unknown. (Is he in fact the same man who occupies centre stage in *The Third of May*? Both look distinct-ly Moorish in appearance. In any event, the patriotic perpetrators of violence in

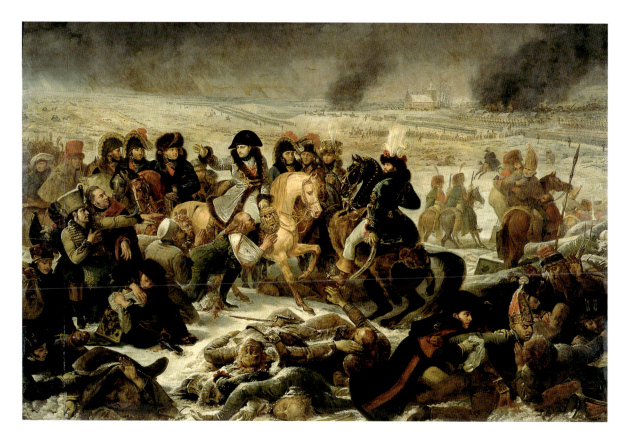

▲ *Napoleon at
the Battle of
Eylau*
1808
Antoine-Jean Gros
OIL ON CANVAS
521 X 784 CM
MUSEE DU LOUVRE,
PARIS

the first painting become the 'innocent' victims of the second.) For all its dynamism and relative unconventionality, however, *The Second of May 1808* is a far less magisterial and memorable image than its sequel.

Murat apparently bragged to Napoleon that: 'Yesterday's events gave Spain to the Emperor.' It was not to prove so simple, however. As it turned out, the bloody events of 2 and 3 May 1808 were only the beginning of a bloodier war, referred to by the Spaniards as the War of Independence, and by the French and English, more neutrally, as the Peninsular War. This was a conflict dominated by a new (but today all-too-familiar) concept, that of guerrilla warfare. Indeed, it was here that the term, from the Spanish for 'little war', first came into being. In the end, as Goya intuited, there were to be no real winners, and few heroes (or heroines). The series of etchings known collectively as *The Disasters of War*, which he began in 1810 and worked on until 1820, but which were published only in 1863, long after the artist's death, are an unforgettable and terrifying indictment of man's brutality to man (and woman), irrespective of allegiances. André Malraux, one of Goya's greatest admirers

in the twentieth century, astutely described *The Disasters of War* as the creation of 'a duped friend as well as a bitter patriot' akin to the 'sketchbook of a communist after the occupation of his country by Russian troops'. Others have drawn an analogy with Beethoven, who dedicated his *Eroica Symphony* to Napoleon but later struck his name from the score. Although many of these prints are even more raw and explicit in their depiction of atrocities than *The Third of May 1808*, a number of them (as above) echo aspects of the latter. The impossibility of dating them precisely, however, makes it difficult to know whether they in fact anticipate the painting or were prompted by it.

On 6 June 1808, Napoleon's older brother (already crowned King of Naples in 1806) was proclaimed King Joseph I of Spain and the Indies. Joseph appears to have been a decent man, who, within just a few days of taking power in Spain, attempted to implement the liberalizing reforms already decreed by Napoleon: notably, the abolition of feudal privileges, the closing of two-thirds of all religious houses and, above all, the suppression of the dreaded Inquisition. Later, when confined on the island of St Helena where he ended his days, Napoleon would loftily claim: 'In the battle of new ideas, in the century's great march against the old Europe, I could not allow Spain to lag behind in social reorganization. It was absolutely essential to involve her, willy-nilly, in the French movement.' The Spanish people, however, thought differently. In August Joseph was forced to flee to the north of the country and Ferdinand was nominally restored to

power, although he chose to remain in comfortable exile, at Talleyrand's estate at Valençay in France. In absentia, he became the darling of the Spanish populace, 'el deseado' (the desired one). Bitter fighting against the French continued in the north, which prompted Napoleon himself to enter Spain on 4 November, and with his help, Joseph was reinstated as king. In 1809 the English entered the conflict on the Spanish side: originally sent to defend Portugal from the French, Arthur Wellesley (later Duke of Wellington) arrived on Spanish soil in July. The war, however, would drag on inconclusively for four more years. Wellington himself expressed horror at the brutalities he witnessed on both sides. 1n 1811 a terrible famine made matters even worse; in Madrid alone some five thousand people starved to death.

During these troubled times, the Spanish government sought refuge in Cadiz, where in 1812 it proclaimed a liberal constitution. At last, on 21 June 1813, the Duke of Wellington defeated Joseph at the Battle of Vitoria, forcing his abdication and the withdrawal of all French troops from Spain. Events on the Iberian peninsula (which kept a quarter of a million French soldiers occupied) would prove a crucial factor in the demise of Napoleon Bonaparte, who would finally abdicate in 1815. Little did the latter realize when he wrote to Murat on 29 March 1808, 'If war breaks out, all will be lost', how right he would prove to be. And on St Helena, he admitted: 'This unhappy war was my undoing.'

Ferdinand VII returned to Spain in late 1813, and in May 1814, for a second time, entered Madrid in triumph; he would rule that country (notwithstanding several insurrections by liberal nationalists) until his death in 1833. The populace went wild with joy, but Ferdinand's reinstatement as king of Spain spelt an end to liberal hopes. The 1812 constitution was abolished out of hand; the notorious Inquisition was reintroduced; freedom of the press was curtailed and a vast network of ecclesiastical and civil spies set up; and all attempts to modernize industry and the economy were ruthlessly suppressed. Goya himself was summoned before the Inquisition in 1815 to 'explain' the indecency of his *Naked Maja* (page 104), which together with its clothed companion had been acquired by the hated Godoy. A young American observer of the events in Spain called Charles Ticknor wrote in 1817: 'The king is a vulgar blackguard. So notorious and so impudent has corruption become, that it even dresses itself in the livery of law and justice.' Even the French Bourbons and Metternich, Chancellor of Austria, rulers hardly known for their liberal attitudes, wondered at the repressiveness of Ferdinand's rule.

because of the difficulties caused by his lack of hearing, but also because of the hatred he professed for the enemy… He promoted the cause of the invasion of Aragon and the ruin of Saragossa, his native birthplace, the horror of which he wished to commemorate in paint.

According to Serna, Goya had wished to flee the country but had been deterred by the threat of having all his property confiscated by the police; he was now in reduced circumstances because of his refusal to draw a salary from the French, and had survived only by selling his jewellery. On the basis of this report, Goya's name was cleared by early April 1815.

In the absence of any other written documentation, it is tempting to take all this at face value. But even Ferdinand knew that this was not the whole truth, allegedly telling Goya, 'In our absence, you deserved exile – even the garotte, but you are a great artist and we pardon you.' Although we know virtually nothing of Goya's whereabouts during the war (except that, apart from a visit to his hometown of Fuendetodos and to nearby Saragossa in 1808, he remained in Madrid), we do know that he was hardly living in penury, especially after the death of his wife Josefa in 1812. We also have the evidence of the images he produced in those years to tell us something of his activities and equivocal alle-

One of Ferdinand's first moves was to enquire into the political conduct of all those employed by the Spanish royal household during the French occupation. The report on Goya, by Fernando de la Serna, director general of postal services, referred to him as 'one of the most distinguished professors of fine art' in the country, and described his wartime activities as follows:

…from the entry of the enemy into the capital [he] lived shut up in his house and studio, occupying himself with works of painting and engraving, ceasing to see people he had formerly dealt with, not only

giances. And the story they tell is considerably more complicated.

For a start, the man who since 1789 had been court painter to the kings of Spain (a position he would continue to hold until just two years before his death in 1828) was also the man who several times immortalized the upstart Joseph I. In 1811 the French rewarded him for his efforts by decorating him with the Red Cravat of the Order of Spain, awarded to their most loyal collaborators and scornfully christened the 'aubergine' by patriotic Spaniards. Nor was he averse to producing likenesses of members of the French military élite. Indeed, so pleased was General Nicolas Guye with the splendid portrait Goya painted of him in 1810 (opposite) that he commissioned a further one, this time of his young nephew. Other portraits executed in those years include vivid likenesses of francophile Spaniards (popularly known as *afrancesados*), such as General José Manuel Romero, Minister of Justice and the Interior, and Canon Juan Antonio Llorente, who continued to put their faith in the civilizing influence of France. Yet, when asked, Goya also painted portraits of passionately nationalistic figures, such as General Palafox and of the Duke of Wellington, commander of the English Army (right). It is not easy to tell from the paintings alone where the artist's political allegiances lay: on the contrary,

the portrait of the French General Guye, for example, portrays a far more humanly sympathetic individual than do the portraits of Wellington (whom we know Goya came to regard as a vain and self-serving womanizer).

The numerous alterations made to a relatively little-known painting by Goya entitled *The Allegory of the City of Madrid* (page 84) vividly embody both the fickle political climate of the day and his willingness to accommodate to that climate. In marked contrast to *The*

▼ *The Duke of Wellington*
1812–14
Francisco de Goya
OIL ON CANVAS
64.3 X 52.4 CM
NATIONAL GALLERY, LONDON

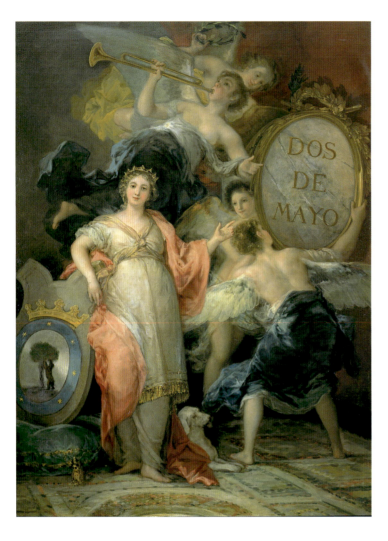

Third of May 1808, this painting is a bland allegorical composition of no great artistic merit, which was commissioned by the usurping French government in 1810 to adorn the town hall in Madrid. The oval medallion originally contained a portrait of Joseph I, but was overpainted with an inscription honouring the new Spanish constitution of 1812 after Joseph fled the city. The portrait was reinstated when he returned, but was replaced by another reference to the constitution when he fled again, this time for good. When the Bourbon monarchy was restored, a portrait of Ferdinand VII took its place; in later years, with the return of a more or less constitutional monarchy after 1835, this was replaced in turn by two inscriptions honouring the constitution, and, finally, another inscription commemorating the events of 2 May 1808.

What is one to make of all this? Clearly, the romantic image of Goya as an isolated and introverted genius whose humanity transcended politics needs to be reconsidered. One must remember that he was a professional painter who had to earn his daily bread. The tensions this entailed were, after all, in evidence well before the War of Independence, when on the one hand he painted the Spanish royal family (with an unflattering frankness that only their vanity seems to have prevented them from seeing) and on the other produced deeply sympathetic portraits of *afrancesados* such as Gaspar Melchior de Jovellanos, who were more often than not close personal friends. Herein lies the conflict, for like these men, Goya the rationalist longed to rescue his country from backwardness and superstition by recourse to the ideas promulgated by the European Enlightenment, and embodied most dramatically in revolutionary France. But when exposed to the ugly realities of

French power, Goya's faith in French revolutionary ideals – and in human nature – was shattered forever. The cruel bitterness of this experience is writ large in the (emphatically unofficial) *Disasters of War* etchings. Indeed, there is an apocryphal story that when Goya began work on the prints, his manservant asked him why he painted the barbarity of the French, to which he replied: 'To tell men eternally not to be barbarians.'

For all that *The Third of May 1808* has become – quite justifiably – a generalized icon of man's barbarity, its origins were clearly tempered by political and financial expediency. An official document of 9 March 1814 reads as follows:

In a letter of the 24th of the past month, addressed to the Regency of the Kingdom by Don Francisco Goya, court painter of His Majesty, he makes manifest his ardent desire to perpetuate with his brush the most notable and heroic actions or scenes of our glorious insurrection against the tyrant of Europe [Napoleon]; and calling attention to the state of absolute penury in which he finds himself and the consequent impossibility of paying the expenses of such an interesting work himself, he asks the public treasury to offer some assistance to carry it out.

Ferdinand, one should remember, had just returned to power (and in fairness to Goya, had not yet had time to blot his copybook). One should bear in mind too that political circumstances between 1808 and 1814 had hardly been conducive to the creation of public statements celebrating Spanish patriotism and damning the French. What better moment than early 1814 to stress the artist's loyalty to the Spanish royal family and, by offering to commemorate in paint the heroism of the 'glorious insurrection against the tyrant of Europe', ingratiate himself with the new ruler? Only in the later prints of *The Disasters of War* and a new series of prints known as the *Disparates* of *c.* 1817–24 would Goya allow himself to express in private his abhorrence of the new regime.

In any event, the same document reveals that the Regency, 'in consideration of the great importance of so praiseworthy an enterprise and of the artist's well-known talents which will enable him to bring it to a successful conclusion', granted him, in addition to the expenses for materials, a modest allowance of 1500 reales per month while working on the pictures. Beyond this, written evidence relating to *The Third of May 1808* and its companion piece is frustratingly scarce. There are no verifiable preparatory works for the painting; while the only two sketches that exist may not even be by Goya's own hand, but may well have been produced in homage to the image by other

artists. No record of Goya at work on this painting exists. A vivid but tantalizing insight into his general working methods (which probably refers primarily to his activity as a portraitist) is contained in a brief biography written in 1831 by his son Javier, the only one of his seven children to reach maturity. In this, he recalls how his father 'painted in one session, sometimes for ten hours, but never in the afternoons, and for the best effect he put the finishing touches on a painting at night time, under artificial light… He distrusted his own works, and sometimes when something did not quite come to him, he said, "I have forgotten how to paint".'

Virtually the only other (less reliable) reference to Goya's technique comes in an article of 1838 by the French writer Théophile Gautier, in which he described the way that Goya applied paint with sponges, brooms and anything else he had to hand, trowelling and modelling his forms as if they were mortar, in a fashion 'as eccentric as his talent'.

Since no public mention is made of Goya's painting until 1834, we can only speculate about its fate up to that point. There is little doubt, however, even on the physical evidence of the paintings themselves (for one thing, their dimensions are identical), that *The Second of May 1808* (sometimes known by the

▼ *An Execution*
(detail)
1636
Jacques Callot
PRINT
BRITISH MUSEUM

fuller title of *The Second of May 1808 in Madrid: The Charge of the Mamelukes*) and the far more famous and distinctive *Third of May 1808* (sometimes referred to as *The Execution of the Defenders of Madrid* or *The Shootings of May Third 1808*) were intended as companion pieces. Some scholars have claimed that Goya's original intention was to execute not two but four related compositions, along the same lines as a contemporaneous series of prints by Tomás Lopéz Enguídanos, which illustrated four episodes in the struggle between the Spanish people and the French invaders: namely, *The Uprising at the Palace*, *The Deaths of Daoiz and Velarde*, *The Puerto del Sol* (page 74) and *The Assassination of the Patriots*. It has also been suggested, again without hard evidence, that the paintings

were displayed on a triumphal arch or pyramid, erected to celebrate the end of the war and the return of the rightful king. Whatever the case, it seems clear that, in the paintings' original context, their political message was never in doubt.

The prints by Enguídanos commemorating the events of 2 and 3 May 1808 are by no means the only such images to which Goya's two paintings in some measure allude. The populist nature of the uprising made the artist's use of imagery created for mass circulation as source material for his own work a logical step. Goya would almost certainly have been aware not only of patriotic Spanish renderings of these events, but also of anti-Napoleonic prints by English artists such as R.K. Porter, which we know were circulated in Spain

▲ *The Shooting of the Monks at Murviedro* (also known as *Assassination of Five Valencian Monks*)
1813
Miguel Gamborino
WOOD ENGRAVING
BIBLIOTECA NACIONAL, MADRID

▲ *Christic on the Cross*
Cross
1780
Francisco de
Goya
OIL ON CANVAS
255 X 153 CM
MUSEO DEL PRADO,
MADRID

A more detailed comparison, however, reveals as many crucial differences as similarities. Most of these prints, of course, are monochrome and technically conventional, if not downright crude, intent on depicting events in as ideologically simplistic a fashion as possible. If not exactly objective, most possess an emotional detachment far removed from the feelings conveyed by Goya's work. A case in point is the print by Zacarías González Velázquez entitled *The Third of May 1808*, probably produced in 1813, which, for all its slightly pedantic conventionality, may have acted as an iconographic source for Goya's painting.

An 1813 engraving by one Miguel Gamborino, showing the assassination of five monks (page 87), provides an especially revealing comparison with Goya's *The Third of May*. Indeed, so similar are the two images in the disposition of the main protagonists that it is hard to believe Goya did not have the print in mind when he embarked on his own composition. However, the presence of utterly conventional cherubs hovering overhead and the fact that all five victims are monks who clearly find solace in the concept of Christian martyrdom embody a vision of the world utterly dissimilar to Goya's. Ultimately, the comparison serves only to highlight Goya's painterly genius for transforming the historically specific, technically banal and religiously complacent into

for propagandist purposes. Ironically perhaps, a French prototype for the image of the firing squad can be discerned in one of the prints from *Les Misères et malheurs de la guerre* (The Troubles of War) by the seventeenth-century artist Jacques Callot (page 86). (Callot's engravings may even have inspired Goya's choice of *The Disasters of War* as a title for his own series of prints.)

an image of searing emotional power and universal relevance.

Another reason why the closest visual counterparts to Goya's painting are to be found in the popular graphic arts lies in the absence of a secular history painting tradition in Spain. On the other hand, *The Third of May 1808* clearly grows out of a centuries-old tradition in Western art of images of Christian martyrs, in which elements, such as the transfiguring light piercing the ambient darkness, the last heartrending gesture of a life about to meet its undeserved and brutal end, and the indifference of the killers, are stock-in-trade. Nor did earlier painters necessarily shy away from depicting the gorier aspects of martyrdom – far from it. Yet religious certitude endows most of these images with a reassuring promise of transcendence so that – in contrast to Goya's painting – there is little tension between the depiction of suffering and horror and the beauty and skill with which they are rendered.

That most Spaniards perceived the war as essentially a religious one, waged against Napoleon the Anti-Christ, is borne out by contemporary texts, such as the following: 'You gave cries as Christians, and the unbelieving sons of Napoleon did not listen, but heaven heard them. Your affliction and helplessness increased the darkness of the night…but the angels saw you and

asked their Sire, and yours, for compensation of the innocence sacrificed. And he said: I will avenge you; and he has fulfilled his promise.' For all his refusal to provide easy solace, it is hardly surprising that Goya, born and bred a Catholic in one of the most Catholic countries in Europe, found it impossible to avoid all references to the Christian faith. Not only are white and yellow, the colours worn by the central figure, traditionally associated with the Church, which is evoked also by the spire in the background, but on closer inspection, his hands seem to bear the imprint of the stigmata – the marks made by the nails at Christ's crucifixion – and his

▼ *Christ with Gas Mask*
1928
George Grosz
PENCIL ON PAPER
44 X 55 CM
AKADEMIE DER KUNST, BERLIN

► *Execution
of the Emperor
Maxmilian
of Mexico*
1867
Edouard Manet
OIL ON CANVAS
252 X 305 CM
KUNSTHALLE,
MANNHEIM

outstretched arms are immediately reminiscent of the crucified Christ, as in Goya's earlier *Christ on the Cross* of 1780 (page 88). The pose recurs in Goya's work, not only in images of victims in *The Disasters of War* prints but also in explicitly Christian images, notably *Christ on the Mount of Olives* of 1819. And, as already mentioned, it is even possible that the shadowy female figure on the far left of the painting contains an implicit reference to the Virgin Mary.

The presence of the monk among the victims also raises interesting questions. As many of the blackly satirical images in his earlier *Caprichos* (Caprices) prints make clear, Goya deplored the superstitious backwardness of most of the Spanish clergy. However, one of his own brothers was a priest and he had paid homage to a monk's bravery in his 1806 series of small paintings depicting the capture of a notorious bandit by a Franciscan friar. In *The Third of May* the monk is depicted as being as vulnerable to human emotion and frailty as his fellow victims, his tensed arms and clenched fists expressive of his anguish. These references to a Christianity that fails to offer meaning, let alone salvation (as well as to a painfully human Christ figure), add extra poignancy to the image and, once again, give the painting a very modern resonance. However obliquely, later politically and religiously charged images, such as George Grosz's 1928

drawing of *Christ with Gas Mask* (page 89), Marc Chagall's depictions of an identifiably Jewish Jesus in works such as *White Crucifixion* of 1938, Graham Sutherland's late 1940s' paintings of Crucifixions inspired by photographs of concentration camp victims (and even, I would suggest, our reading of those terrible photographs themselves, some of which do indeed show the corpses in cruciform poses), are all in some measure indebted to Goya's example.

In some cases, of course, the homage paid by later artists to *The Third of May 1808* is more obvious and straightforward. Most famous perhaps is the reworking of Goya's composition by Edouard Manet in his three versions of *The Execution of the Emperor Maximilian* of 1867 (opposite), which alludes to the controversial betrayal of the puppet ruler of Mexico by Napoleon III and his subsequent execution by firing squad. In keeping with the greater emotional and pictorial restraint characteristic of the French artist, the image is far more detached and dispassionate, less dramatic perhaps but even more chilling. The matter-of-factness of the soldier taking time out to test his gun adds to the sense that for him and his fellow executioners this is just part of a day's work. Closer in spirit to Goya's painting is a less well-known work on paper by Manet called *The Barricade*, which vividly evokes the confusion and violence of the days of the Paris Commune of 1871. As described on page 118, Manet's keen interest in Spanish art pre-dated his first and only visit to Spain in 1865. Interestingly, his letters from Spain make no mention of *The Third of May*; it may well be that it was a monochrome wood engraving of the painting reproduced in a monograph on Goya by

▼ Cartoon in *Gedéon*, a Spanish periodical 3 May 1908

Charles Yriarte and published in Paris in 1867 that served to rekindle Manet's interest in the image when it became relevant to his own concerns.

Nearly forty years later, a political cartoon published in a Spanish periodical in 1908 (page 91) pointedly alludes to the 1808 image by depicting Prime Minister Maura and Home Secretary La Cierva as members of a firing squad shooting at the populace, presumably to comment on the brutal suppression of Catalan nationalists by the Spanish government in that year. Although we know that Picasso had *The Third of May* in mind in 1937 while working on *Guernica*, his own heartfelt protest against the horrors of war perpetrated on an innocent Spanish civilian population, he does not allude directly to it in that work. That *The Third of May* possessed a powerful resonance for others during that period is borne out by André Malraux:

That painting always gave me the impression of being under a spell. A spell, I suppose, cast by something supernatural. Especially during the Spanish Civil War, because the man raising his arms symbolized our pals. I wasn't thinking about the lighting; I was thinking about the gesture – those arms raised like a large V. Since then we've seen General de Gaulle make the same gesture; and Churchill, with his fingers. During the Civil War, V didn't yet mean victory. But arms raised up like that – we knew them well; they are the arms of crucifixions, in which the cross is a forked tree…

▼ *Massacre in Korea*
1951
Pablo Picasso
OIL ON PLYWOOD
109.5 X 209.5 CM
MUSEE PICASSO, PARIS

▲ *Goya: The Third of May 1970*
1970
Robert Ballagh
ACRYLIC ON CANVAS
165 X 220 CM
HUGH LANE MUNICIPAL
GALLERY OF MODERN
ART, DUBLIN

During the Spanish Civil War, Goya's painting, together with other works from the Prado, was removed from Madrid for safekeeping, first to Valencia, then to Barcelona, and finally to the greater security of Geneva. At some point, the lorry carrying *The Second* and *Third of May* had an accident and the two paintings were slightly damaged – a fact that seems symbolically appropriate.

In 1951 Picasso painted his *Massacre in Korea* (opposite), this time paying overt homage to the earlier Spanish master. Far easier to 'read' than *Guernica* (but with similarly monochrome figures), *Massacre in Korea* is also distinctly cruder and more simplistic in its imagery, perhaps too obviously reliant on Goya's example, too conventional in its juxtaposition of those predictable archetypes of innocence, women and children, and the robotic embodiments of mechanized murder. That Goya's masterpiece has been perceived as relevant to more recent conflicts is evidenced by works such as *Goya: The Third of May 1970* by Robert Ballagh (above), which alludes to the troubles in Northern Ireland of August 1969, equating the presence of British troops in Ireland with that of Napoleon's army in Spain. It is telling, too, that a department of political and international studies in an Australian university should choose to use Goya's painting to promote itself on the Internet.

In 1834 *The Third of May 1808* and its companion piece were listed in an inventory of paintings held in storage at the Prado, suggesting, if nothing else, that the works had remained in the possession of the Spanish government. In his 1845 *Voyage en Espagne*, the writer and critic Théophile Gautier lamented the fact that *The Third of May* had been 'relegated without honour to the antechamber' of the Prado. The two paintings were included in its published catalogue only in 1872, where they were matter-of-factly listed as an 'Episode of the French Invasion in 1808' and 'A Scene of the Third of May 1808'. The lukewarm public reception that all this implies is more readily understandable if one bears in mind that the official 'restoration style' associated with the reign of Ferdinand VII was diametrically opposed to the

▲ *The Famine in Madrid*
1818
José Aparicio Inglada
OIL ON CANVAS
315 X 437 CM
MUSEO DEL PRADO, MADRID

passionate humanism of Goya's two canvases. A formulaic neo-classical style applied to noble themes, often taken from ancient history, which directly or indirectly celebrated the virtues of the Spanish Bourbon regime was now the order of the day. In such a climate, mediocrity flourished, in the shape of artists, such as Francisco Xavier Ramos, José de Madrazo y Agudo and José Aparicio Inglada (above), the last being appointed court painter in 1815, who are now barely heard of outside Spain. The tumultuous events of 2 and 3 May 1808 continued to be commemorated in art throughout the nineteenth century (opposite), but with a blandness and predictability that accentuate the extent of Goya's originality.

That Goya's art was celebrated for different reasons as the nineteenth century progressed is testimony to the sometimes bewildering variety and multifaceted nature of this artist's *oeuvre*. In the middle of the century Goya was admired (by Manet among others) primarily for his realism and the vivid depictions of contemporary life that mainly characterized the early part of his career. Later that century, it was the

fantastical and macabre elements in his work that most excited attention; in the early twentieth century, with the development of abstraction and the advent of a formalist approach to art, it was the apparent modernity of Goya's handling of paint that was emphasized. And then, from the time of the Spanish Civil War onwards, it was the passion of his political engagement with contemporary events that seemed particularly pertinent. Only in the course of the twentieth century, with its succession of terrible conflicts, was the disturbing relevance of Goya's dark vision of the world fully appreciated.

Today, at the start of the twenty-first century, that vision seems no less disturbing, and no less relevant. For all these reasons and more, the work of Francisco de Goya y Lucientes, most of which has remained in Spanish public collections, has become one of modern Spain's major cultural attractions, and the artist himself a national hero. So iconic, moreover, has his *Third of May 1808* become that it has even graced a Spanish postage stamp.

▲ *Death of Daoiz*
1862
Manuel Castellano
OIL ON CANVAS
249 X 390 CM
MUSEO MUNICIPAL,
MADRID

▼ Spanish postage stamp 1996

EDOUARD MANET

OLYMPIA 1863

This unconventional work by an inherently conventional man met with outrage and incomprehension when it was first exhibited at the French Salon in 1865 – but critics had come to expect no less from the artist who had

scandalized them just two years earlier with his *Déjeuner sur l'herbe*. Although most criticism of *Olympia* focused on the formal properties of the work, such as its harsh lighting and lack of half-tones, it is clear in retrospect that its real shock value lay in the challenges it offered to social and sexual mores.

▶ *Olympia*
1863
Edouard Manet
OIL ON CANVAS
130.5 X 190 CM
MUSEE D'ORSAY, PARIS

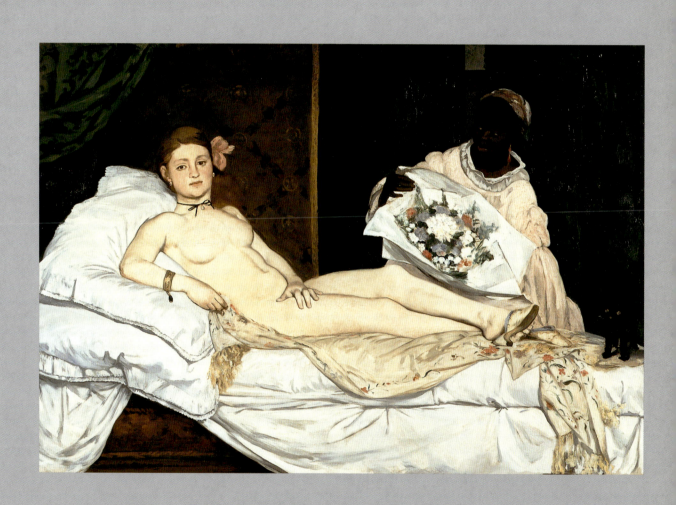

'Never has a painting excited so much laughter, mockery and catcalls as this *Olympia*. On Sundays in particular the crowd was so great that one could not get close to it...' LOUIS AUVRAY, 1865

These days, one often gets the feeling that artists are consciously out to shock, and that the degree to which they accomplish this is all too often taken as a measure of their success. It may come as a surprise, therefore, to learn that one of the most notorious paintings of the nineteenth century was produced by an artist who had no wish to shock whatsoever, and yet did so – more profoundly, I suspect, than do the likes of present-day 'bad boys', such as Damien Hirst and his friends.

Indeed, on one level, Edouard Manet saw himself as a solid member of the French establishment. Born in 1832 into a more than respectable *haut bourgeois* family, and originally destined for a career in the law, he never regarded himself as a rebel, either artistic or social. (Although a staunch left-wing republican all his life, he never allowed politics to enter directly into his work.) By his own admission, he viewed the government-sponsored Salon, dominated by the Ecole des Beaux-Arts and held annually at the Palais de l'Industrie in Paris, as 'the real field of battle': '...it is there,' he claimed, 'that one must take

one's measure.' Yet as a result, first of the *succès de scandale* of his *Déjeuner sur l'herbe* (opposite) at the Salon des Refusés of 1863 (held in response to the unusually large number of works rejected by the Salon in that year), and above all the outrage provoked by *Olympia* at the official Salon in 1865, Manet found himself the focus of admiration of a group of younger artists with more consciously anti-establishment views. Intent on capturing passing moments of contemporary life in an appropriately sketchy and impromptu-seeming style, these young painters – among them Claude Monet, Auguste Renoir and Alfred Sisley – were later to be dubbed the Impressionists. As Jules Claretie, writing in *L'Artiste*, put it:

Once upon a time there was a young man called Manet who, one fine day, bravely exhibited among the rejected paintings a nude woman lunching with some young men dressed in sack suits and capped with Spanish sombreros. Many cried shame, some smiled, others applauded, all noted the name of the audacious fellow who already had something and who promised much more. We find him again this year

OLYMPIA EDOUARD
MANET

with two dreadful canvases, challenges hurled at the public, mockeries or parodies, how can one tell? Yes, mockeries…

We know that Manet started work on *Olympia* in 1862 and completed it in 1863. Yet he deliberately chose not to submit it to the 1864 Salon, offering instead *Incident in a Bull Ring* and *Dead Christ with Angels*, which were unlikely to arouse strong feelings, and indeed were duly accepted. Was he perhaps waiting for the fuss over *Déjeuner sur l'herbe* to die down before submitting a work that might well provoke similarly mixed reactions? Faced with a lack of direct evidence, we can only speculate about his motives. The paucity of primary documentation combines with the often inscrutable nature of his imagery to make Manet one of the most enigmatic artists of his time.

In the end, he submitted two works to the 1865 Salon, *Olympia* and *Christ Mocked by the Soldiers* (page 101), which were hung one above the other, with the former on top. The title of the painting seems to have been the brainchild of Manet's friend, the art critic Zacharie Astruc. The entry for *Olympia* in the Salon catalogue included the first stanza of a long poem by

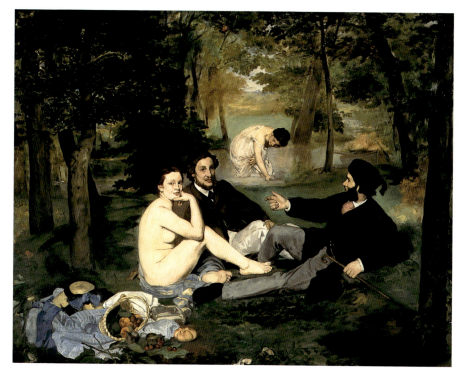

◄ *Déjeuner sur l'herbe*
1863
Edouard Manet
OIL ON CANVAS
208 X 264.5 CM
MUSEE D'ORSAY

Astruc entitled *Olympia, la fille des îles*: 'When, weary of dreaming, Olympia awakes,/Spring enters in the arms of a gentle black messenger,/It is the slave, who like the amorous night,/Comes in and makes the day delicious to see with flowers:/The august young woman in whom the flame burns constantly.' Manet's reasons for associating himself with this rather second-rate, sub-Baudelairean text remain unclear. Was it a gesture of solidarity or gratitude to Astruc, one of his few supporters in 1863? Or was he perhaps making fun of the tendency of many Salon paintings to be accompanied by long, pretentious and unwieldy literary (or pseudo-literary) texts? In any event, this verbal attempt to elevate the subject of the painting, universally recognized as a prostitute, into an 'august young woman' only added fuel to the fire.

On display at the 1865 Salon were 2,243 paintings, closely packed together, as was the norm. By the 1860s, a far wider Parisian public than hitherto was being encouraged to attend large exhibitions of contemporary art such as the Salon. Although in principle this was a democratic development, it did inevitably mean that many viewers were culturally and intellectually ill-equipped to make sense of what they saw – particularly when the art in question was as complex and sophisticated in its references and impli-

cations as Manet's *Olympia*. Daumier's double-edged caricature (opposite), with its caption reading, 'Why the devil is that big red woman *en chemise* called Olympia?' 'But, my friend, it may be the cat that's called that.' is a vivid illustration of the man (and woman) in the street's incomprehension.

The professional critics, however, were scarcely more comprehending. Of some eighty pieces of writing devoted to the enormous exhibition, sixty or so – a huge proportion – singled out *Olympia* for special mention. Of course, a certain amount of mud-slinging was *de rigueur* when it came to passing judgement on one of the most important cultural events of the year. Yet even the more intelligent and enlightened critics of the day seemed unable to deal with the painting. As we will see, those few who did defend it did so primarily on formal grounds. The vast majority of reviews, however, were derisive, angry and, at best, confused. *Christ Mocked by the Soldiers* (opposite), although hardly favourably received, attracted far less attention.

So extreme were the reactions of most of the critics that they are worth quoting at some length. A careful analysis of these initially puzzling texts can transform them into eye-opening evidence of contemporary mores, and can thereby go a long way to account for their virulence. The critic Félix Deriège, for example, described Olympia as

…lying on her bed, having borrowed from art no ornament but a rose which she has put in her towlike hair. This red-head is of a perfect ugliness. Her face is stupid, her skin cadaverous. She does not have a human form; Monsieur Manet has so pulled her out of joint that she could not possibly move her arms or legs. By her side one sees a Negress who brings in a bouquet, and at her feet a cat who wakes and has a good stretch, a cat with hair on end, out of a witches' sabbath by Callot [a seventeenth-century French graphic artist]. White, black, red and green make a frightful confusion on this canvas: the woman, the Negress, the bouquet, the cat, all this hubbub of disparate colours and impossible forms, seize one's attention and leave one stupefied.

Théophile Gautier (a writer and art critic who should have known better) dismissed the painting in the following terms: 'The colour of the flesh is dirty, the modelling non-existent. The shadows are indicated by more or less large smears of blacking… The least beautiful woman has bones, muscle, skin, and some sort of colour. Here there is nothing…'

Curiously, although the critics had been quick enough to recognize – and decry – the artistic allusions (principally to Titian and Raphael) in the *Déjeuner sur l'herbe*, only two seem to have noticed one of the primary references in *Olympia*, to Titian's

◀ *Before the Painting of M. Manet*
1865
Honoré Daumier
LITHOGRAPH
BIBLIOTHEQUE NATIONALE, PARIS

▼ *Christ Mocked by the Soldiers*
1865
Edouard Manet
OIL ON CANVAS
191 X 147.5 CM
THE ART INSTITUTE OF CHICAGO

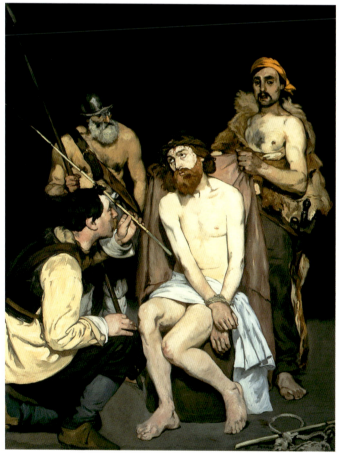

famous *Venus of Urbino* of *c.* 1538 (below), which Manet had in fact copied in Florence when he was a student. One of these was Amédée Cantaloube, writing in *Le Grand Journal* on 21 May 1865, who described the woman as a 'sort of female gorilla, a grotesque of India rubber outlined in black [who] apes on a bed, in a state of complete nudity, the horizontal attitude of Titian's *Venus*, the right arm rests on the body in the same fashion, except for the hand which is flexed in a sort of shameless contraction'. The other was a writer calling himself Pierrot in a fly-by-night publication eponymously titled *Les Tablettes de Pierrot*: 'a woman on a bed, or rather, some form or other, blown up like a grotesque in india rubber; a sort of monkey making fun of the pose and the movement of the arm in Titian's *Venus*, with one hand shamelessly flexed.' So similar are these two descriptions that one can only suppose either that the two writers were one and the same individual, or that the one was shamelessly plagiarizing the other. Certainly, the titillatingly chaste position of Venus's hand over her genitals is a far cry from the almost aggressive, sexually threatening tenseness of Olympia's hand. Was the difference between Olympia's confrontational contemporaneity and the

▼ *Venus of Urbino*
(detail)
c. 1538
Titian
OIL ON CANVAS
119 X 165 CM
UFFIZI GALLERY,
FLORENCE

▲ *Large Odalisque*
1814
J.A.D. Ingres
OIL ON CANVAS
91 X 162 CM
MUSÉE DU LOUVRE,
PARIS

seductive, 'safe' sensuality of Titian's *Venus* indeed so great that the connection between them became irrelevant, invisible to a mid-nineteenth-century public?

By 1865, of course, the image of the reclining female nude was well-entrenched in the history of Western art. Since its appearance in the hedonistic, sensual milieu of sixteenth-century Venice, it had rapidly become one of the staple subjects for an art catering primarily to the erotic needs of the privileged, moneyed male spectator. In retrospect, it has been easy for scholars to identify the multiple allusions in *Olympia* to images of women past and present. One such reference may be to a painted storage chest decorated by the workshop of Botticelli with an image of three cherubs and a Venus with an unusually con-

frontational and inscrutable gaze. Another, more obvious, reference is to Goya's frontally defiant, almost insolent *Naked Maja* of *c.* 1796 (page 104), so unacceptable in the repressive cultural climate of Catholic Spain that for years it was hidden from public view, and which Manet would have known only in the form of a copy. Other images by Goya may also have been in Manet's mind: in several of the *Caprichos* (Caprices), sexually provocative young women are juxtaposed with older female companions. Other works to which Manet's painting makes implicit, if equivocal, reference include French Rococo images, such as Jean-Marc Nattier's *Mademoiselle Clermont at the Bath* of 1733 (page 105), one of several that deliberately set up a contrast

▲ *The Naked Maja*
c. 1796
Francisco de Goya
OIL ON CANVAS
97 X 190 CM
MUSEO DEL PRADO,
MADRID

between white and black flesh. By the middle of the next century, this motif had established itself in the form of the Odalisque or 'oriental' harem beauty attended by a darker-skinned servant, as in Ingres's well-known painting of 1839. His *Large Odalisque* of 1814 (page 103) also comes to mind. Indeed, fluent preliminary sketches for Olympia (page 110) show the figure in a pose more reminiscent of Ingres's painting than of Titian's. Only in the larger watercolour that immediately preceded the oil painting did Manet opt for Titian's *Venus* instead. The two works, moreover, share a certain linearity, and we know that Manet professed a profound admiration for the older artist's 'irreproachable purity of line'. Although the cool frontality of the women's gazes is also comparable, the erotic languor and exoticism of Ingres's nude is ultimately a far cry from

the taut contemporaneity of Manet's figure. Delacroix's paintings of Odalisques, warmer in colour and more overtly sensual than those by Ingres, and Courbet's unashamedly fleshy renderings of the female nude would also have been familiar to Manet. Closer to home still, in 1847 Thomas Couture, with whom Manet studied in the early 1850s, had produced his huge and much talked-about allegorical canvas *The Romans of the Decadence*, ostensibly a comment on the corruption of French society of his own day. The central figure of the courtesan in this composition may well have been in Manet's mind during the genesis of his own painting.

Mid-nineteenth-century photographs of the Paris Salon immediately reveal a disproportionate number of female nudes – a fact that only very rarely gave rise to comment (page 113). It is in this

context that Manet's purported remark to his friend Antonin Proust (father of the writer Marcel Proust), 'It seems that I've got to paint a nude. Very well! I'll do them one,' makes sense. A lithograph by Daumier is notable for drawing attention to the inevitably awkward position of the female viewer of such images. Published in *Le Charivari* on 10 May 1865, it shows two middle-aged women fleeing a gallery hung with nudes, one of them exclaiming: 'This year still more Venuses…always Venuses… As if there were women made like that!' Paintings of a 'soft porn' variety abounded, yet raised hardly an eyebrow. Indeed, one of the best-known of these, *The Birth of Venus* by Alexandre Cabanel (page 107), exhibited at the 1863 Salon (the self-same Salon that rejected Manet's *Déjeuner*), was purchased by Emperor Napoleon III.

A comment by the critic Théophile Thoré helps explain why:

The paganism of these painters nonetheless is not indecent, and these unveiled figures have nothing of the natural woman about them, nor of the woman who reveals her voluptuousness. No bone, no flesh, no blood, no skin… One might find the Venuses of Titian immodest…but our Parisian Venuses do not have even this quality of reality. Inoffensive phantoms like the wallpaper

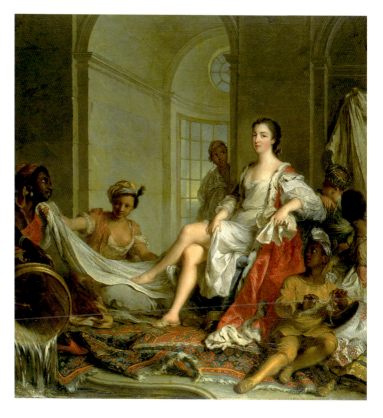

▲ *Mademoiselle Clermont at the Bath*
1733
Jean-Marc Nattier
OIL ON CANVAS
110 X 106 CM
THE WALLACE COLLECTION, LONDON

nymphs of cafés. One should make them into lithographs coloured in pink for the boudoirs of Breda Street [an area well known for its prostitutes].

Furthermore, as the novelist and art critic Camille Lemonnier wrote in 1870: 'In order to stay virgin the nude in art must be impersonal and must not particularize; art has no need of a beauty spot upon the neck or a mole on the hindquarters. It hides nothing and shows nothing…' Idealized, depersonalized, sculptural in form, divested of all body hair, distanced and made respectable by a mythological, biblical or geographically exotic setting,

eyes closed or half-closed, passively available (at least to the male imagination), these nudes – in stark contrast to *Olympia* – posed no threat, no challenge to the status quo.

So great was the outrage caused by *Olympia*, that two gendarmes were stationed in front of it to guard it from attack. Eventually, towards the end of May, shortly before the exhibition closed, it and its companion piece were moved from their original position on the stairs, and hung instead above the door in the last room, at a height where, according to Jules Claretie in *Le Figaro*, 'even the worst daubs had never been hung' and 'where you scarcely knew whether you were looking at a parcel of nude flesh or a bundle of laundry'. Nevertheless, as another critic, Paul de Saint-Victor, wrote, 'the mob continued to crowd round Manet's gamey *Olympia* and disgusting *Ecce Homo* as if they were at the morgue'. References to the morgue can be found in numerous other reviews as well. Victor de Jankovitz, for example, wrote how 'The author represents for us under the name of Olympia a young girl lying on a bed, having as her only garment a knot of ribbon in her hair, and her hand for fig leaf. The expression of her face is that of a being prematurely aged and vicious; her body, of a putrefying colour, recalls the horror of the morgue.'

Art history has tended to stress the groundbreaking formal qualities of Manet's work, hailing him as a pioneer of a modernist approach to art, in which aesthetic issues unequivocally take precedence over subject matter. Thus, the illusion of spontaneity he achieved in his handling of paint strikes a chord of recognition in those who view this quality as one of the hallmarks of modern art; the poet Mallarmé described how Manet 'hurled himself on his bare canvas in a rush, as if he had never painted before'. Manet broke radically with academic tradition in abandoning the practice of covering the canvas with a dark, usually brown, tone upon which the composition was built up with heavier layers of pigment and translucent glazes. His work of the early 1860s reveals layers of firm, opaque paint and little glazing; from the start, each colour was chosen and applied for its final effect. This was a technique known as *alla prima* painting, which enabled him simply to scrape back to the canvas surface and begin afresh the next day if he was dissatisfied with a particular area. Important in both practical and expressive terms, Manet's adoption of the *alla prima* technique was to have a far-reaching effect on his younger colleagues, the Impressionists, as was his insistence on having his subject directly in front of him while painting it. Indeed, the methods of Manet and the Impressionists gradually became the norm in subsequent painting practice.

▲ *Birth of Venus*
1863
Alexandre
Cabanel
OIL ON CANVAS
130 X 225 CM
MUSEE D'ORSAY, PARIS

Similarly, his conspicuous tendency to abolish half-tones in a favour of an emphasis on the (relative) flatness of the picture surface has been seen by many, including such highly influential twentieth-century critics as Clement Greenberg, as paving the way for the development of a totally abstract art. According to Greenberg, 'Manet's paintings became the first Modernist ones by virtue of the frankness with which they declared the surfaces on which they were painted.' By his own admission, Manet believed that 'light appeared to the human eye with a unity such that a single tone was sufficient to render it, moreover it was preferable, crude though it might seem, to pass suddenly from light to darkness rather than accumulate features that the eye does not see'. The influence both of Japanese and popular French wood-block prints has been detected here. Also relevant is his tendency to simplify forms by making one dab of paint stand as shorthand for a more complex reality. (Once again, the Impressionists – who would in turn influence Manet's later work – took this approach much further.) Even Gustave Courbet, a more consciously iconoclastic figure than Manet, whose renderings of contemporary subjects – including prostitutes – aroused considerable controversy, homed in on the painting's lack of modelling and wittily compared Olympia to 'the Queen of Spades after her bath'.

▶ *Continued on page 110*

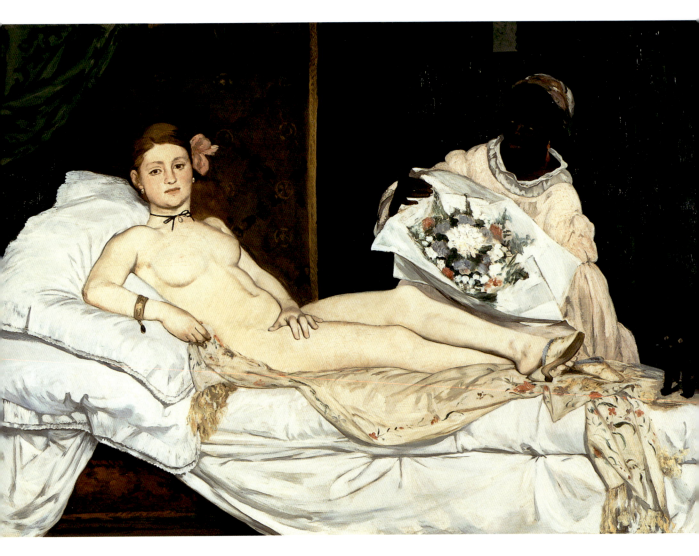

OLYMPIA EDOUARD MANET

Although female nudes were a staple subject in French academic art, they were invariably portrayed as idealized and passive. Along with other Realist artists and writers, such as Courbet and Zola, Manet challenged the social and artistic status quo. His Olympia, far from being a Venus, was clearly a prostitute.

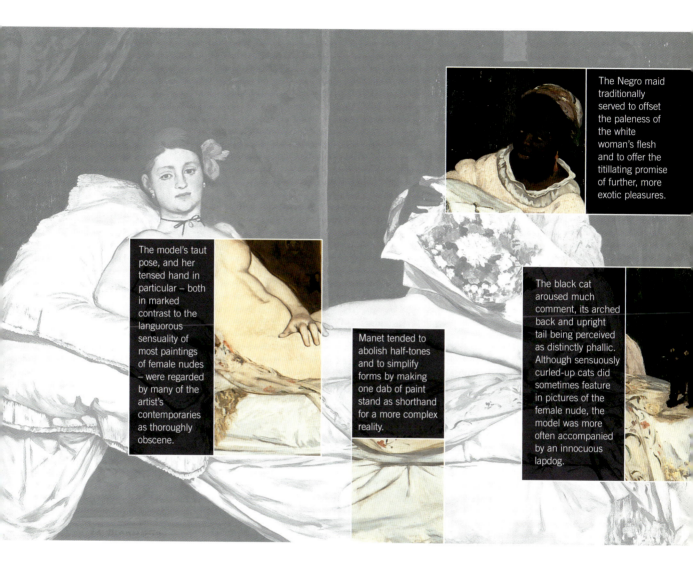

The Negro maid traditionally served to offset the paleness of the white woman's flesh and to offer the titillating promise of further, more exotic pleasures.

The model's taut pose, and her tensed hand in particular – both in marked contrast to the languorous sensuality of most paintings of female nudes – were regarded by many of the artist's contemporaries as thoroughly obscene.

Manet tended to abolish half-tones and to simplify forms by making one dab of paint stand as shorthand for a more complex reality.

The black cat aroused much comment, its arched back and upright tail being perceived as distinctly phallic. Although sensuously curled-up cats did sometimes feature in pictures of the female nude, the model was more often accompanied by an innocuous lapdog.

By using strong, opaque pigments applied directly to the canvas with little glazing and no dark underpainting, Manet broke dramatically with French academic tradition. This radically new technique, known as *alla prima* painting, allowed for a far greater freedom and spontaneity in the handling of paint, and influenced his younger contemporaries, the Impressionists. They took the technique even further, and in turn influenced Manet himself, but it is no exaggeration to say that his work paved the way for most subsequent art practice.

► Emile Zola, to whose role in defending *Olympia* Manet pays tribute in his 1868 portrait of the writer, and whose 1867 pamphlet on the artist was illustrated by etchings based on the painting, is to a large extent to blame for this predominantly formalist approach to Manet's work. There is a distinct irony here, of course, since it was Zola, the staunch upholder of naturalism in literature, who, only a few years later, would gain notoriety for his forthright depiction of a prostitute's life in his novel *Nana*, to which Manet's 1877 painting of the same name (opposite) in turn alludes. (Although published in 1880, Zola was already working on it three years earlier.) One can thus only assume that Zola hoped to deflect attention from the iconography that seemed to cause such widespread indignation when, in defence of what he described as 'the veritable flesh and blood of the painter...the most characteristic example of his talent, his greatest achievement', he asserted:

▼ Study for
Olympia (first
version)
1862–3
Edouard Manet
SANGUINE (RED CHALK)
22.4 X 29.8 CM
MUSEE DU LOUVRE,
CABINET DES DESSINS,
PARIS

At first sight one is aware of only two tones in the picture – two violently contrasting tones. Moreover, all details have disappeared... Everything is simplified, and if you want to reconstruct reality, move back a few paces. Then a strange thing happens – each object falls into correct relation... Accuracy of vision and simplicity of handling have achieved this miracle. The artist has worked in the same manner as Nature, in large, lightly coloured masses, in large areas of light, and his work has the slightly crude and austere look of Nature itself. But the artist has his partis pris [prejudices]: for art can only exist by enthusiasm. These partis pris consist of precisely that elegant dryness and those violent contrasts which I have pointed out... What does all this amount to – you scarcely know, no more do I. But I know that you have succeeded admirably in doing a painter's job, the job of a great painter...

A handful of other writers chose to defend the painting on formal grounds. Gonzague Privat, for example, wrote: 'Solid and painterly qualities predominate in it. The young girl is done in a flat tone, her flesh is of an exquisite delicacy, a nicety, in a perfect

relationship with the white draperies.'
For the most part, though, when formal
issues are alluded to in contemporary
texts, it is, as we have seen, in tones of
outrage and revulsion ('a grotesque in
india rubber outlined in black', 'this
hubbub of disparate colours and impos-
sible forms', etc.) that are surely more an
unacknowledged response to the paint-
ing's subversive iconography than to
purely formal matters. In the twentieth
century, the literature on Manet was
dominated by an often blinkered
emphasis on his pictorial achievement.
In his short monograph of 1946 on the
painting, François Mathey concluded:
'If Manet put nothing into [the model's]
gaze, it is because it expressed nothing.
One painted and the other posed.
Conscientiously. Simply.' 'With the
Olympia,' claimed Lionello Venturi, 'he
introduced the principle of the autono-
my of vision into art, and all modern art
has used it as a basis and as a banner.'
Only a few solitary voices, such as the
poet Paul Valéry, who in the 1930s
wrote of 'the cold and naked Olympia,
that monster of banal sensuality', still
saw the image itself as important.

Recently there have been attempts by
some scholars to redress the balance by
placing Manet firmly back into his
historical context, and reinstating the
importance of his subject matter. Most
of these are academics of a Marxist
and/or feminist persuasion, who for the

most part are far more interested in
social history than in aesthetics. For all
the undeniable importance of their
research and analyses, I would suggest
that the one approach does not necessar-
ily preclude the other. After all, *Olympia*
would not possess the enduring power it
undoubtedly does were it not for the fact
that form and content, the senses and
the intellect are ultimately inseparable.

So what exactly was it about Manet's
painting that aroused such strong emo-

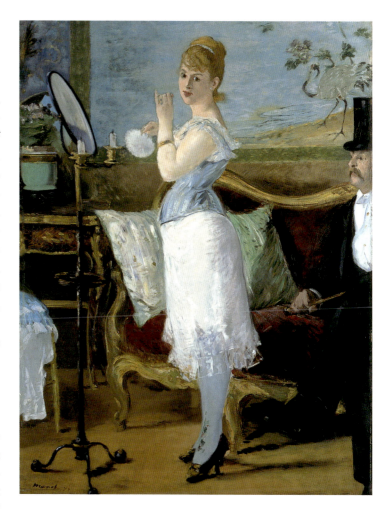

▲ *Nana*
1877
Edouard Manet
OIL ON CANVAS
154 X 115 CM
KUNSTHALLE,
HAMBURG

tion, such outrage, such disgust? Even today, *Olympia* retains the power to disconcert, to unsettle one's complacency. The imperturbability and inscrutability of Olympia's expression – and of the image as a whole – persist. (It is symptomatic of the change in attitude outlined above that in the Jeu de Paume the painting used to hang in the company of Impressionist and post-Impressionist works, thus reinforcing its role in the development of the avantgarde. Since the opening of the Musée d'Orsay in the mid-1980s, however, it has been exhibited alongside its academic contemporaries, the nudes beloved by the Salon.) In the context of mid-nineteenth-century Paris, that power was infinitely greater.

As already mentioned, the woman in the painting was instantly recognizable by her attributes – the slipper, the jewellery, the hair adornment, the cat, the black servant carrying a bouquet from an (implied) male visitor – as a contemporary courtesan or prostitute. Even her lack of obvious voluptuousness conformed to the fashion of the day: according to Baudelaire, 'there is in thinness an indecency which makes it charming'. Her social status, however, is ambiguous: the trappings with which she is surrounded suggest a certain affluence and glamour; but her face and body suggest working-class origins, a harsh experience of life marked out on her flesh. The very name Olympia (Olympe in French) was one commonly associated with prostitutes, both in real life and in literature. A contemporary survey confirms that, along with similarly elevated names such as Aspasia, Lucretia, Sidonia and Calliope, it was much favoured by a better class of working girl. Olympia was the name of Armand Duval's mistress in Alexandre Dumas's *La Dame aux camélias* (written as a book in 1848, and as a play in 1852); it was also the name of a notorious Renaissance courtesan, recently made the heroine of a popular novel by Etienne Delécluze; and in *The Sand Man* by E.T.A. Hoffmann, Olympia is a mechanical doll, beautiful but coldly inhuman.

The actual model for Olympia was a young woman called Victorine Meurend, whom Manet had already used on several other occasions (including the *Déjeuner sur l'herbe*) and whose services were also called upon by other artists. Research has revealed that she was not only an artist's model, but also (as was often the case) a prostitute who on occasion posed for *risqué* photographs. Often marketed as 'art photographs', such images (page 116) frequently emulated the poses and props of 'high art' renderings of the female nude. Indeed, they were used by artists such as Delacroix and Degas as practical aids. Manet, needless to say, would have been familiar with such photographs, which were almost

certainly yet another source and point of reference for *Olympia*. Intriguingly, it transpires that Victorine Meurend was herself a painter of some accomplishment: ironically, her paintings were accepted at the Salon of 1876, a year in which Manet's own works were rejected; and in 1879 she exhibited a work entitled *La Bourgeoise de Nurembourg*.

Once we realize that prostitutes were a focal point of public concern (and hypocrisy) around the time that *Olympia* was painted, the passions roused by the painting become easier to understand. Paul de Saint-Victor, looking back on the Second Empire of 1852–70, observed: 'Courtesans exist in all times and places… But has there ever been an epoch where they made the noise and held the place they have usurped in the last few years? They figured in novels, appeared on stage, reigned in the Bois [de Boulogne], at the races, at the theatre, everywhere crowds gathered.' Prostitutes' lives feature prominently in the literature of the 1870s and 1880s as well: in Joris-Karl Huysman's *Marthe* of 1876; Edmond de Goncourt's *La Fille Elisa* of 1877; Emile Zola's *Nana* of 1880; and Guy de Maupassant's *Boule de suif* and *La Maison Tellier*, of 1880 and 1881 respectively. Plays that featured prostitutes, such as Dumas's *La Dame aux camélias* and *Marion Delorme* by Victor Hugo, as well as others of less literary merit by Barrière and Thiboust,

Feuillet, Augier, Meilhac and Halévy, also enjoyed considerable success.

It has been estimated that during the Second Empire, there were some 120,000 prostitutes in Paris alone. Those who were officially registered – the *filles soumises* – could at least be subject to a measure of control. Far more worrying were the unregistered prostitutes – the *filles insoumises*. Not only public morals but public health were perceived as being under threat – one explanation, surely, of the frequent references to disease, degeneration and

▼ Caricatures of
Salon paintings
1863
J.J. Baric
BIBLIOTHEQUE
NATIONALE, PARIS

Naissance de Vénus
aux longues jambes.
Drôle de mer que son amere
mère.

Autre naissance de Vénus.
Pardon : *La Vague et la Perle* (fable persane.)
Dans tous les cas, ce n'est pas une perle fine, et la
vague est bien vague.

Naissance de Vénus
au bras long.
Une des plus jolies choses du Salon.

Naissance de Vénus
écharpée.

▲ *The Young
Courtesan*
1821
Xavier Sigalon
OIL ON CANVAS
121 X 154 CM
MUSEE DU LOUVRE,
PARIS

death in the reactions to *Olympia*. Sociologists cite the huge influx of rural workers to the city earlier in the nineteenth century, a corollary of Hausmann's dramatic reconstruction of the metropolis – single men alone and in need of sexual solace. But by the 1860s this explanation was clearly inadequate, since bourgeois and aristocratic males too were well known to frequent brothels. Indeed, many 'high-class' prostitutes had became exceedingly wealthy, and were now familiar figures in the public arena. Ironically, many 'respectable' women began to ape the manners, speech and dress of these *grandes cocottes*. Clearly, class as well as sexual boundaries were becoming increasingly blurred and ill-defined – just as in prostitution itself money and sex are inextricable. It is thus hardly surprising that an image such as *Olympia*, which (to a large extent, unwittingly) embodied such topical

issues, aroused both fear and fascination.

The age-old madonna/whore dichotomy, the distinction, in more historically specific terms, between *la fille honnête* and *la fille publique*, also raises its head here. The latter was, in fact, well represented in French art of the period, but nearly always obliquely: most commonly, as we have seen, she is shown as Venus or Odalisque. Sometimes, as in the paintings of Jean-Léon Gerôme and Xavier Sigalon (left) she appeared in the guise of a famous courtesan from history. If, occasionally, a contemporary relevance was intended, she might be shown in modern dress but with overtly moralizing intent; or in allegorical form, as in Thomas Couture's *The Romans of the Decadence,* or Auguste Glaize's *The Purveyor of Misery* of 1860 (opposite).

Emile Zola's observation is pertinent here: 'When our artists give us a Venus, they "correct" Nature, but Edouard Manet has asked himself, "Why lie, why not tell the truth?" He has made us acquainted with Olympia, a contemporary girl, the sort of girl we meet every day on the pavements, with thin shoulders wrapped in a flimsy, faded woollen shawl.' As for *la fille honnête*, representations of this social and sexual stereotype of the 'good' woman, upholder of hearth and home, abounded in nineteenth-century art. It is illuminating to compare

114

Olympia with a painting by Manet's friend Alfred Stevens called *Palm Sunday* (or *Devotion*) of *c.* 1862, exhibited in the 1863 Salon to considerable acclaim, for which – ironically – Victorine Meurend may also have acted as model.

Most critics, as we have seen, revelled in pouring scorn and ridicule on *Olympia*. Many – sometimes in the same breath – professed utter bewilderment. The image, it seems, defied so many categories, remained so unreadable in conventional terms that it became almost literally unthinkable. Only one critic, it can be argued, came anywhere close to a true – albeit intuitive – understanding of Manet's painting. This was Jean Ravenel, friend and biographer of the painter Millet, writing under the name of Alfred Sensier in *L'Epoque*:

M. Manet – Olympia. The scapegoat of the Salon, the victim of Parisian lynch law. Each passer-by takes a stone and throws it in her face. Olympia is a very crazy piece of Spanish madness, which is a thousand times better than the platitude and inertia of so many canvases on show in the Exhibition... Armed insurrection in the camp of the bourgeois: it is a glass of iced water which each visitor gets full in the face when he sees the BEAUTIFUL courtesan in full bloom. Painting of the school of Baudelaire, freely executed by a pupil of Goya; the vicious strangeness of the little faubourienne [working-class] woman of the night from Paul Niquet [this was a bar catering to needs of porters from Les Halles], from the mysteries of Paris and the nightmares of Edgar Poe. Her look has the sourness of someone prematurely aged, her face the disturbing perfume of a fleur du mal; her body fatigued, corrupted, but painted under a single transparent light...

▲ *Odalisque*
1854
Eugène Durieu
PHOTOGRAPH

nothing of the bearing, the glance, the smile or the living 'style' of one of those creatures whom the dictionary of fashion has successively classified under the coarse or playful title of 'doxies', 'kept women', 'lorettes' or 'biches'…

Among these women, some, in whom an innocent yet monstrous fatuity is only too apparent, carry in their faces and in their eyes, which fix you audaciously, the evident joy of being alive (in truth, one wonders why). Sometimes they find, without seeking them, poses both provocative and dignified, which would delight the most fastidious sculptor, if only the sculptor of today had the courage and the wit to seize hold of nobility, even in the mire…

Charles Baudelaire was indeed a crucial influence on the painter of *Olympia*. Although his essay *The Painter of Modern Life*, published in 1863, but completed in 1860, focused primarily on the minor watercolourist Constantin Guys (page 118), the ideas contained in it are equally relevant to Manet. Particularly relevant here are the following passages:

By 'modernity' I mean the ephemeral, the fugitive, the contingent, the half of art whose other half is the eternal and immutable…

If a painstaking, scrupulous, but feebly imaginative, artist has to paint a courtesan of today and takes his 'inspiration'…from a courtesan by Titian or Raphael, it is only too likely that he will produce a work which is false, ambiguous and obscure. From the study of a masterpiece of that time and type he will learn

Passages from Baudelaire's poetry reveal a distinct affinity with the vision of woman expressed in *Olympia*: in *Les Bijoux*, for example, we read: 'Her eyes fixed on me, like a tamed tigress, /With a vague, dreamy air she was trying poses, /Her candour and her lubricity /Gave new charm to each metamorphosis.'

The role of the cat in Manet's *Olympia* also gave rise to much debate. The painting was popularly referred to as the 'Venus with a Cat', and contemporary caricatures often exaggerated its importance to comic and usually lewd effect (right). Interestingly, cats feature prominently in Baudelaire's work, expressive of a dark and sometimes sin-

ister sensuality. Edgar Allan Poe's story *The Black Cat*, which Baudelaire translated in 1857, begins with an allusion to 'the ancient superstition that all black cats are sorcerers in disguise'. In 1868, moreover, Manet created an erotically suggestive lithograph entitled *The Cat's Rendezvous* to illustrate Champfleury's book *Les Chats*, an exploration of the role of cats in art, literature and folklore from ancient times to the present. Manet's replacement of the more usual curled-up lapdog (to be found not only in Titian's *Venus of Urbino* (page 102), but also in numerous nineteenth-century paintings of the female nude) – symbol not only of domesticity and fidelity, but also of indolence and luxury – with a tensed-up black cat with staring eyes and phallically upright tail, traditionally associated with promiscuity, witchcraft and dark doings, was bound to attract attention.

The Negress similarly features in Baudelaire's poetry as emblem of a dreamy, exotic sensuality; and, indeed, it was a cultural cliché in the nineteenth century (and clearly part of the colonialist's fantasy world) that black women were intrinsically more highly sexed than white ones. In addition, as we have seen, the convention of depicting black servants submissively yet provocatively offsetting the whiteness of their mistresses' bodies (page 105) was well established. When collecting material for his novel

La Fille Elisa in the 1870s, Edmond de Goncourt could even instruct himself to 'make the prostitute's friend a Negress, study the type and incorporate it into the story'. However, the exact role of the black servant in *Olympia* (for whom the model was 'Laure, a very beautiful Negress') is hard to establish. Once again, we are left with something of an unresolved riddle, in that there is no obvious correlation between the different elements in Manet's painting. To a mid-nineteenth-century public used to more explicitly narrative images, this would have been yet another source of irritation and confusion.

By the time the 1865 Salon closed, Manet had become a figure of ridicule, 'the hero of songs and caricatures'. According to the painter Jacques-Emile Blanche, he was 'followed as soon as he showed himself by rumours and wisecracks; the passers-by on the street turning to laugh at the handsome fellow, so well-dressed and correct, and him the

▲ One of the many caricatures Manet's painting spawned at the time of its first public showing

▲ *Reclining Prostitute*
1850-60
Constantin Guys
WOODCUT

man who "painted such filth"'. The artist himself was both bewildered and profoundly upset by all the fuss. In a letter to Charles Baudelaire, he wrote: 'I really would like you here, my dear Baudelaire; they are raining insults on me, I've never been led such a dance… I should have liked to have your sane verdict on my pictures, for all these cries have set me on edge, and it's clear that someone must be wrong…' The poet, it seems, was unsympathetic and apparently retorted: 'It's really stupid that you should get so worked up… Do you think you're the first man to be placed in a similar position?'

In the event, Manet reacted by leaving the country, travelling to Spain, where he encountered at first hand works by Goya, Velázquez and others which had already had such a profound impact on him. Although he never abandoned his belief that 'one must be of one's time, and paint what one sees', none of his later renderings of contemporary life – with the possible exception of *A Bar at the Folies-Bergère* of 1882 – touched the raw nerve-ends of French society in the way that *Olympia* had, nor acquired the almost iconic status and expressive power of that painting. The few nudes he produced in the 1870s, notably the *Brunette Nude* and the *Blonde Nude*, were relatively conventional half-length renderings of fashionable and pretty women. By 1883, Edouard Manet was dead, aged only fifty-one, following a slowly progressive illness and an operation to amputate a gangrenous leg (both almost certainly the result of tertiary syphilis). The official recognition he had craved for so long – a second-class medal at the Salon and the Legion of Honour – came to him in 1881, when he was too ill to enjoy it.

Like Zola, Manet seemed to have considered *Olympia* his masterpiece, and he kept it with him until his death. In 1867, on the occasion of the Exposition Universelle, he had a special hut built to house his work – including *Olympia* – on the Avenue de l'Alma. Although it originally featured among the items offered for sale by his widow in 1884, it was later withdrawn; in 1890, on the initiative of Claude Monet, it was bought from Madame Manet by public subscription for the

▲ *A Modern
Olympia*
c. 1870
Paul Cézanne
OIL ON CANVAS
45 X 55.5 CM
MUSEE D'ORSAY, PARIS

price of 19,415 francs, and offered to the French nation. The price the artist's widow originally set on the painting was 25,000 francs, worth about £25,000 in today's money. This may seem ridiculously little when one realizes that it would now (in the very unlikely event that it should ever be put up for sale) be expected to fetch anywhere between £30 million and £60 million. However, since most of the people to whom Monet turned for financial support were avant-garde artists and writers, it was no mean achievement to raise even that sum. Camille Pissarro and Auguste Renoir, for example, then virtually penniless, each contributed the equivalent of £50.

This was not the end of the story since the authorities were far from convinced that *Olympia* deserved the accolade of entering a French public collection. The painter Berthe Morisot met the director of the French National Museums in late 1889, and noted that he went berserk at the very mention of the painting, 'insisting that as long as he was there Manet would never enter the Louvre'. In early 1890 Monet wrote the following letter to the Minister of Public Instruction, a copy of which he sent to the newspaper *Le Figaro*, which published it in full. In it, he claimed (not entirely truthfully) that 'the discussions that swirled around Manet's paintings, the hostilities they

▲ *I Like
Olympia in
Black Face*
1970
Larry Rivers
MIXED MEDIA
CONSTRUCTION
102.7 X 195 X 85 CM
MUSEE NATIONALE
D'ART MODERNE,
CENTRE GEORGES
POMPIDOU, PARIS

provoked have now subsided… We have wanted to retain one of Edouard Manet's most characteristic canvases, one in which he appeared victorious in the fight, master of his vision and of his craft. It is the *Olympia* that we put back in your hands, M. Minister.'

The letter would prove decisive. *Olympia* found its first official home in the Musée du Luxembourg, founded in the early nineteenth century to show the work of contemporary artists, and in 1907, once again at the instigation of Claude Monet, was transferred to the Louvre, where – by an ironic twist – it was given a place of honour opposite Ingres's *Large Odalisque* (page 103). In 1947, it was moved to the Jeu de Paume, and thence, in 1986, to its current location, the Musée d'Orsay.

The influence of the painting has continued to reverberate through the years.

The first major artist to engage directly with it was Cézanne, who produced several variations on it (page 119) during the 1870s, which, by evoking a more erotically charged milieu, were – ironically, given the title – distinctly less innovative than the original. Gauguin produced a relatively conventional copy of the painting in 1890–1, but its influence expresses itself more freely and creatively in works produced in Tahiti, such as *Woman with Mangoes* of 1896 – again, however, considerably more conventional than Manet's painting. In 1901, Picasso produced a parodic drawing of the work, transforming the main protagonist into a 'primitive' negro idol (complete with dog and cat) and introducing two naked male figures (himself and a friend), as well as a bowl of fruit. Interestingly, the two men and the still life would resurface in early sketches for the *Demoiselles d'Avignon* (page 191), suggesting that Manet's 1863 rendering of a prostitute was indeed one of the sources for that even more famous work.

In 1950 Jean Dubuffet, although clearly rejecting the realism of Manet's painting, paid unconscious tribute to its refusal to idealize in his own *Olympia*, part of his iconoclastic, emphatically anti-classical *Corps de Dame* series. In 1965 a tongue-in-cheek performance piece entitled *Site* featured the minimalist artist Robert Morris removing a large white panel to reveal a nude model

reclining à la *Olympia* on a white sheet against a white panel. And in 1970 Larry Rivers explored the racial implications of white madam, black maid in his mixed-media construction defiantly called *I Like Olympia in Black Face* (opposite), commissioned as a part of an ensemble of works symbolizing the history and condition of the American Negro. In 1974 another American artist, Mel Ramos, produced a sleekly updated version of the painting (below), which in its blatant reference to 'girlie' magazine photographs, makes explicit the original's links with the popular erotic imagery of its day. Last but not least, feminist artist Sylvia Sleigh, in works depicting a reclining male nude, such as

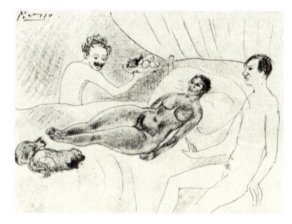

Imperial Nude: Paul Rosano of 1975, wittily forces the viewer to question the dubious conventions governing the depiction of the female nude in Western art – just, indeed, as Manet had done a century earlier. The challenges issued by *Olympia* and its ultimate refusal to surrender its multiple meanings make it more than likely that it will continue to provoke us for many years to come.

▲ *Parody of Olympia*
Pablo Picasso
1901
PEN AND INK AND
COLOURED CRAYON
15.3 X 23 CM
LEON BLOCH
COLLECTION, PARIS

◄ *Manet's Olympia*
1974
Mel Ramos
COLLOTYPE
39 X 56.5 CM
FINE ART MUSEUMS
OF SAN FRANCISCO

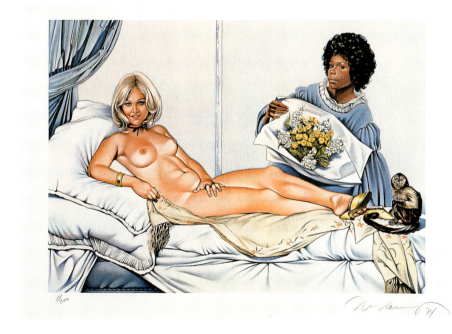

VINCENT VAN GOGH

SUNFLOWERS 1888

With its simplicity of form and energetic brushstrokes, *Sunflowers* is instantly identifiable as the work of Vincent van Gogh. The careful harmony of the composition, built up mainly in different shades of yellow and with a rich variety of surface textures, counters the popular image of the artist as madman, pouring out his emotions in paint. His desire to

produce joyous art that would appeal to everyone is richly achieved in this evocative painting – its subject matter, like Van Gogh's short and tragic life, ephemeral yet magnificent.

▶ *Sunflowers*
1888
Vincent van Gogh
OIL ON CANVAS
93 X 73 CM
NATIONAL GALLERY, LONDON

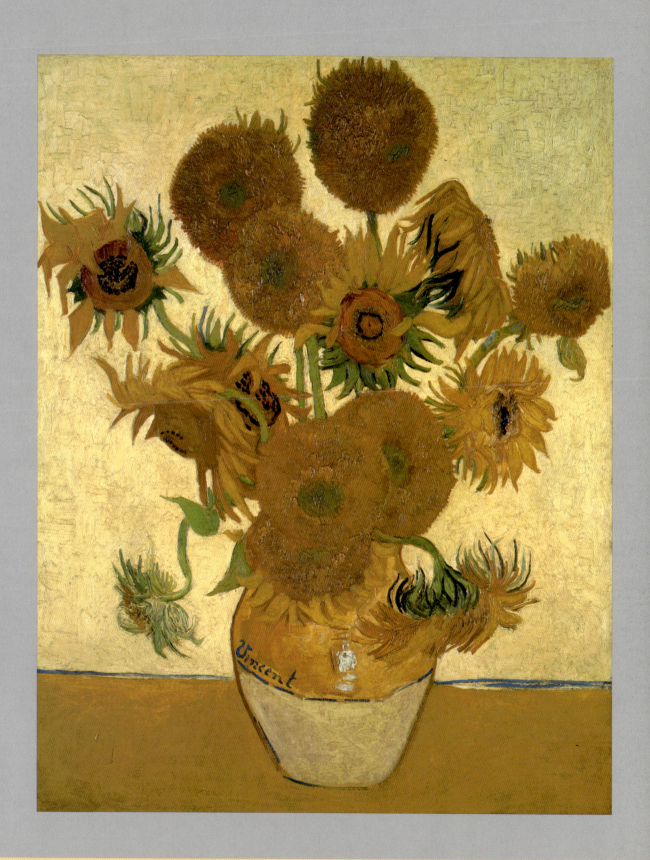

▲ Cover design for a Van Gogh exhibition catalogue 1892 Roland Holst

'The *Sunflowers*...have contributed perhaps more than any other of Vincent's paintings to make his name known throughout the world [and]...are in some cases the only works with which he is identified.' JAN HULSKER, 1980

Vincent Van Gogh received virtually no public recognition of his artistic worth during his own short, intense lifetime, but posthumous fame – contrary to popular belief – was not long in coming. That his life and his art were immediately perceived as inextricable, and the sunflower motif central to the construction of his mythic persona, is evident from the cover of a catalogue for the first large retrospective exhibition of Van Gogh's work in 1892 (above), just two years after his death by suicide. Accompanied by a setting sun, a single shrivelled sunflower droops pathetically, its long stem circled by a

halo, the anthropomorphic association with the artist reinforced by the leaf-like form of the first letter of his first name.

The romantic myth of the solitary, misunderstood, mentally unbalanced yet almost saintly artist-martyr was quick to establish itself. The voluminous and intimate correspondence between Vincent and his devoted younger brother Theo (some 650 letters have survived) proved a treasure trove for the mythologizers. The fact that when he was satisfied with his work (which was not very often), Van Gogh signed it 'Vincent' further encourages the illusion of unusual intimacy with

SUNFLOWERS VINCENT VAN GOGH

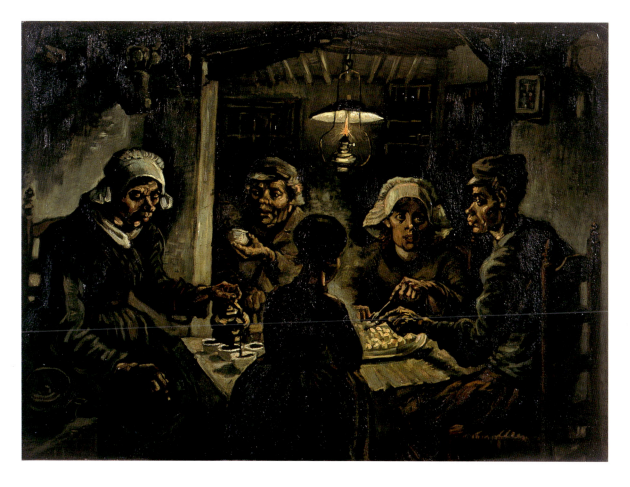

the artist. The first novel to be inspired by Van Gogh's turbulent life was written as early as 1913. The best-selling biographical novel, *Lust for Life* by Irving Stone (also author of the equally successful *The Agony and the Ecstasy*, based on the life of Michelangelo), appeared in 1934, and was turned into a film by Vincente Minnelli in the mid-1950s, with Kirk Douglas in the starring role. Other films have followed, as well as theatrical productions. The myth has been further bolstered by popular songs, such as 'L'Homme au chapeau de paille' of 1961 and 'Vincent', performed by Don McLean in the 1970s. The Van Gogh Museum in Amsterdam opened in 1973, and almost immediately became one of the best loved and most visited museums in the world. The life story and the pictures continue to reinforce each other: the life would be of little real interest had not the man who lived it been an artist of stature and integrity; but equally, without the colourful biography to underpin them, the pictures would never, one suspects, have acquired the aura they have come to

▲ *The Potato Eaters*
1885
Vincent van Gogh
OIL ON CANVAS
82 X 114 CM
RIJKSMUSEUM
VINCENT VAN GOGH,
AMSTERDAM

to transmute his religious fervour into paint. Early works produced in Nuenen, sombre in colour, awkward in execution but full of empathy for the humble peasant workers he depicts (*The Potato Eaters* of 1885, page 125, is the best known of these), show him following solidly in the nineteenth-century Dutch realist tradition as typified by the work of Jozef Israels. (Decades later, the latter's son, Isaac Israels, would pay homage to Van Gogh in his painting *Woman Standing in Front of Van Gogh's Sunflowers* (left). The version of the *Sunflowers* depicted here is the painting now in the National Gallery, London, which Theo's widow lent to Israels between 1917 and 1920, and which features in two other figure studies by this artist.) Interestingly, but not perhaps surprisingly, Van Gogh's work of this period has never been as popular or as sought-after by collectors as the work he produced in France, and in Arles in particular.

Van Gogh received little formal training until 1885–6, when he spent three months at the Academy in Antwerp, during the course of which he 'discovered' Japanese prints and the work of Rubens. The new interest in colour and painterly effects prompted by his study of Rubens was consolidated by his move to Paris, the mecca of both the art establishment and the avant-garde, in 1886. Here, a pronounced lightening of mood and palette, and a move away from social

possess. The *Sunflowers* would still be a magnificent painting, and no doubt a popular one, but it would not, I think, have acquired the status of an icon.

The pastor's son from a small town in Holland, dismissed by the Protestant Church authorities for being 'over-zealous', abandoned his earlier hopes of becoming a cleric, and in 1880, at the age of twenty-seven, made the decision

realism, reveals the influence of Impressionism, and a greater self-consciousness in the rhythmic handling of his brush, the influence of Pointillism. It was in Paris too that he first started painting self-portraits and flowerpieces.

Van Gogh's first paintings of sunflowers were produced not in the sunny south of France, but in the French capital. The very earliest of these shows a vase of mixed flowers and was painted in the autumn of 1886. Several images of sunflowers growing in the cottage gardens of Montmartre (right) were produced during the summer of 1887. In the late summer of that year, he painted four canvases depicting a small number of dried sunflowers viewed from close up, to great dramatic effect (page 128). As Ambroise Vollard relates in his *Recollections of a Picture Dealer* (published in 1918), two of these studies were modestly put on public view:

One day, as I was walking along the Boulevard de Clichy, curiosity drove me into a little restaurant whose signboard bore the device 'Au Tambourin'. Inside were to be seen a large number of tambourines on which artists had painted all sorts of subjects. And the tambourines were not all: there were canvases too, in colour schemes that might be termed startling. Someone who came in at the same

time as myself enquired of the landlady:
'Has Vincent come?'
'He's this minute gone out. He came in to hang up those Sunflowers, and went off again at once.'
And that was how I just missed meeting Van Gogh.
As may be imagined, the owner of this shop, a certain Madame Segatori, did not grow rich by her clientèle of artists. She ended by seeing the whole of her stock, her tambourines and her Van Goghs scattered

▲ *Montmartre Path with Sunflowers* 1887 Vincent van Gogh
OIL ON CANVAS
35.5 X 27 CM
MUSEUM OF FINE ARTS, SAN FRANCISCO

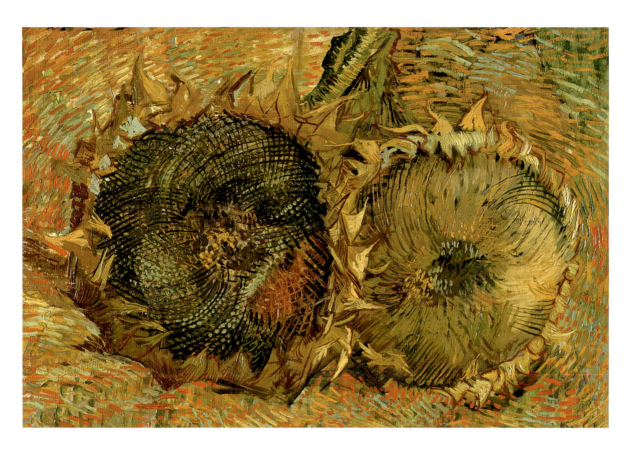

haphazard at auction – for Van Gogh's success so far was but a succès de rire.

As the preceding passage implies, bohemian Paris was not an entirely congenial environment for the socially awkward young man, who soon found himself on the verge of both physical and mental collapse. By 1888 his sights were set on moving to Provence, which, in his idealizing, perhaps naive mind's eye, acquired the near-mythic aura of a land far from the metropolitan rat race, close to nature, a kind of 'Japan in the South'. In late 1889, he would recall that he had gone to Arles 'to see a dif-

ferent light, believing that looking at nature under a brighter sky can give us a closer idea of the Japanese way of feeling and drawing'. And in a letter to Theo of September 1888, he declared: 'If we study Japanese art you see a man who is undoubtedly wise, philosophic and intelligent, who spends his time how? In studying the distance between the earth and the moon? No. In studying the policy of Bismarck? No. He studies a single blade of grass.' Van Gogh had in fact begun to collect Japanese prints in Paris. A portion of his collection has remained intact, and now belongs to the Van Gogh Museum

in Amsterdam. Decorative yet meticulously observed, works such as Utagawa Hiroshiga's *Peony and Blue and White Fly-catcher* (right) bear out his passionate conviction that Japanese artists were indeed closer to the natural world.

Van Gogh left Paris for Arles in the spring of 1888. A letter written to his sister Wil (Willemina) in September describes his new home at 2 rue Lamartine, known as the 'Yellow House' (page 130) in almost euphorically visual terms: 'painted the yellow colour of fresh butter on the outside with glaringly green shutters, it stands in the full sunlight in a square which has a green garden with plane trees, oleanders and acacias. And it is completely whitewashed inside, and the floor is made of red bricks. And over it there is the intensely blue sky. In this I can live and breathe, meditate and paint.'

Hand in hand with all this went the dream of establishing a kind of artistic confraternity, in which Paul Gauguin, whom Van Gogh had met in Paris and already revered, would play a central role. Although he never shared Van Gogh's fervour for the arrangement, Gauguin's own situation, both financial and personal, was such that in June 1888 he agreed to the move, on the condition that Theo (who worked for the Paris art dealers Boussod et Valadon) would provide him with a monthly stipend, in return for which he would

▲ *Peony and
Blue and White
Fly-catcher*
(detail)
1850s
Utagawa
Hiroshige II
PRINT
23.5 X 17.5 CM
RIJKSMUSEUM
VINCENT VAN GOGH,
AMSTERDAM

receive one painting a month. Much of Van Gogh's energies thereafter focused on creating an environment fit for his new companion. In this, the paintings of sunflowers figured prominently.

Thus, on 18 August 1888, he wrote to fellow artist Emile Bernard: 'I am thinking of decorating my studio with half a dozen pictures of "Sunflowers", a decoration in which the raw or broken chrome yellows will blaze forth on various backgrounds – blue, from the pale malachite green to royal blue.' And a few days later, he wrote to Theo:

I am hard at it, painting with the enthusiasm of a Marseillais eating bouillabaisse, which won't surprise you when you know that what I'm at is the painting of some great sunflowers.

▲ *The Yellow House*
1888
Vincent van Gogh
OIL ON CANVAS
76 X 94 CM
RIJKSMUSEUM
VINCENT VAN GOGH,
AMSTERDAM

I have three canvases in hand – 1st, three huge flowers in a green vase, with a light background, a canvas of size 15; 2nd, three flowers, one gone to seed, stripped of its petals, and another in bud against a royal blue background, canvas of size 25; 3rd, twelve flowers and buds in a yellow vase (canvas of size 30). The last is therefore light on light, and I hope it will be the best. I probably shall not stop at that. Now that I hope to live with Gauguin in a studio of our own, I want to make a decoration for the studio. Nothing but big sunflowers…

If I carry out this idea there will be a dozen panels. So the whole thing will be a symphony in blue and yellow. I am working at it every morning from sunrise, for the flowers fade so soon, and the thing is to do the whole at one go.

The first painting referred to, actually a size 20 canvas (approx. 73 x 58 cm), is now in a private collection; the second, actually a size 30 (approx. 98 x 69 cm), which ended up depicting not three but five blooms, was formerly in a Japanese collection, but was destroyed by fire during the Second World War. The third painting (right) is the one now in the Neue Pinakothek in Munich.

A few days after that, he wrote to Theo: 'I am now on the fourth picture of sunflowers. This fourth one is a bunch of 14 flowers, against a yellow background, like a still life of quinces and lemons that I did some time ago. Only it is much bigger, it gives rather a singular effect.' And the next day, referring to the same painting: 'The sunflowers are getting on, there is a new bunch of 14 flowers on a greenish-yellow ground, so it is exactly the same effect – but in a larger size, a size 30 canvas – as a still life of quinces and lemons, which you already have – but in the sunflowers the painting is much more simple.' This work (which actually depicts fifteen blooms) is the one that since 1924 has hung in the National Gallery in London (page 123). (Why Van Gogh should have got the sizes of his own canvases wrong, and, moreover, miscalculated the number of blooms represented in his own paintings, remains a mystery.) The provenance of this version – unlike some of the others – is impeccable, since it remained the property of Theo's widow, Johanna Van Gogh-Bonger, until 1924, when it was sold via the Leicester Galleries in London to the National Gallery.

A comparison between the *Sunflowers* and a still life of fruits (page 134) similar to the one mentioned by the artist above is illuminating. Both paintings, unusually in Van Gogh's *œuvre*, are virtually mono-

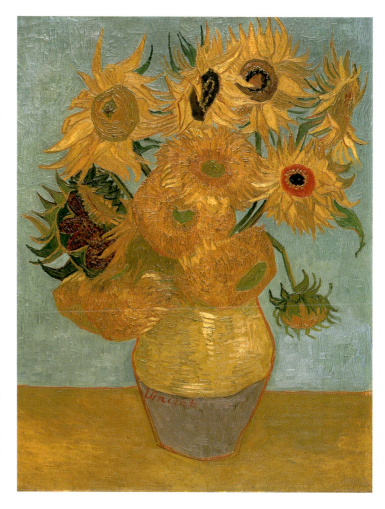

▲ *Twelve Sunflowers in a Vase*
1888
Vincent van Gogh
OIL ON CANVAS
91 X 71 CM
NEUE PINAKOTHEK, MUNICH

chromatic, exploring the rich range of possibilities inherent in the colour yellow. The surface of the 1887 still life, although more dazzling, is vibrant to the point of restlessness: there is little distinction between objects and background, no anchoring of the dynamic surface in a more stable compositional framework.

In the National Gallery work, by contrast, the thick impasto of the flowers themselves (and of their centres in

▶ *Continued on page 134*

A CLOSER LOOK

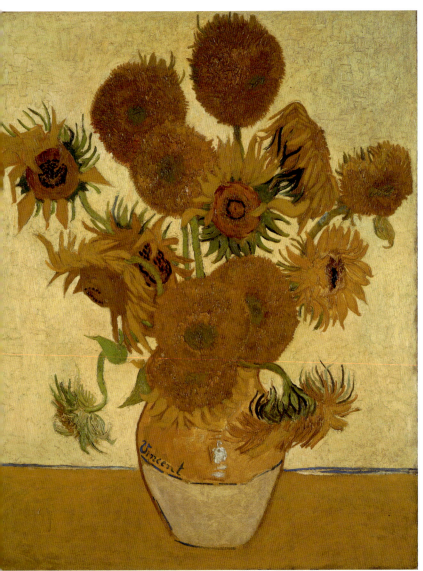
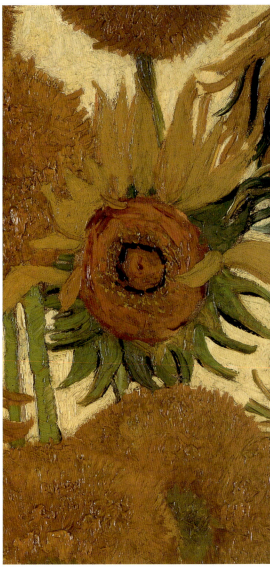

SUNFLOWERS VINCENT VAN GOGH

Through bold use of colour and vigorous, some say crude, brushstrokes, Van Gogh created a distinctive style through which he explored technical and personal preoccupations. For him, sunflowers embodied the invigorating power of the sun, but they also symbolized the transience of life.

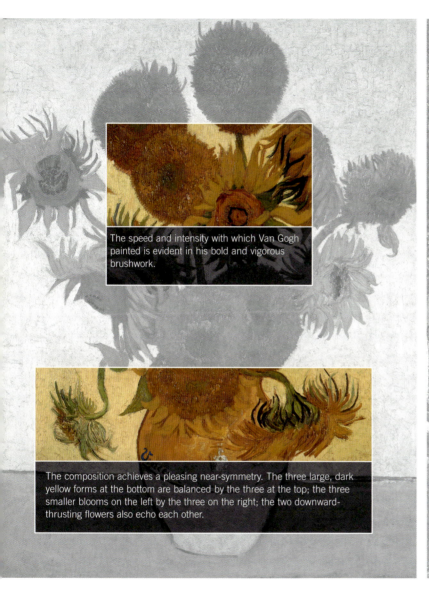

The speed and intensity with which Van Gogh painted is evident in his bold and vigorous brushwork.

The composition achieves a pleasing near-symmetry. The three large, dark yellow forms at the bottom are balanced by the three at the top; the three smaller blooms on the left by the three on the right; the two downward-thrusting flowers also echo each other.

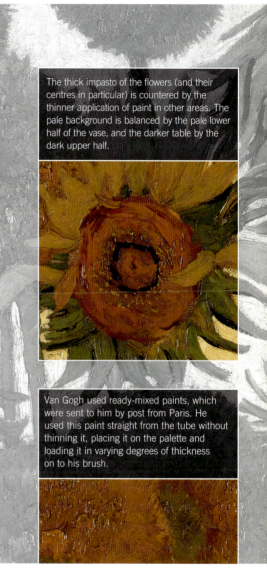

The thick impasto of the flowers (and their centres in particular) is countered by the thinner application of paint in other areas. The pale background is balanced by the pale lower half of the vase, and the darker table by the dark upper half.

Van Gogh used ready-mixed paints, which were sent to him by post from Paris. He used this paint straight from the tube without thinning it, placing it on the palette and loading it in varying degrees of thickness on to his brush.

Technical advances during the nineteenth century greatly expanded the range of colours available to artists in easily portable tubes. In fact, a range of bright, strong pigments based on the newly discovered elements chromium, cadmium, zinc and cobalt made it possible for Van Gogh to order no fewer than eighteen shades of chrome yellow from his supplier in Paris. New shapes of brushes, developed by introducing metal ferrules, probably encouraged him to experiment with different brushstrokes and textures too.

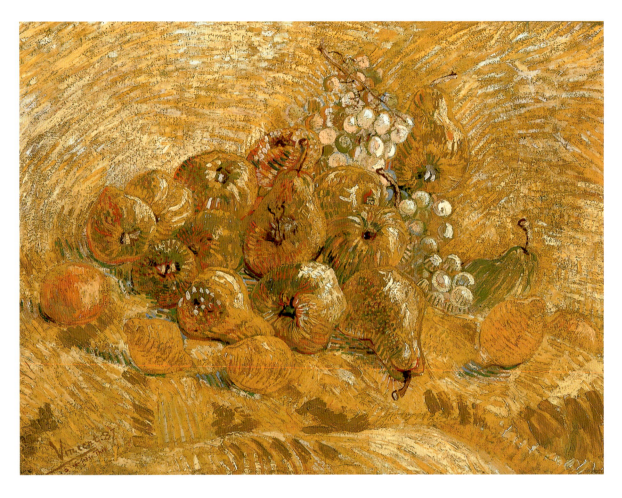

▲ Lemons,
Pears, Apples,
Grapes and an
Orange
1887
Vincent van
Gogh
OIL ON CANVAS
49 X 65 CM
RIJKSMUSEUM
VINCENT VAN GOGH,
AMSTERDAM

▶ particular) is counterbalanced by the thinner application of paint in other areas of the composition. Further stability is achieved by the way in which the pale background is balanced by the lower half of the vase, and the darker table by the upper half. As in all of Van Gogh's finest work, the emotions evoked by the subject matter (here, above all, a poignant sense of nature's beauty inseparable from its transience) are held in check by a tight formal structure. Notice, for example, the elegance and near-symmetry of the arrangement of the flowers: the way in which the three large dark yellow centres at the bottom are balanced by the three at the top; the three smaller blooms with their drooping petals on the left balanced by the three similar forms on the right; the two downward-thrusting flowers at the bottom echoing each other. In the image of the twelve flowers, the composition is distinctly clumsier, too weighted to the left-hand side of the canvas. This is almost cer-

tainly the main reason, I would suggest, why the Munich version of the *Sunflowers* has never acquired quite the same aura as the London version. Deceptively simple, the latter appears so immutable, so inevitable; decorative, easy on the eye, yet hinting at inner depths. Magisterial is the rather pompous word that comes to mind.

On 9 September 1888, Vincent once again wrote to Theo:

The room you will have then, or which will be Gauguin's if he comes, will have white walls with a decoration of great yellow sunflowers.

In the morning, when you open the window, you see the green of the gardens and the rising sun, and the road into the town.

But you will see these big pictures of bouquets of 12 or 14 sunflowers, crammed into this tiny boudoir with a pretty bed and everything else dainty. It will not be commonplace.

By the end of September, his enthusiasm was unabated; but the season for sunflowers was now over, and his supplies of paint low (unsurprisingly, given the thick impasto with which he was applying it): 'I wanted to do some more sunflowers, but they were already gone.' The dried-up blooms which had satisfied him in Paris would no longer do.

The sunflower paintings were executed with extraordinary speed and intensity.

◀ *Vase with Flowers*
c. 1875
Adolphe
Monticelli
OIL ON PANEL
51 X 39 CM
RIJKSMUSEUM
VINCENT VAN GOGH,
AMSTERDAM

That Vincent was well aware of this is made clear by a touching letter to Theo, written that summer:

I must warn you that everyone will think I work too fast. Don't you believe a word of it. Is it not emotion, the sincerity of one's feeling for nature, that draws us, and if the emotions are sometimes so strong that one works without knowing one works, when sometimes the strokes come with a sequence and a coherence like words in a speech or a letter, then one must remember that it has not always been so, and that in time to come there will again be heavy days, empty of inspiration. So one must strike while the iron is hot, and put the forged bar on one side.

The freshness and spontaneity in the handling of paint, so evident in the sunflower paintings, were in large measure

indebted to the example not only of the Impressionists whom Van Gogh had met and admired in Paris, but also of Edouard Manet. Commenting on a Manet painting of peonies, he wrote that it was 'painted in a perfectly solid impasto…that's what I call simplicity of technique. And I must tell you nowadays I am trying to find a special brushwork without stippling or anything else, nothing but the varied stroke.' In another letter he asserts: 'All the colours that the Impressionists have brought into fashion are unstable, so there is all the more reason not to be afraid to lay them on too crudely – time will tone them down only too much.' Some of the canvases he produced in Arles are far more extreme and anti-naturalistic in hue than the *Sunflowers*, but the latter clearly reveals the artist's desire to exploit the expressive and symbolic potential of colour. His much-quoted credo – 'Instead of trying to reproduce exactly what I have before my eyes, I use colour more arbitrarily, in order to express myself forcibly' – is relevant here as well, albeit in relatively muted form.

Manet's flower paintings were not the only ones for which Van Gogh expressed admiration. In early 1889 he would write: 'You know that the peony is Jeannin's [a minor nineteenth-century artist], the hollyhock belongs to Quost, but the sunflower is somewhat my own.' Although the painters named are now barely remembered, Van Gogh greatly admired them, and Ernest Quost – a painter of 'magnificent and perfect hollyhocks', trained as a decorator of Sèvres porcelain – in particular. Indeed, Vincent liked to defer to him as 'Père Quost' – even though he was only nine years his senior. Another contemporary painter of flowers whom he often singled out was Adolphe Monticelli (page 135), well known for his vivid colours and vigorous use of impasto. (Theo had in fact acquired six of his canvases.) By the nineteenth century, most images of flowers had lost the symbolic resonances that they originally possessed in seventeenth-century Holland, where the genre first established itself, and had become purely or primarily ornamental. It is tempting therefore to see Van Gogh's combination of the decorative with the symbolically charged as in some measure harking back to his cultural roots.

Van Gogh's brief two years in the south of France were undoubtedly the most fruitful and productive of his entire career. While in Arles, he executed some two hundred paintings and one hundred drawings, among them the most famous and well-loved of all his works. As his sister-in-law, Johanna Van Gogh-Bonger, put it in her memoir of the artist: 'At Arles, Vincent reaches the summit of his art… He paints *The Sower*, *The Sunflowers*, *The Starlit Night*, the sea at Ste. Marie: his creative impulse and

power are inexhaustible.' She quotes the artist's own words: 'I have a terrible lucidity at moments, when nature is so glorious in those days I am hardly conscious of myself and the picture comes to me like in a dream… Life is after all enchanting.' While in general terms numerous images celebrate the light and heat of the Mediterranean, *The Sower* (page 138) of October 1888, in which a giant golden sun frames the head of the peasant in the form of a halo, is more directly related to the *Sunflowers* in its celebration of solar energy.

Gauguin finally joined Van Gogh in Provence in late October 1888. Whatever the emotional imbalances of their relationship, it is clear that he genuinely admired Vincent's renderings of sunflowers. Indeed, he had already exchanged one of his own Martinique landscapes for two of Van Gogh's Parisian sunflower paintings. These had found a home in Gauguin's Paris studio where, according to Vollard: 'He had given place of honour to the two painters he liked best: Cézanne and Van Gogh. Three Van Goghs hung above his bed: in the middle, a landscape in a mauve tonality; to the right and left, *Sunflowers*.' In any event, Vincent wrote to Theo on 28 October: 'I do not yet know what Gauguin thinks of my decoration in general. I only know that there are already some studies he really likes, like the sower, the sunflowers and

the bedroom.' That Gauguin attached considerable importance to the motif is borne out by the fact that he chose to depict Van Gogh in the very act of painting sunflowers (page 140), even though the actual paintings had been executed well before his own arrival in Arles. Van Gogh clearly sensed the tension and intensity with which Gauguin – almost prophetically – had endowed the image: 'It is certainly I, but it's I gone mad,' he conceded, according to Gauguin's 1903 memoirs.

By mid-December 1888, the relationship between the two men was clearly on a collision course. The drama that ensued acquired distinctly larger-than-life proportions, and has indeed become the stuff of legend. On 23 December, they had, it seems, an even more heated and impassioned argument than usual, in which – as ever – personal and aesthetic issues were inextricable. The story goes that, having first threatened Gauguin with a razor, Van Gogh cut off part of his own left ear, took himself off to the local brothel and proceeded to offer the severed lobe to one of the prostitutes there. The next day, realizing that he needed urgent help, he turned himself in to the local hospital.

Gauguin left Arles on 26 December 1888, the relationship between the two men irrevocably damaged. Yet Van Gogh's almost pathetic wish to please him persisted, as evidenced by references

▲ *The Sower*
1888
Vincent van
Gogh
OIL ON CANVAS
33 X 40.5 CM
RIJKSMUSEUM
VINCENT VAN GOGH,
AMSTERDAM

in letters to Theo, such as the following, of 23 January 1889:

But if you like you can exhibit the two pictures of sunflowers. Gauguin would be glad to have one, and I should very much like to give Gauguin real pleasure. So if he wants one of the two canvases, all right, I will do one of them over again, whichever he likes… You will see that these canvases will catch the eye. It is a kind of painting that rather changes in character, and takes on a richness the longer you look at it… Gauguin likes them extraordinarily.

Van Gogh and his sunflowers clearly continued to linger in Gauguin's memory. In 1894 he produced a prose-poem commemorating that obsession, and in Tahiti in 1900 he ordered sunflower seeds from Paris, and in posthumous homage to Vincent proceeded to paint a number of still lifes from the plants that grew from these (page 141).

Opinions still vary as to the exact nature of Van Gogh's mental illness. Menières disease and acute intermittent porphyria have been cited as possibilities, although the most commonly accepted diagnosis is that he suffered from a hereditary form of epilepsy. Whatever its medical name, the 'madness' that is so integral a part of the myth surrounding this artist never prevented him from working – for all the emotional intensity of his canvases of this period – in a focused and considered way. While much is made of the dramatic fact that Theo would die mentally unhinged a mere six months after his brother, the troubled fate of Vincent's other siblings is usually overlooked. His youngest brother Cor (Cornelis) died by his own hand in 1900, aged just thirty-two, and his favourite sister, Wil, who had hopes of becoming a writer, was committed to a mental asylum at the age of forty-one. (In 1887 she sent Vincent a manuscript, in which she wrote that although many flowers bloom, 'in nature many flowers are crushed underfoot, suffer from frost or get scorched by the sun' – a poignant comment both on the fate of the Van Gogh family and on the symbolic significance of flowers.)

When he returned home from hospital on 6 January 1889, Van Gogh set himself the task of creating 'absolutely identical replicas' of the sunflower paintings made for Gauguin the previous summer. The results of this symbolic act of faith in the future are the two canvases now housed in the Van Gogh Museum in Amsterdam (the copy of the National Gallery composition) and the Museum of Art in Philadelphia (the copy of the Munich composition). In late January, he wrote to Theo: 'I have set to work again with a nerve of iron… Now to get up heat enough to melt that gold, those flower tones – it isn't everybody who can do it, it needs the sole and entire force and concentration of a single individual.'

It was at this juncture that Van Gogh began to conceive the idea of a series of secular triptychs, in which his image of *La Berceuse (The Cradle Rocker)* (page 142) – actually a portrait of Mme Roulin, the local postman's wife, in which, curiously, the handle of the cradle is all that is actually shown of it – would be flanked by images of sunflowers, in homage to passionately held ideals of light and warmth, maternity and fertility:

I picture to myself these same canvases [La Berceuse] between those of the sunflowers, which would thus form torches or candelabra beside them, the same size, and so the whole would be composed of seven or nine canvases… You must realize that if you arrange them this way, say La Berceuse in the middle and the two canvases of sunflowers to the right and left,

Van Gogh
Painting
Sunflowers
1888
Paul Gauguin
OIL ON CANVAS
73 X 92 CM
RIJKSMUSEUM
VINCENT VAN GOGH,
AMSTERDAM

it makes a sort of triptych [page 143]. And then the yellow and orange tones of the head will gain in brilliance by the proximity of the yellow wing… The frame for the central piece is the red one. And the two sunflowers which go with it are the ones framed in narrow strips.

(This mention of frames is a reminder that Van Gogh had firm views on the subject, favouring simple strips of thin pale wood, left bare or painted white or in colours that would complement, rather than match, the colours of the painting. The ornate gilded affairs that usually grace his paintings are a complete travesty of his own wishes.)

In May 1889, however, Van Gogh suffered another breakdown, and voluntarily entered the asylum at nearby St Rémy. His plans for a series of triptychs were thus thwarted, although he never entirely abandoned the idea. He resumed painting as his condition improved, but other subjects – irises, olive trees, the interior of the building, copies of works by Millet, Rembrandt and others – were to preoccupy him.

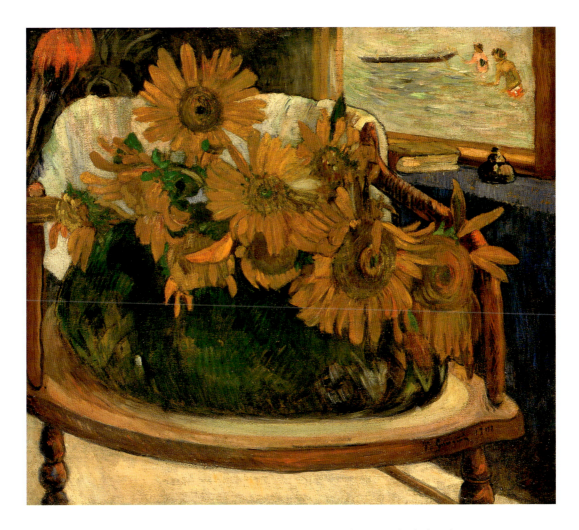

In most of the documentary sources, it is extremely difficult to ascertain which of the many versions of the *Sunflowers* are being referred to. However, a letter from Theo of 21 May 1889 does tell us something of the paintings' subsequent history: 'Some days ago I got your consignment, which is very important: there are superb things in it. Everything arrived in good condition and without any damage. The cradle, the portrait of Roulin, the little sower with the tree, the baby, the starry night, the sunflowers and the chair with the pipe and tobacco pouch are the ones I prefer so far.' On 16 July he wrote: 'In general people like the night effect and the sunflowers. I have put one of the sunflower pieces in our dining room against the mantelpiece. It has the effect of a piece of satin and gold embroidery; it is magnificent.' Around this time, Theo moved many of these works to Père Tanguy's paint

▲ *La Berceuse
(The Cradle
Rocker)*
1888–90
Vincent van
Gogh
OIL ON CANVAS
81.5 X 65.5 CM
STEDELIJK MUSEUM,
AMSTERDAM

ized by the Belgian symbolist group *Les Vingt* (The Twenty) in Brussels. He submitted six works, two of them images of sunflowers. It was this occasion that prompted the French critic Albert Aurier to write what turned out to be the only text dedicated to the artist during his lifetime, in which Aurier referred to 'the sumptuous sunflower, which he repeats tirelessly, like a monomaniac'. It was in correspondence with Aurier that Van Gogh described his sunflower paintings as possessing 'certain qualities of colour', and (rather mysteriously) as expressing an idea symbolizing 'gratitude'.

In May 1890, Vincent discharged himself from the asylum, left Provence and moved to the small northern French town of Auvers-sur-Oise, to put himself under the care of Dr Paul Gachet, amateur artist and friend of both Pissarro and Cézanne. Gachet, however, could do nothing to halt his charge's ever-mounting depression. On 27 July he shot himself in a wheatfield, and died two days later, aged only thirty-seven. The centrality for Van Gogh of flowers, the life-affirming colour yellow, and sunflowers in particular was acknowledged at the funeral. As Emile Bernard wrote to Aurier on 1 August 1890: 'On the coffin there was a plain white sheet, then masses of flowers, sunflowers which he loved so much, yellow dahlias, yellow flowers

shop, which also served as an informal exhibition space. (In 1887 Van Gogh had painted a superb portrait of Tanguy, in the pose of a Buddhist deity and surrounded by Japanese prints.) On 22 December Theo wrote to his brother: 'The sunflowers were on show at Tangui's [sic] this week, and made a very good effect, your pictures brightened Tangui's shop.'

In January 1890 Van Gogh was invited to participate in an exhibition organ-

everywhere.' And as a memorial gesture, Theo exhibited six of his brother's sunflower paintings in his own apartment.

In his memoirs, the pioneering dealer Vollard relates an amusing anecdote about an art collector who 'in the course of a serious illness fell into a sort of prostration from which nothing could rouse him'. His doctor was pessimistic and felt that 'only some unexpected event, some very strong emotion, for instance, might provoke a favourable reaction'. The man's family thus pretended that his mother-in-law, of whom the patient was very fond, had had a stroke: the patient, however, 'received the news with the utmost indifference'. In desperation, knowing him to be passionate about his picture collection, his family pretended they were about to sell his favourite painting, Van Gogh's *Sunflowers*: 'A well-known dealer, let into the secret, came to see

the Van Gogh, valued it, discussed it, took it down. As he appeared to be going off with it, the patient suddenly showed signs of violent agitation, sat part way up in bed, and fell back sobbing. "He is saved!" cried the physician.' A fine example, indeed, of the emotions aroused by the possession of a magnificent painting.

In 1983 one of the two sunflower paintings by Van Gogh still in private hands was loaned to the National Gallery by its owners, the Beatty family, and for a few years hung alongside the gallery's virtually identical (but in this case signed) rendering of the same motif. In 1987, however, the family decided to auction the work (page 145). It duly went under the hammer at the London branch of Christie's and fetched the unprecedented sum of $39.9 million. John Herbert's book *Inside Christie's* contains a vivid description of the auction:

▲ Sketch of proposed triptych, *La Berceuse Flanked by Sunflowers* 1889 Vincent van Gogh INK ON PAPER (LETTER TO THEO) RIJKSMUSEUM VINCENT VAN GOGH, AMSTERDAM

▶ *Self Portrait
with Bandaged
Ear*
Vincent van Gogh
OIL ON CANVAS
60.5 X 50 CM
COURTAULD GALLERY,
LONDON

*The atmosphere was electric when the
Sunflowers, which was on a special easel,
came up for sale. Charlie [Allsopp, chair-
man of Christie's] opened the bidding at
£5 million. There was no shortage of bid-
ders from the main saleroom, the three
closed circuit TV rooms and on the tele-
phone. The bidding went quickly up in
£500,000 steps to £20 million, at which
point the audience clapped with excite-
ment. The bidding then developed into a
nail-biting duel between James Roundell
and John Lumley, both bidding on the
telephone. Finally – after less than two
minutes, although it had seemed much
longer – Charlie knocked it down to James
Roundell for £22,500,000, which with
the premium made the price £24,750,000
($39.9 million); this was more than three
times the previous world record auction
price for a picture, for Mantegna's
Adoration of the Magi.*

*Down below in the Press Office there
was champagne for the journalists and the
staff; there was also a huge birthday cake
in honour of Van Gogh's anniversary [the
date of the sale, 30 March, was also Van
Gogh's birth date] with the Sunflowers
reproduced in icing on the top.*

Two days later the buyer was revealed to
be the Japanese corporation Yasuda Fire
and Marine Insurance.

Whether Yasuda felt a passion for the
work comparable to Vollard's collector is
more than doubtful. It may well be the
case that Japanese corporations feel a
genuine respect for the visual arts and a
strong cultural responsibility to their
employees, but it is also true that con-
siderable social *kudos* is attached to the
possession of Western works of art in
Japan; and it was clearly felt to be bene-
ficial to the company's public image that
it be associated with such a spectacular
purchase. Yasuda hung the *Sunflowers* in
the art museum it had set up in 1976 on
the forty-second floor of its Tokyo head-
quarters to house its already large collec-
tion of mainly nineteenth-century
Japanese and French works of art. A spe-
cial amphitheatre was constructed to
accommodate the new acquisition.
Between October and December 1987,
170,000 people paid for the honour of
seeing it; in 1990 as many as 400 people
a day were still paying, and the sale of
posters and postcards continued apace.

Today, the painting is displayed behind glass in Yasuda's headquarters, and the munificent company is in the process of financing a new wing for the Van Gogh Museum in Amsterdam.

Needless to say, the sale caused an absolute furore. An advertisement in the *Observer* of 5 April 1987, showing the sunflower painting dropping its leaves and bearing the caption 'If only everything in life was as reliable as a Volkswagen', made witty reference to the sale on the assumption that everyone had heard about it. But unsurprisingly, the question of the painting's authenticity was soon raised, and was acrimoniously debated. The fact that no documentation existed to account for its whereabouts between 1889 and 1901 (the date of the first major Van Gogh exhibition in France), and that it had once been owned by Emile Schuffenecker, a minor painter who is known to have produced copies of Van Gogh's work, led many scholars to claim that this was in fact one such copy. The matter is still not completely resolved, but most now agree that it is indeed an original Van Gogh. Wisely perhaps, Yasuda itself kept very quiet during all this. It has, however, at last agreed for the work to be shown alongside the London and the Amsterdam versions of the *Sunflowers* for the first time, in a major exhibition entitled 'Van Gogh and Gauguin' to be held at the Chicago Art

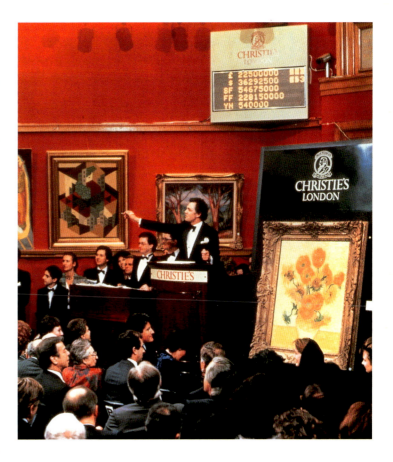

Institute and the Van Gogh Museum in Holland in late 2001/early 2002.

Although few people acknowledged it, there was a certain justice in the fact that the painting ended up in Japan, since another sunflower painting by Van Gogh (page 130), which had been acquired by a Japanese private collector around 1920, had been destroyed during the Second World War. Furthermore, as we have seen, the artist had been a passionate admirer of Japanese art and culture. However, what Van Gogh would have made of the astronomical sum fetched by his painting is another matter altogether.

▲ The auction of Van Gogh's *Sunflowers* (formerly in the Beatty Collection) at Christie's in London 1987

EDVARD MUNCH

THE SCREAM 1893

Prompted by the memory of hearing a 'loud, unending scream piercing nature', Munch's heartfelt rendering of this traumatic and personal experience was also very much a product of its own time and place. In today's fashionably apocalyptic climate it has again become acutely relevant – an icon of the modern age, expressing anxiety, fear and alienation. Even when trivialized by popular culture, this deliberately raw and elemental image retains its power to shock and unsettle.

▶ *The Scream*
1893
Edvard Munch
OIL, PASTEL AND CASEIN ON CARDBOARD
91 X 73.5 CM
NATIONAL GALLERY, OSLO

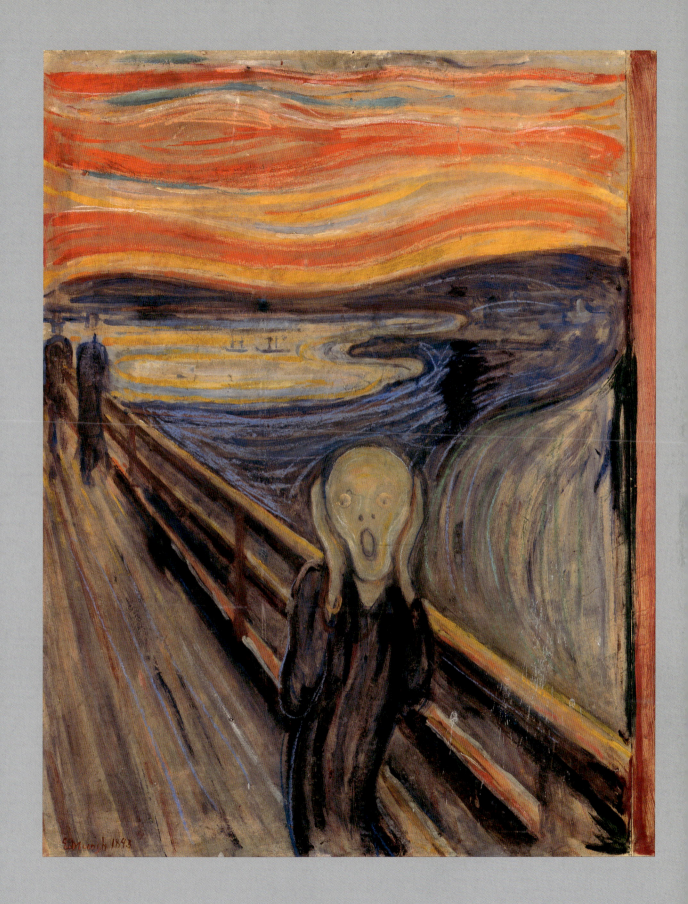

The tormented face of one man's despair and alienation, set against the social fragmentation and moral vertigo of the last fin-de-siècle, has been resurrected and pressed into service, through pop-culture pastiche and parody, as the poster-child for self-mocking millennial anxiety. MARK DERY, 1998

The text that accompanies the mass-produced 'Scream Giant Inflatable' (left) is a classic example of shameless but amusing commercial 'hype':

Did Edvard Munch predict life in the 1990s a century ago?… He must have seen it all coming when he created 'The Scream', the timeless work of art that sums up all the stress, tension, frustration, and just plain AUUGGHH!! that we all feel now and then. Now you can bring Munch's master-piece to life right in your own home or office with the unique SCREAM GIANT INFLATABLE! It's fun – THE SCREAM GIANT INFLATABLE will help you laugh instead of cry. It's educational – THE SCREAM GIANT INFLATABLE will prepare your children for the realities of adult life. It's therapeutic – THE SCREAM GIANT INFLATABLE will be the one who understands you when no one else does.

And on the packaging of a miniature version of the same product, we read: 'Are things getting out of control? Work! Kids! Love! Deadlines! Taxes! Politics! Diets! Birthdays! Mondays! Computers! Overload! When you can't make life any

▲ 'The Scream Giant Inflatable' – one of many ways in which Munch's image has been exploited commercially.

better, make it funnier(?) with Scream Jnr.' (DACS, the organization set up to protect artists' rights, was so outraged at all this that it attempted to sue the American manufacturers of the inflatable screamer with breach of copyright. The product disappeared from the shops for a while, but has now returned.)

Divorced from the landscape context that is an intrinsic part of the painting's meaning, the screamer crops up in the strangest places. Thus, the poster and publicity stills for the 1991 family comedy *Home Alone* (right), starring Macaulay Culkin, show the boy actor emulating the expression and pose of Munch's homunculus; while Wes Craven's 1995 cult horror film *Scream* and its sequels make explicit reference to Munch's image, and in turn have spawned further products, including an extremely scary Halloween mask (right). The counterpart to the familiar smiley face of popular culture, Munch's screamer has even been dubbed a Norwegian alien, in reference to the equally familiar almond-eyed alien face, half-sinister, half-cute. A chain of British pubs called 'It's a Scream' exploits the hip aura of the image in its decor; big blackboards on the walls give instructions on 'screaming for the beginner'. (Nor should one forget the appearance in recent years of a therapeutic method popularly, if inaccurately, known as primal scream therapy. In 1997, moreover,

"CHRISTMAS STARTS RIGHT HERE
WITH A CRACKER OF A
GOOD-TIME MOVIE"
Shaun Usher DAILY MAIL

WHEN THE McCALLISTERS LEFT ON THEIR HOLIDAY
THEY FORGOT ONE MINOR DETAIL...

KEVIN

FROM JOHN HUGHES
HOME ALONe
A FAMILY COMEDY WITHOUT THE FAMILY.

▲ Macaulay Culkin does his impression of *The Scream* in the 1991 film *Home Alone*

◀ A halloween mask, as used in the 1995 film *Scream*, directed by Wes Craven

a British psychiatrist concluded his study of 'white-knuckle' rides in amusement parks by recommending them – and the screaming they inevitably provoke – as an antidote to stress.) Cartoons and caricatures making reference to Munch's painting are almost commonplace. A noteworthy recent example is the T-shirt produced by the political adversaries of Dan Quayle (Republican candidate for the US presidency in 1995), the Scream cartoon adorning it suggesting that electing Quayle might indeed be cause for anguish. And in trendy shops today, one can buy a garish postcard that reproduces Munch's screaming figure against an acidic green background coyly bearing the caption 'Bad Hair Day'.

Relatively few of the people who buy the 'Scream Giant Inflatable' (or any other of the painting's contemporary by-products) are likely to be familiar with the painting that gave birth to it, while for those who share the joke, it is hard not to feel smugly superior. So ubiquitous has the image of the screamer become, so emblematic both of modern *Angst* and modern irony, that it is hard to see the original painting with fresh eyes, and even harder to appreciate how very much a product both of its maker's neuroses and of its own time it was.

On one level, the painting, executed in 1893 by Edvard Munch, grew directly out of the Norwegian artist's traumatic life history. Born in 1863, he was the second son of a military doctor who also treated the poor of Kristiania's slums (the city was renamed Oslo in 1926), a man prone to depression and obsessive religiosity. (In later years the artist recalled a moment of terror he experienced when he was thirteen years old: 'It is Christmas Eve… Suddenly I feel myself giving a silent scream of terror. Now, at any moment now, you will be standing before your maker and you will be condemned to eternal punishment.') Scary ghost stories (including one about a shrieking fisherman), in which Nordic folklore abounds, also featured prominently in Munch's childhood. His mother died of tuberculosis shortly after giving birth to his sister Inger, when Edvard was just five, and his aunt took over the running of the

▲ *The Sick Child* 1885 Edvard Munch OIL ON CANVAS 119.5 X 18.5 CM NATIONAL GALLERY, OSLO

household. In 1877, aged fifteen, his sister Sophie died of the same disease, from which his brother Andreas, who died in 1895, would also suffer. The artist himself was a sickly child, suffering not only from TB but also from chronic asthmatic bronchitis and several serious attacks of rheumatic fever. As if all this were not bad enough, his sister Laura would later be diagnosed as suffering from melancholia, and end her days in an asylum (as their grandfather had before her). Little wonder that Munch felt haunted. 'I live with the dead every day,' he wrote. 'I inherited two of mankind's most deadly enemies – the heritage of consumption and insanity… Sickness, madness and death

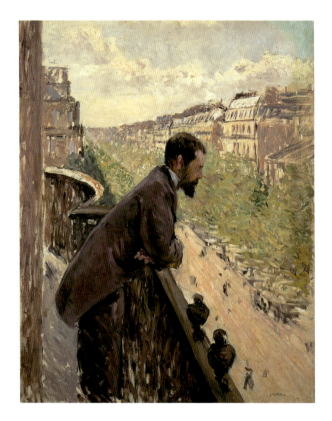

▲ *Man on a Balcony*
1880
Gustave Caillebotte
OIL ON CANVAS
116 X 90 CM
PRIVATE COLLECTION,
PARIS

living). In this, he vowed no longer to paint 'interiors, people who only read and knit… There should rather be living people breathing and feeling, suffering and loving.' In practice, as the dramatic contrast between the light-hearted, pointillist-inspired *Spring Day on Karl Johan* of 1890 (page 158) and *Evening on Karl Johan* (page 159), painted two years later, makes clear, it took him a while to put these ideas into practice. In the latter, spring sunlight has been replaced by sinister lamplight, a relaxed scene showing Kristiania's main boulevard by a tense image of anxiety and isolation, even in a crowd, whose blank, undifferentiated, almost skull-like faces in some measure anticipate that of the solitary figure in *The Scream*.

obscure German artist called Thomas Theodor Heine. Another evident influence at this juncture was the work of the French Impressionist Gustave Caillebotte, whose *Man on a Balcony* of 1880 (above), with its single male figure leaning over a balustrade and sharply raked perspective, finds an echo in Munch's impressionistically rendered painting of *Rue Lafayette* of 1891 (opposite).

Munch had decided to abandon the domestic preoccupations that dominated late nineteenth-century Norwegian art (and much French art too) as early as 1889, when he penned his so-called 'St-Cloud Manifesto' (named after the Parisian suburb in which he was then

From the early 1890s onwards, dark and difficult emotions would indeed come to dominate Munch's output. As we have seen, isolated early works such as *The Sick Child* (page 153) and *Puberty* revealed his preoccupation with pivotal moments in human life. Now, however, based in Berlin, he envisaged an ambitious cycle of paintings that would echo, complement and reinforce each other in a meaningful way, and that would in due course acquire the momentous title *The Frieze of Life*. Although we have come to view *The Scream* as a self-sufficient and unique image (which in many respects it is), it is important to realize that it was

not necessarily viewed as such by its maker. In a letter to the Danish painter Johan Rohde of March 1893, Munch wrote: 'I am working on a series of paintings at the moment… I believe [my paintings] will be more easily understood once I put them all together. The series will deal with love and death.'

The idea of dealing with these elemental themes in a sequential fashion was not in fact a new one. Indeed, many works from earlier in the century had done so, but they tended to treat the subjects of love and death in an anecdotal and moralizing fashion. (A whole tradition of piously didactic Victorian paintings comes to mind here.) The German artist Max Klinger had depicted the crucial stages of a tragic love affair in his 1887 sequence of prints entitled *A Love*, but the style he employed was essentially naturalistic. Similarly, while the emblematic, archetypal nature of Munch's imagery has its counterparts in certain works by late nineteenth-century Symbolist artists, such as Gustav Klimt and Puvis de Chavannes, no other artist of a Symbolist persuasion (with the possible exception of Paul Gauguin) had chosen to resort to such a bold simplification of forms, such strong, anti-naturalistic colours and such freedom in the handling of his materials. In many respects, Munch's radical stylistic approach anticipated the art of the German Expressionists in the very early part of the twentieth century – painters

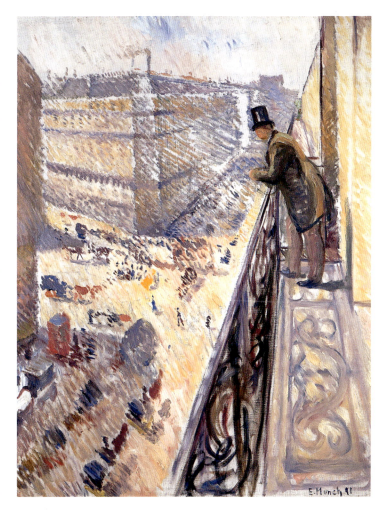

▲ *Rue Lafayette*
1891
Edvard Munch
OIL ON CANVAS
92 X 73 CM
NATIONAL GALLERY,
OSLO

and printmakers such as Ernst Ludwig Kirchner, Erich Heckel and Karl Schmidt-Rottluff – who would hail Munch as one of their heroes.

Munch visited Germany for the first time in 1892, where an exhibition of his work in Berlin caused such a furore that it closed after one week, cementing his credentials among the German avant-garde. In 1893, the year in which he painted *The Scream*, he was living in a hotel room in Berlin. Although he

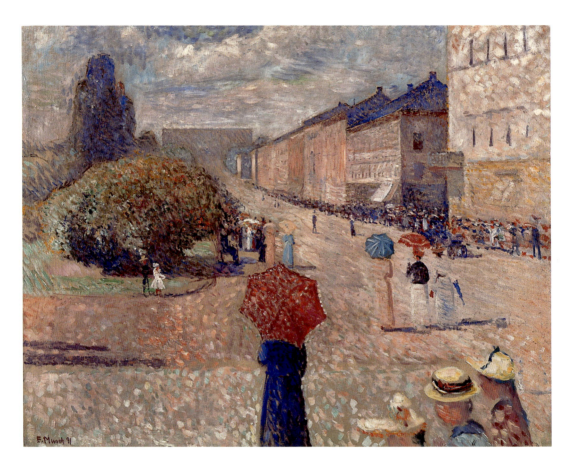

▲ *Spring Day on Karl Johan*
1890
Edvard Munch
OIL ON CANVAS
80 X 100 CM
BILLEDGALLERI,
BERGEN

usually returned to Norway each summer, he would continue to live mostly abroad until well into the 1900s, mainly in Berlin or Paris. In Berlin he consorted with members of the Black Piglet group of (mostly) expatriate writers, among them the Swedish playwright August Strindberg, the critic Julius Meier-Graefe and the Polish writer Stanislaw Przybyszewski (who would edit the first monograph on the artist), and shared their deep interest in the embryonic disciplines of psychology and neurology. (Although Sigmund Freud and Munch did not know of each other's existence, they were almost exact contemporaries and shared many of the same preoccupations.)

In his monograph, entitled *The Work of Edvard Munch: Four Contributions*, published in German in 1894, Przybyszewski declared:

The last evolutionary stage of art – Naturalism – has made us alien to psychic and mental phenomena, has made our views of deep and infinite thoughts so shallow, that it is now absolutely impossible to project ourselves into a new artistic ideal which does not even make use of the

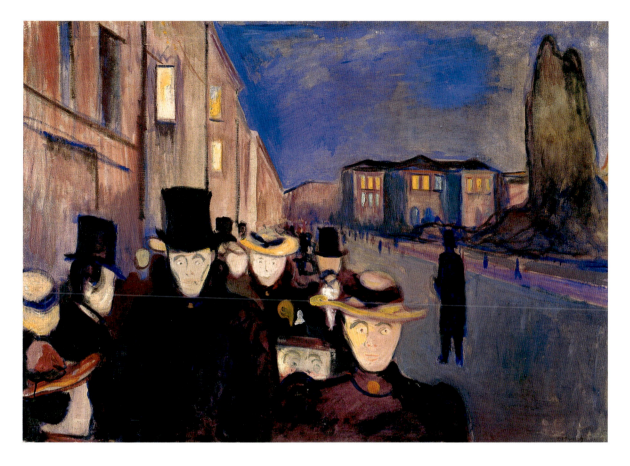

▲ *Evening on
Karl Johan*
1892
Edvard Munch
OIL ON CANVAS
84.5 X 121 CM
RASMUS MEYER
COLLECTION, BERGEN

technique of realism, which exists solely in psychic areas, in the subtlest and finest emotions of the soul.

This is what makes Munch so great and so significant, that everything which is deep and dark, all that for which language has not yet found any words, and which expresses itself solely as a dark, foreboding instinct, that all this takes on colour through him and enters our consciousness.

That Przybyszewski's own work was deeply coloured by Munch's vision of the world, and by *The Scream* in particular, is evident from the following passage from his novella *Vigils* (1895):

*Why did I have to love you?
And a mood arises within me and then reflects my own deepest, innermost feelings onto the outside world in a rainbow of powerful light…
And I see the sky dissolving into every colour, into glowing fires, into clouds constantly shifting in great haste. Yellow-green at the edges, ash-grey above the violet-purple shore of the horizon, and from the west a jagged wound on the giant brow of the sky.*

▶ *Continued on page 162*

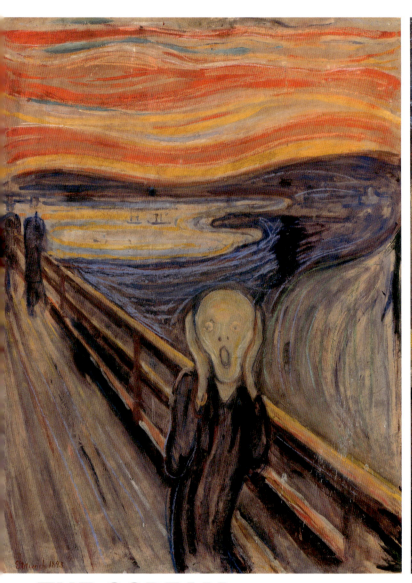

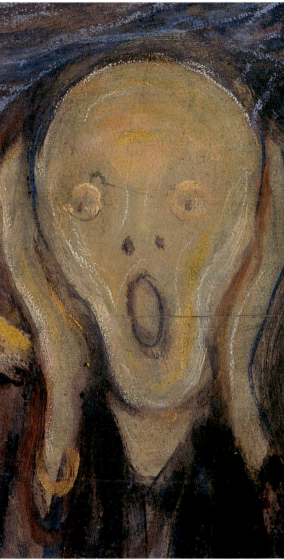

THE SCREAM EDVARD MUNCH

The Scream was conceived as part of *The Frieze of Life*, a sequence of paintings that Munch worked on during the 1890s. His interest in love, death and extreme emotions was shared by many contemporaries, including Sigmund Freud and August Strindberg, but Munch's work drew its emotional power from his own traumatic life.

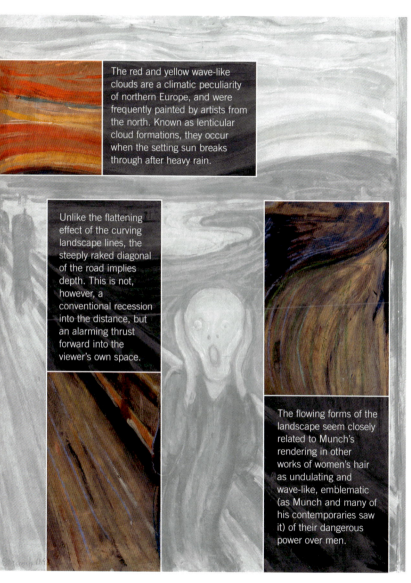

The red and yellow wave-like clouds are a climatic peculiarity of northern Europe, and were frequently painted by artists from the north. Known as lenticular cloud formations, they occur when the setting sun breaks through after heavy rain.

Unlike the flattening effect of the curving landscape lines, the steeply raked diagonal of the road implies depth. This is not, however, a conventional recession into the distance, but an alarming thrust forward into the viewer's own space.

The flowing forms of the landscape seem closely related to Munch's rendering in other works of women's hair as undulating and wave-like, emblematic (as Munch and many of his contemporaries saw it) of their dangerous power over men.

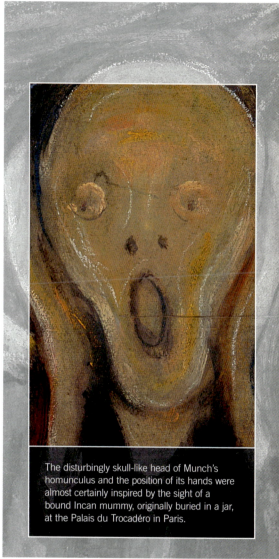

The disturbingly skull-like head of Munch's homunculus and the position of its hands were almost certainly inspired by the sight of a bound Incan mummy, originally buried in a jar, at the Palais du Trocadéro in Paris.

Munch's most famous painting is far more crude and expressionistic in style than any other work in *The Frieze of Life* series. It is also the only one not painted in oil on canvas. Munch reworked the image at various times and in different media, but on each occasion he conveyed intense feelings of anguish through swirling lines, undulating forms and spatial compression. The dramatically raked diagonal of the road accentuates the instability of the composition.

▶ Another contributor to the volume was the critic Franz Servaes, who described the universe evoked by *The Scream* as follows, clearly empathizing with the screamer:

…a madhouse, and in insane colours screaming together loudly in bloody reds and cursing yellows, the sky appears in whirling stripes like a shaken striped rug. The earth shivers, lamp posts move, people become insignificant shadows. It is I alone that exist in my endless terror. Shrivelled into a repulsive worm-like form is the remnant of my body. My staring eyes and screaming mouth are all that I feel. Staring and screaming, screaming and staring, and feeling my stomach twisting – this is the only experience remaining in the madness of despaired love.

An obvious precursor of *The Scream* is a painting Munch produced in 1892, originally exhibited as *Mood at Sunset* or *Deranged Mood at Sunset*, but now known as *Despair* (page 164), which transposes some of the compositional elements of his earlier *Rue Lafayette* (page 157) into a dramatically different context, elaborating on the bleakness of his *Allegory of Death* drawings (page 155). Gone is the debonair, top-hatted man about town observing the boulevards of Paris; in his place is a nameless, faceless male figure seen in profile, hunched and despairing as he looks over the railings, seemingly oblivious to the turbulent land- and seascape behind him. Munch continued to work on the *Despair* motif during 1892, gradually metamorphosing it into the image that would become *The Scream*. A charcoal drawing, for example, shows a reduction in the size of the two figures in the background, while a small pen and ink sketch introduces a schematic frontal view of the main protagonist.

The Scream in its definitive form was first worked out in pastel on cardboard in a study dating from *c.* 1893. Aside from the crucial fact that the figure is now unequivocally facing outwards to the viewer and has been endowed with radically simplified, cadaverous features, perhaps the most significant difference is that the visual drama is no longer confined to the colours of the sky, but is expressed by the entire composition. The final version of the motif (still called *Despair* when it was first exhibited in 1893, page 149) was also executed on cardboard, but using a mixture of oils, pastel and casein. (The last is a milk protein used as a binder to help paint adhere to the support. It tends, as here, to create a matt and somewhat brittle surface.) The reverse side of the work reveals an unfinished, schematic rendering of the basic elements of the final painting, but with a less dramatically tilted diagonal, which Munch presumably found unsatisfactory – causing him

to turn the cardboard over and start again. In this final version, the form of the central figure is twisted still further to become one with the swirling backdrop, and all traces of neo-Romantic melancholy have disappeared.

By 1900, *The Frieze of Life* was complete. It was first exhibited in a systematic sequence in 1902 at the Berlin Secession, and a year later in Leipzig (page 165). (Some of the works in this extraordinary and disturbing series had been exhibited previously, but in a less formalized way.) The paintings were hung on four separate walls, which seems to have prompted Munch to divide them into four thematic groupings, to which he gave the titles 'Love's Awakening', 'Love Blossoms and Dies', 'Fear of Life' and 'Death'. The first grouping included *The Voice* and *Moonlight*; the second, *Love and Pain* – now known as *The Vampire* – and *Madonna*. In the lithograph based on the last of the three (page 166), in which the almost blasphemous central image is framed by sperm-like forms and a skeletal embryo, the artist's association of female sexuality with death finds even more vivid embodiment than usual. The third group included *Evening on Karl Johan* (page 159) and *The Scream*, and the final one, works like *The Death Bed* and *The Dead Mother and the Child*. *The Frieze of Life* would be exhibited again, in

Copenhagen, Kristiania and, finally, in Prague. The paintings chosen for inclusion varied each time it was shown, and there appears to have been no fixed sequence. (The fact that Munch produced so many versions of some of his works makes it even harder to ascertain exactly which were exhibited.)

The critical and public reaction to *The Scream* was generally negative in the extreme. One French newspaper compared the artist's technique to dipping a finger in excrement and smearing it all over the picture surface. Many viewers felt that the evidence of insanity it provided might somehow be contagious, and was in any case dangerously subversive of the established order. Psychiatrists almost immediately took an interest in the painter who could produce such a work. As we have seen, though, there were people who felt quite differently about it. One such individual was a wealthy Norwegian collector called Olaf Schou, who purchased the original painting of *The Scream* in 1901 for 600 krona (approximately $15,000) from an Oslo gallery which was holding it, and five other works by Munch, in lieu of money owed to them by the artist. In 1909 Schou donated the work to Oslo's National Gallery, where it has hung ever since, with only rare forays abroad on the occasion of temporary exhibitions. Thus, the 1893 painting would

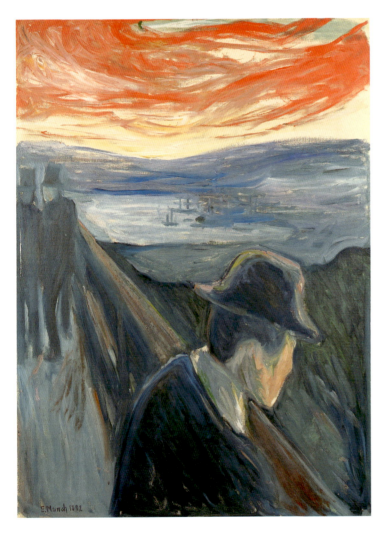

▲ *Despair
(Deranged Mood
at Sunset)*
1892
Edvard Munch
OIL ON CANVAS
92 X 67 CM
THIEL GALLERY,
STOCKHOLM

the figure in Munch's first sketch for *Despair*. This has led some experts to question its date, and to suggest that it may instead be an additional study for the 1893 painting. However, it is also quite close in conception to the lithograph of *The Scream* that Munch produced two years later (page 168).

The print – of which the artist produced numerous copies, which did much to popularize the image – was first published in December 1895 in the French avant-garde journal *La Revue Blanche*. Although all were printed in black ink, some were hand-coloured (page 169), or printed on different colour paper. (Interestingly, the print also made an early appearance in Japan, in 1912, on the back cover of a magazine featuring an article on the artist. The Japanese have long claimed to feel a particular affinity with Munch's world view.) The print is unusual in the artist's graphic output in that it does not reverse the composition of the original painting, which suggests that he considered its directional thrust from left to right too important to be sacrificed. Indeed, the descending line achieved by this was identified by late nineteenth-century theorists as expressive of an unhappy or depressive mood (while a line reading upwards from right to left was seen to evoke a more positive, happy mood). Inscribed with the work's title *Geschrei* (the German word for the Norwegian

not, presumably, have been among *The Frieze of Life* works that travelled abroad in the very early 1900s.

However, realizing its importance to him and to his *oeuvre* as a whole, Munch soon set about producing other versions of the motif. One, in pastel and oil, is signed and dated 1895, and differs from the original primarily in the way that one of the background figures leans over the railing in the manner of

Skrik – 'shriek' or 'cry', although in English, 'scream' is a closer approximation), some copies also carried the words (in German): 'I felt a great scream in nature.' Divested of the painting's extraordinary colours, the print relies for its considerable power on the linear rhythms and tensions within it. It has also been pointed out that the visual analogy found elsewhere in Munch's work (page 166) between a woman's long flowing hair and the forms of swirling water (suggestive perhaps of her

dangerous power to suck a man into her depths) is more conspicuous here than in the painted renderings of the motif.

Another version, in oil on cardboard, is in the Munch Museum (which opened in 1963 to house the huge number of works left in the artist's estate to the city of Oslo). Although sometimes dated 1893, most experts now believe that it was executed later, possibly in 1895, but more likely *c.* 1909 or even *c.* 1915-18. This was the period in which he produced

▼ *The Frieze of Life*, including *The Scream* (third from top left), as exhibited at Galerie P.H. Beyer, Leipzig, 1903

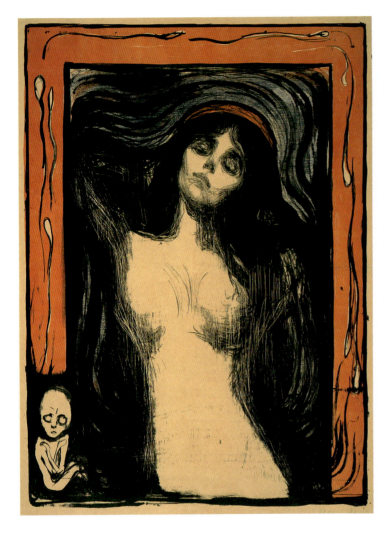

It was probably in 1891 that Munch underwent the cataclysmic experience that ultimately gave birth to *The Scream*. Although he would later produce several subtly different accounts of what happened (which in turn became a sort of dramatic prose-poem), the following diary entry, written in Nice in the south of France in January 1892, but referring to an event experienced in Norway, is the earliest:

I was walking along the road with two friends. The sun set. I felt a tinge of melancholy. Suddenly the sky became a bloody red.

I stopped, leaned against the railing, dead tired. And I looked at the flaming clouds that hung like blood and a sword over the blue-black fjord and city.

My friends walked on. I stood there, trembling with fright. And I felt a loud, unending scream piercing nature.

new versions of many of his *Frieze of Life* paintings in the far looser and less intense style – achieved through the use of very thin oil paint mixed with turpentine – characteristic of the latter part of his career. Another related work is *Angst* (or *Anxiety*) of 1894, in which the blankly staring huddle of figures familiar from *Evening on Karl Johan* (page 159) have been transposed to the apocalyptic setting alongside the fjord.

Curiously, while Munch's verbal account evokes a 'scream piercing nature' (in other versions, it is 'the great scream in [or of] nature', 'a droning scream passing through nature'), in the painting the silent scream appears to issue from the mouth of the humanoid figure in the foreground. (Synaesthesia, and in particular 'colour-hearing', that is to say, the correlation between sounds and colours, was of considerable interest not only to experimental psychologists but also to

avant-garde artists in the late nineteenth and early twentieth centuries. Thus, an extreme utterance like a scream would logically be visualized in extreme colours.) Who, or what, then, is doing the screaming? Sexless, cadaverous, the figure's curving contours echo the swirling forms of the landscape behind and around it, which flatten the picture surface and exist in dramatic tension with the steeply raked diagonal lines of the road, which in contrast imply depth – not, however, a recession into the distance, but an alarming thrust forward into the viewer's own space. The rather odd vertical strip on the right-hand side of the composition increases the spatial tensions in the work. Even today, the painting's crude urgency and utter lack of aesthetic polish come as a shock to the unsuspecting first-time viewer. In certain areas, including the face of the homunculus, the bare canvas shows through the roughly painted surface – a device common enough in more recent art (as in the work of Jackson Pollock), but in Munch's time, extremely unusual.

For all the intensely subjective mood of *The Scream* and the expressionistic liberties it takes with appearances, the lurid sky Munch describes in words and depicts in paint (and which contemporaries derided as resembling tomato ketchup and egg yolk) may well have had a meteorological basis in a bizarre natural phenomenon found only in northern Europe, known as a 'lenticular' cloud formation. In late autumn it sometimes happens that after heavy rain subsides and a cold front pushes the moisture westwards, the setting sun transforms the clouds into undulating stripes of red and yellow in the blue sky. Munch would not have been the first artist to be fascinated by this unforgettable sight: J.C.C. Dahl, a Norwegian follower of Caspar David Friedrich, was just one of many to have immortalized it in his own work (page 170)

Similarly, there are enough clues in the painting to enable us to identify the precise geographical location where his traumatic experience took place. Munch, it seems, was walking along Ljabroveien, the road running along the eastern shore of the fjord between the capital and Nordstrand (not along a bridge, as is sometimes claimed). The representation of the fjord and hills of Kristiania and of the Royal Palace, however summary, towards the top right-hand corner of the composition corresponds to the view of the city from the stretch of road on top of Ekeberg Hill – a spot favoured by nineteenth-century landscape painters for the picturesque views it afforded. For Munch, the associations of this location would have been very different: just below was an insane asylum from which, it was said, one could some-

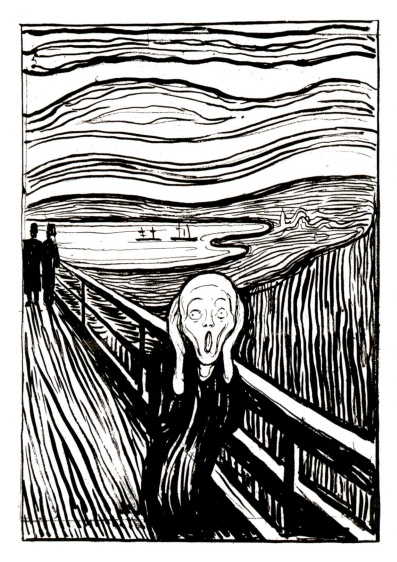

▲ *The Scream*
1895
Edvard Munch
LITHOGRAPH
35 X 25.2 CM
MUNCH MUSEUM,
OSLO

Munch, we know, harboured numerous deep-seated fears: of strangers, women, death, illness, germs – and empty spaces. In fact, it has been established that he suffered from a form of agoraphobia accompanied by panic attacks – not to mention insomnia, chest pain and extreme fluctuations in mood, all symptoms frequently associated with agoraphobia. (The alcoholism to which he frequently succumbed is also apparently consistent with these mental disorders.) On one level, Munch's written description of his experience fits well with the sensations of someone experiencing a panic attack. That the artist was well aware of his mental instability at this juncture in his life is evident both from the faint pencilled inscription at the top of the painting, 'Can only have been painted by a madman' (although doubts have since been cast on its authenticity), and a text he wrote in 1905: 'And for several years, I was almost mad – at that time the terrifying face of insanity reared up its twisted head. You know my picture *The Scream*. I was being stretched to the limit – nature was screaming in my blood – I was at breaking point.'

times hear the screams of madwomen (his own sister, Laura – suffering from melancholia, as depression was then known – had entered an asylum in 1892); close by, too, were the city's stockyards and slaughterhouses, which may also have informed the mood of the painting. Moreover, a close friend of the artist, Kalle Løchen, had recently committed suicide near this very spot.

In 1908, Munch finally did experience a total nervous breakdown, and spent half a year in a Danish clinic undergoing drastic treatment. He emerged 'cured' of most of his problems, and went on to live a far more

168

isolated existence in and near Kristiania; his later work, however, possesses almost nothing of the neurotic intensity that makes the earlier images so memorable. Ironically, for one so hounded by both mental and bodily ill health, Munch lived until the ripe old age of eighty – long enough to witness the invasion of his country by the Nazis in 1940, their branding of his art as 'degenerate' and the confiscation of a large number of his works from German collections.

While the immediate impetus for Munch's painting was undoubtedly his own highly subjective experiences, there are numerous cultural precedents for his perception of nature as hostile, anguished and vertiginous. The rendering of landscape as a state of soul had its origins firmly in the northern European Romantic tradition, of which the German artist David Caspar Friedrich, well known in Norway, was a notable exponent. In Friedrich's words, 'The painter should depict not only what he sees before him, but also what he sees inside himself,' and he exhorted his fellow painters to 'Close your physical eyes so that you see your picture first with your spiritual eye. Then bring forth what you saw inside you so that it works on others from the exterior to their spirit.' A comparison between a typically brooding, contemplative work by the German painter, such as *Two Men Watching a*

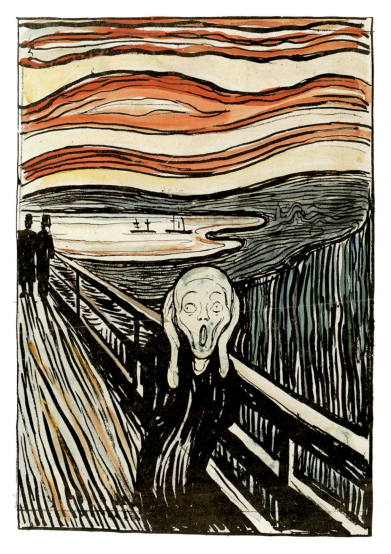

▲ *The Scream*
1895
Edvard Munch
HANDCOLOURED
LITHOGRAPH
35.4 X 25 CM
MUNCH MUSEUM,
OSLO

Sunset of 1819 (page 171) or *Man and Woman Contemplating the Moon* of *c.* 1830-5, and an early work by Munch, such as *Evening: Loneliness* of 1888 (page 172) or *Summer Night: Inger on the Shore* of 1889 (page 173), makes it clear that Munch was well aware of Friedrich's work. This quintessentially Romantic attitude to art can also be seen in the work of the German Romantic writer

Ludwig Tieck. In his novel *Franz Sternbald's Travels* (1798), Tieck's painter-hero declares: 'You cannot believe how much I wish to paint something which expresses totally the state of my soul and which would arouse the same emotions in others.' A passage from Munch's autobiographical text, *Diary of a Mad Poet*, expresses almost identical sentiments: 'In the same way as anatomy is discussed in Leonardo's drawings, here the anatomy of the soul is discussed – the mechanics of the soul…my task is the study of the soul, that is, the study of myself – myself used as an anatomical soul specimen.'

By the early 1890s, the emotions Munch was exploring in his art were far more extreme, far more focused on nature as the mirror of human emotions than on the pantheistic empathy between man and nature found both in Friedrich's and his own earlier work. Although there are few obvious visual precedents for *The Scream* beyond its generic roots in the tradition of the Sublime in early nineteenth-century landscape painting, literary precedents are easier to find. The German writer Georg Büchner, for example, in his short story 'Lenz' (1839) has the eponymous hero exclaim on the

▲ *Two Men
Watching a
Sunset*
1817
Caspar David
Friedrich
OIL ON CANVAS
51 X 66 CM
NATIONAL GALLERY,
BERLIN

evening before his attempted suicide: 'Don't you hear it? Don't you hear that terrible voice screaming across the entire horizon and which we normally call silence?' (That Munch too may have been feeling suicidal on the day he heard the scream, although never actually stated, is a distinct possibility.) Similarly, Henrik Ibsen's 1873 play *The Emperor and the Galilean* contains a description by Julian the Apostate of a vision of himself isolated on a vast, motionless ocean:

Suddenly the surface became more and more transparent, lighter and thinner. Until finally it no longer existed and my ship hung above an empty gaping abyss. There was nothing green, no sun down there – only the dead slimy black bottom of the ocean in all its repulsive nakedness.

But up above me, in all that endlessly curving vault which I had previously thought was empty – there was life. There chaos took on form and silence sounded.

There are echoes too in Munch of

certain philosophers: above all, perhaps of Friedrich Nietzsche, who declared in *Thus Spake Zarathustra* (1883–5): 'Of all that has been written, I love only that which someone writes with his own blood. Write with blood: and you will see that blood is spirit.' The state of mind so vividly embodied by *The Scream* also brings to mind a passage from *The Concept of Anxiety* (1844) by the Danish theologian and philosopher Søren Kierkegaard: 'We can compare anxiety to dizziness. He whose eyes look down into a yawning abyss becomes dizzy. But the reason for this is as much his eyes as it is the abyss itself. For we can easily suppose him not having looked down. Therefore anxiety is the dizziness resulting from freedom.' Although he acknowledged his debt to German culture, Munch was proud of his Scandinavian ancestry, and in a let-

ter to the Swedish art historian Ragnar Hoppe of 1929 would write: 'I am glad to hear you describe [my work] as exemplary of "Nordic spiritual life". People are always trying to shove me down to Germany. But we do after all have Strindberg, Ibsen, Søren Kierkegaard and Hans Jaeger up here…'

As we have seen, the concept of melding figure and background into a psychological whole has its origins in German Romantic painting. Art-historical precedents for the open-mouthed figure itself include such disparate works as Masaccio's *Adam and Eve*, Bernini's *Anima Damnata*, the screaming woman in Nicolas Poussin's *Massacre of the Innocents*, Guido Reni's Baroque rendering of the same subject, Caravaggio's *Medusa* and William Blake's *Uriel*. A more direct influence was probably an Inca mummy, buried in a jar in a foetal

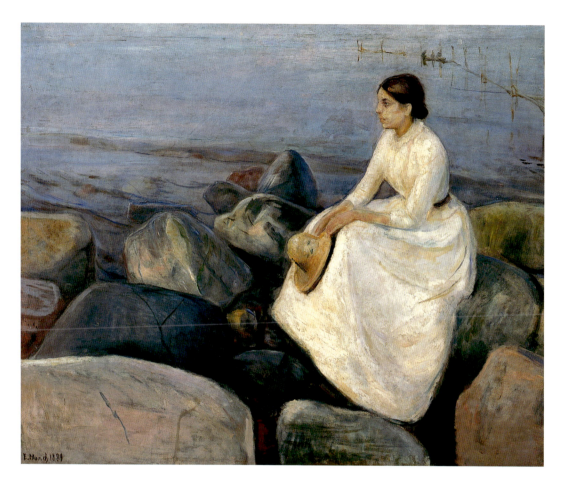

position (page 174) that Munch could well have seen in Paris at the Palais du Trocadéro (now the Musée de l'Homme), and which Gauguin too had clearly noticed (page 192). (Medieval and early Renaissance images of sinners in hell also come to mind.) It is interesting to note that northern European artists have through the centuries generally been less squeamish about depicting ugliness and suffering than their Italian, classically inspired counterparts. Generally speaking, however, extremes of raw emotion had been eschewed in Western art as somehow improper and inappropriate to the dignity of the medium. As the German writer Gotthold Ephraim Lessing explained in *Laocoön* (1766), his influential treatise on aesthetics:

He [the visual artist] had to tone down the scream into a sob, not because screaming reveals a base or unheroic soul, but because it distorts the face in a repulsive manner… Even without considering how forcibly and disgustingly the remaining portions of the face are twisted by it, the wide opening of the mouth is transformed

▲ Peruvian
mummy
c. 15th century
MUSEE DE L'HOMME,
PARIS

into a dark spot in a painting and in a sculpture turns into a deep concavity, both of which have the most repulsive effect imaginable.

Indeed, in the nineteenth century, the philosopher Artur Schopenhauer would claim, in his *Philosophy of Art*, that art's inability to reproduce a scream was precisely one of its defining limits.

Only in the twentieth century has the taboo on screaming – in art as in life – been lifted. The dramatist Antonin Artaud, for example, intent on liberating European theatre from its inhibitions, claimed that 'in Europe no one knows how to scream any more'. In the field of music, *The Scream* offered a radical challenge to the bounds of tonality. Arnold Schoenberg defined art itself as 'the cry of despair of those who experience the destiny of mankind'. And in his monodrama *Erwartung* (Expectation), the nameless woman screams for help when she discovers the body of her lover. Similarly, in Richard Strauss's *Elektra*, Clytemnestra gives two cries of haunting horror (left without notation in the score) as her son murders her. More recently, a choir of Finns, calling themselves the Screaming Men, have toured Europe with a series of performances in which they scream, howl and shout instead of singing.

Yet, although the image of *The Scream* has become one of the great negative icons of modern popular culture, its direct influence on other artists has been surprisingly slight. A few later artists have, however, taken up the challenge. Most visceral and subtle, perhaps, is the way in which the British artist Francis Bacon, during and in the wake of the Second World War, made reference to *The Scream* in some of his most profoundly disturbing works: paintings such as the right-hand panel of *Three Studies for Figures at the Base of a Crucifixion* of 1944 (page 176) or *Head VI* of 1949. Although Munch is by no means the only, or even the primary, source to which Bacon alludes in such canvases, their raw anguish cannot fail to bring the Norwegian artist to mind.

Compared with this, contemporary 'bad girl' Tracey Emin's appropriation of Munch is almost comical in its self-consciousness and self-indulgence. In his 1999 book *This Is Modern Art* (and its accompanying television series), the critic Matthew Collings recalls seeing the painting with her:

I went on a boat up a fjord recently with Emin to see The Scream in the flesh at the Munch Museum in Oslo. Was it male or female, did she think? A foetus, she thought. And it wasn't the mouth screaming, but the whole painting: the fjords, everything. It was the painting of a sound – maybe it was the first Conceptual art painting. After that she went out on the jetty near Munch's house [he omits to mention that she was naked at the time] and did some screaming herself. It was for art, so it wasn't a raw scream. It was already half-cooked. It was half-embarrassing, half-harrowing.

Norway rarely features prominently in the international news, but in 1994 it hit the headlines for two very different reasons. First, in February of that year, the tiny town of Lillehammer was playing host to the Winter Olympics. The attention of millions focused on that event, and a third of the entire Norwegian police force had been assembled there in case of trouble. At the National Gallery in Oslo, however, security was rather more lax. At 6.31 on the morning of 12 February, under the nose of a well-placed surveillance camera, two men smashed an upper window of the gallery, and in less than a minute had helped themselves to *The Scream*, Norway's most famous and prized work of art, then valued (rumour had it) at £48 million. The alarm apparently did go off, but the guard on duty assumed it was due to a fault in the system. The theft thus went undetected for almost twenty minutes, until a passing policeman happened to notice a ladder resting against the wall. To add insult to injury, the thieves left behind a postcard of a modern Norwegian painting called *The Good Story*, showing three men laughing uproariously, bearing the mocking message, 'Thanks for the poor security'.

At first, the finger of suspicion was pointed at Norway's anti-abortion lobby, which had in fact threatened to pull off a stunt during the Olympics. This later proved to be a red herring, but the lobby exploited the publicity by circulating posters bearing the emotive slogan: 'Which is of greater value, a child or a painting?' The police held fire, hoping that the real thieves would soon reveal themselves by demanding a ransom. In the meantime, the Norwegian Chief Inspector Leif Lier made contact with John Butler, head of Scotland Yard's experienced art and antiques squad, and

PABLO PICASSO

LES DEMOISELLES D'AVIGNON 1907

Few artists have exercised such a hold on the public imagination during their lifetime as Pablo Picasso, one of the most innovative and multi-faceted of twentieth-century artists. With its distorted faces and flagrant eroticism, *Les Demoiselles d'Avignon* was initially greeted with incomprehension and dislike. It has since come to be regarded as a major milestone in modern art, most importantly as the harbinger of Cubism.

▶ *Les Demoiselles d'Avignon*
1907
Pablo Picasso
OIL ON CANVAS
243.9 X 233.7 CM
MUSEUM OF MODERN ART, NEW YORK

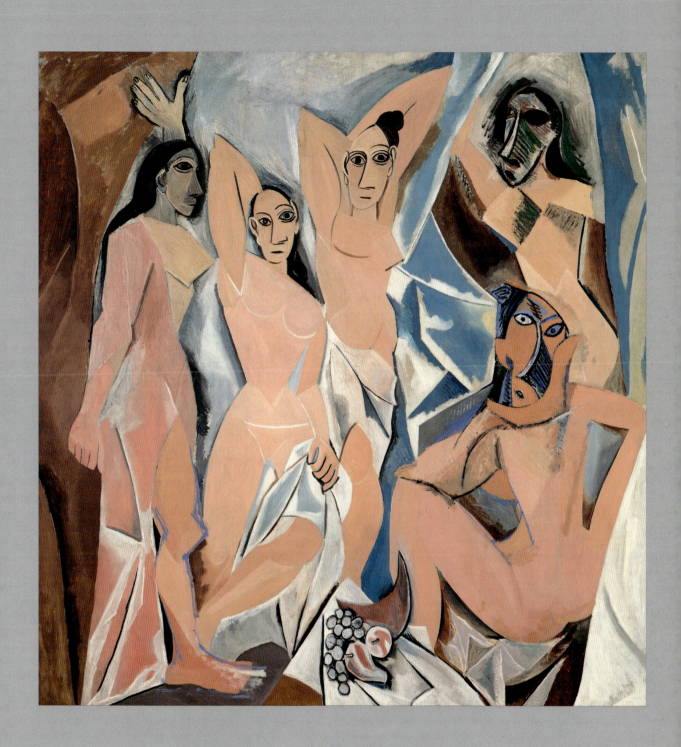

For all that the Demoiselles is deeply rooted in Picasso's past, not to speak of the Iron Age Iberians, El Greco, Gauguin and Cézanne, it is essentially a beginning: the most innovative painting since Giotto…it established a new pictorial syntax; it enabled people to perceive things with new eyes, new minds, new awareness. *Les Demoiselles d'Avignon* is the first unequivocally twentieth-century masterpiece, a principal detonator of the modern movement, the cornerstone of twentieth-century art. For Picasso it would also be a rite of passage: what he called an 'exorcism'. JOHN RICHARDSON, 1991

By the age of thirteen, Pablo Picasso was copying plaster casts of antique sculptures in the School of Fine Arts in La Coruña, Spain, with such consummate skill that his father, a minor naturalistic painter, is purported to have handed over his palette, paints and brushes to the young student, declaring that he would never paint again. Accomplished compositions such as *The First Communion* and *Science and Charity*, produced in his mid-teens, soon proved beyond doubt his mastery of academic conventions. His first exhibition, in 1901 at the Galeries Vollard in Paris, attracted significant interest; one critic described him as 'the brilliant newcomer' and continued, 'each influence is transitory… One sees that Picasso's haste has not yet given him time to forge a personal style; his personality is in this haste, this youthful impetuous spontaneity.'

Just a year or so later, Picasso had indeed forged a personal and extremely distinctive style out of disparate influences. Between 1902 and 1903, during his so-called Blue Period, poignantly angular, often virtually monochrome renderings of melancholy figures inhabiting the outer fringes of society predominate. (Less well known are the almost caricatural drawings of a sexually explicit nature that he produced during this time, which – as we will see – were to have a bearing on the *Demoiselles d'Avignon*. Another little-known work that would become relevant to that painting is the 1903 portrait of *Celestina*, an ageing, one-eyed procuress.) Hard on their heels followed his Rose Period (*c.* 1904–6), in which the mood of the paintings becomes lighter, more lyrical, less doomladen.

In the spring of 1904, the young Picasso stopped dividing his time

between Barcelona and Paris, and settled in the French capital for good. He took up residence in a ramshackle and dilapidated building at 13 rue Ravignan in Montmartre. Christened the Bateau Lavoir (Laundry Boat) by his poet friend and fellow resident Max Jacob, this would acquire almost mythical status as the place where the *Demoiselles d'Avignon* came into being, and hence the cradle of Cubism.

Some years later Daniel-Henri Kahnweiler, who would become the Cubists' principal dealer, wrote a vivid description of his own first encounter with the Bateau Lavoir in his book *My Galleries and Painters*:

[I] entered that strange structure that was later named 'the laundry boat' because it was made of wood and glass, like those boats that existed then, where housewives used to come to do their washing in the Seine. You had to speak to the concierge of the adjacent building, for the house itself had none. She told me that [Picasso] lived on the first flight down, for this house, hanging on the side of the hill of Montmartre, had its entrance on the top floor, and one walked down to the other floors…

So I walked into that room, which Picasso used as a studio. No one can ever imagine the poverty, the deplorable misery of those studios in rue Ravignan… The wallpaper hung in tatters from the

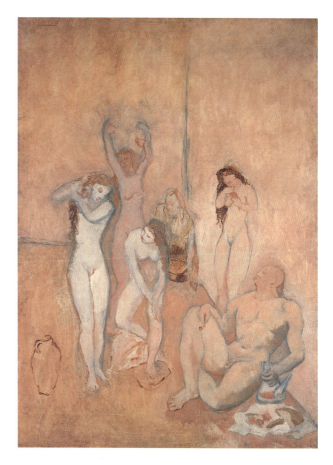

unplastered walls. There was dust on the drawings and rolled-up canvases on the caved-in couch. Beside the stove was a kind of mountain of piled-up lava, which was ashes. It was unspeakable.

In the autumn of 1904, Picasso met the languorous, auburn-haired Fernande Olivier, who would be his mistress for the next seven years. Born out of wedlock, she earned a meagre living as an artist's model, a fact that helped fuel

▲ *The Harem*
1906
Pablo Picasso
OIL AND CHARCOAL
ON CANVAS
154.3 X 109.5 CM
CLEVELAND MUSEUM
OF ART

▲ *Three Bathers*
c. 1881–2
Paul Cézanne
OIL ON CANVAS
50 X 50 CM
MUSEE DU PETIT
PALAIS, PARIS;
FORMERLY OWNED
BY HENRI MATISSE

Picasso's jealous nature; their turbulent relationship, which reached crisis point in mid-1907, would feed directly into the *Demoiselles*. The apogee of the couple's happiness seems to have come during the summer of 1906, which they spent together in Gósol, a remote village in the Spanish Pyrenees. Works such as *La Toilette*, *Woman Combing Her Hair* and *The Harem* (page 181) are a paean to Fernande's beauty and to the physical satisfactions of their relationship. (The phallic implications of the still life in *The Harem* would find an echo in the *Demoiselles*.) However, news of a nearby outbreak of typhoid, and their subsequent return to Paris, put an abrupt end to this idyll.

Nudes preoccupied Picasso through the winter of 1906–7, partly, one

speculates, in response to the implicit challenge represented by Henri Matisse's Fauve idyll *Bonheur de Vivre*, shown at the Salon des Indépendants in the spring of 1906. Ingres's *Turkish Bath* of 1862, an unashamedly erotic mass of writhing female bodies, would also almost certainly have been in his mind at this point; part of the permanent collection of the Louvre, it had featured prominently in a retrospective of that artist's work at the 1905 Salon d'Automne. Delacroix's *Women of Algiers* of 1833, also in the Louvre, provided another famous precedent for a voluptuous harem scene. Paul Cézanne's renderings of female nudes, both erotically charged early works, such as *The Temptation of St Anthony*, and later, more 'classical' bather images, such as the *Three Bathers* (above), once owned by Matisse, would also have been a natural reference point, since both in 1905 and following his death in late 1906, Cézanne's work had been much in the public eye. (Indeed, the squatting figure on the far right of the *Demoiselles* can be seen in part as a direct response to the seated nude on the far right of Cézanne's *Three Bathers*.) A further challenge would come in the form of André Derain's large *Bathers* and Matisse's *Blue Nude* (*Souvenir of Biskra*) (opposite), both exhibited at the 1907 Salon des Indépendants, where the latter in par-

ticular caused something of a furore.

Picasso rose to all these challenges with a vengeance. His close friend, the poet and art critic André Salmon, also a resident of the Bateau Lavoir, tells us that at the end of 1906, the artist 'turned his canvases to the wall and threw down his paintbrushes. For many long days and nights, he drew…[but] never was labour less rewarded with joy, and without his former youthful enthusiasm Picasso undertook a large canvas that was intended to be the first fruit of his experiments.' Such was the beginning of the *Demoiselles d'Avignon*.

Only in the later 1980s did the revelation that the newly established Musée Picasso in Paris possessed huge numbers of hitherto unseen sketchbooks fully bear out Salmon's claim for the existence of preparatory drawings. (The museum was set up in the wake of Picasso's death in 1973 at the grand old age of ninety-one, primarily to house the large number of works that still belonged to the family and which were handed over to the French State in lieu of death duties.) Some five hundred studies have come to light – a vast number by any standards, and certainly unique in the history of twentieth-century art. Most of these drawings are akin to rapid jottings, shorthand *aides-mémoire* which focus on single elements or particular aspects of the ambitious composition. Often, it seems, ideas and motifs were worried at

▲ *Blue Nude
(Souvenir of
Biskra)*
1907
Henri Matisse
OIL ON CANVAS
92.1 X 141.6 CM
BALTIMORE MUSEUM
OF ART

and ultimately discarded in favour of solutions that were worked out directly on the canvas, apparently with minimal forethought. Although the chronology of the sketchbooks is often hard to ascertain, since Picasso seems frequently to have used whatever blank piece of paper came to hand, they provide a vivid insight into his mental and visual processes and into the painting's evolution – all the more valuable since there are frustratingly few firsthand contemporary accounts of its progress. (Curiously, the Museum of Modern Art in New York, where the painting has been housed since 1939, has not to date X-rayed the entire canvas.)

The most significant fact of all, that Picasso originally planned to depict not five but seven figures, two of them male, has, on the other hand, been common knowledge for a long time. A pencil and

charcoal study in the Kunstmuseum, Basel (above), reveals Picasso's initial ideas for the composition as a whole: a man holding a book (in another sketch he is shown holding both a book and a skull, and there are several separate drawings of skulls), identified by the artist as a medical student (although, interestingly, an early sketch for this figure possesses features distinctly like his own), enters from the left, as if pulling open the curtain to reveal the inner sanctum of what the French call a *maison close* (in other words, a brothel). Meanwhile, another male figure, identifiable in other sketches by means of his striped top (and by Picasso's say-so) as a sailor, sits among the naked women, clearly the client to whom the whores are displaying their wares.

The elimination in the final painting of the two male protagonists changed the overall tenor of the work dramatically. (The watercolour now in the Philadelphia Museum of Art (opposite) is virtually the only sketch of the final ensemble that Picasso seems to have made.) Their presence had lent the project the aura of a kind of morality tale, in which the sailor represented instinct, abandon, the life of the senses and the pleasures of the flesh; while the medical student, complete with *memento mori* and evidence of intellectual pur-

suits, represented rationality, control, mortality and the life of the mind. Indeed, it has been suggested that consciously or not, Picasso was expressing not only the two polarities of existence, Eros (Love) and Thanatos (Death), but two elemental aspects of himself as well. This would to some extent have been in keeping with the symbolic thrust of much his work prior to 1907. With the removal of the male figures, the moralizing and narrative implications of the work vanish; the focus of the composition shifts to the women alone and it is the viewer (both male and female, albeit with differing results) who bears the brunt of their implacable gazes.

As suggested by the sheer number of preparatory sketches, Picasso seems to have realized from the start that he was embarking on a major and quite possibly momentous project. The fine almost linen-like canvas, moreover, was larger than any he had yet worked on, and the fact that he had it lined in advance again suggests that he was aware of the work's likely significance. (Only *The Family of Saltimbanques* of 1905 had come anywhere close to it in size.) Its unusual format – a kind of truncated vertical – may well have been suggested by a remarkable painting of similar dimensions by El Greco, now best known as *Apocalyptic Vision* (page 188), which in 1907 was probably in the Paris collection of a minor Spanish

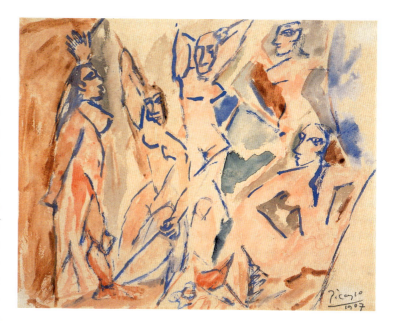

▲ *Five Nudes* (Study for *Les Demoiselles d'Avignon*) 1907
Pablo Picasso
WATERCOLOUR
17.2 X 22.2 CM
A.E. GALLATIN COLLECTION, PHILADELPHIA MUSEUM OF ART

painter and acquaintance of Picasso called Ignacio Zuloaga. This painting may have inspired Picasso in other ways too, since the exaggerated distortion of the figures and the rhythmic, almost independent energy of the drapery in this work are distinctly reminiscent of the later canvas. Both are characterized by a predominantly blue and pink colour scheme (although, in Picasso's case, this also represents an amalgam of the colours he had favoured during his Blue and Rose periods.) One cannot help wondering, too, whether the anatomically implausible hand of the demoiselle on the far left of Picasso's painting is in some measure indebted to the prominent hand in the top left-hand corner of El Greco's composition.

Picasso soon felt the need for extra space and privacy. Fernande's feminine

▶ *Continued on page 188*

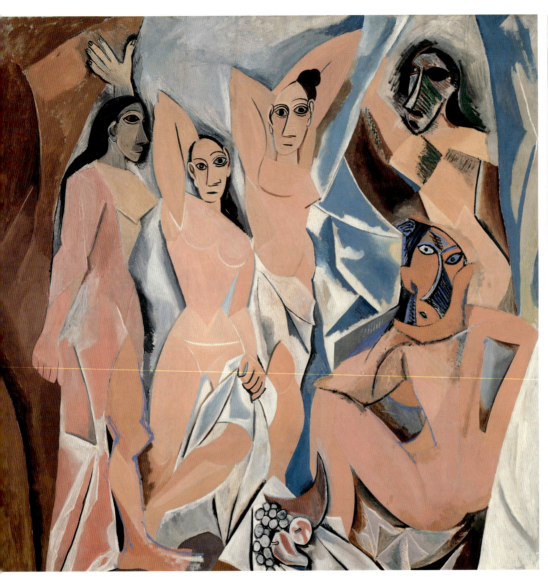

LES DEMOISELLES D'AVIGNON PICASSO

Prostitutes, regarded as subversive of the social and sexual status quo, had played a significant role in the evolution of avant-garde art and literature during the nineteenth century. Picasso's painting, however autobiographically inspired and stylistically radical, needs also to be viewed in this context.

PABLO **PICASSO**

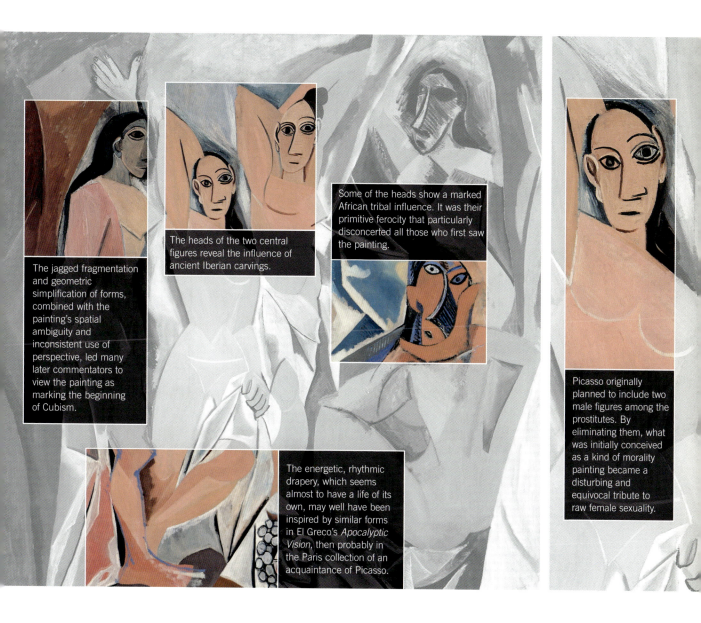

The jagged fragmentation and geometric simplification of forms, combined with the painting's spatial ambiguity and inconsistent use of perspective, led many later commentators to view the painting as marking the beginning of Cubism.

The heads of the two central figures reveal the influence of ancient Iberian carvings.

Some of the heads show a marked African tribal influence. It was their primitive ferocity that particularly disconcerted all those who first saw the painting.

The energetic, rhythmic drapery, which seems almost to have a life of its own, may well have been inspired by similar forms in El Greco's *Apocalyptic Vision*, then probably in the Paris collection of an acquaintance of Picasso.

Picasso originally planned to include two male figures among the prostitutes. By eliminating them, what was initially conceived as a kind of morality painting became a disturbing and equivocal tribute to raw female sexuality.

As evidenced by paintings produced during his teens, Picasso had considerable technical skill and was well able to work in an academically accomplished style if he so wished. In 1907, however, he turned his back on any form of naturalism to embrace a raw 'primitivism' inspired by ancient Iberian and African tribal carvings. This was part of a wider trend among avant-garde artists, but also arose from his ambivalent feelings towards the opposite sex, prompted by his troubled relationship with his current mistress, Fernande Olivier.

▶ presence in the relatively small studio was clearly becoming burdensome to the ambitious young artist; and what is more, apparently infertile, Fernande was intent on adopting a child. Her entreaties eventually prevailed upon Picasso, and in April they adopted a thirteen-year-old orphan girl called Raymonde, who lived with them for almost four months before it was clear that the arrangement was a disaster. (A sexually explicit drawing by Picasso of Raymonde washing herself suggests that her presence in the Bateau Lavoir created a disturbing if unacknowledged erotic undertow.)

Even the frequent visits of the so-called *bande à Picasso*, a small and almost incestuously close-knit group of friends, consisting primarily of the poets Guillaume Apollinaire, Max Jacob and André Salmon, were hardly conducive to concentrating on the matter in hand. In February the Steins came to the rescue by agreeing to pay the rent for a second studio in the Bateau Lavoir, a dark room on the floor below, where Picasso could work undisturbed. At around the same time, Ambroise Vollard contracted to buy the remainder of the artist's collection of early work, giving Picasso the impression of enough financial security (although Vollard did not actually pay him in full until the following December) to allow him to focus entirely on the new undertaking.

Picasso seems to have worked on the *Demoiselles* in two separate, intense phases (often working at night, and stark naked when the weather was warm), interrupted by a short break in the spring, during which he turned instead to sketching scenes of carriages in the Bois de Boulogne. While this may seem a somewhat abrupt change of subject matter, John Richardson in his authoritative and multi-volume biography of the artist (not yet completed) has astutely pointed out that an earlier artist, Constantin Guys, celebrated by the poet Charles Baudelaire as 'the painter of modern life', was known

both for his images of prostitutes (page 118) and of bourgeois Parisians at leisure. This in turn provides a direct and interesting link not only with Edouard Manet, but also with the disconcertingly unglamorous – and, even today, shocking – renderings of contemporary prostitutes by Edgar Degas, one of whose monotypes of this subject was later bought by Picasso (page 190), and Toulouse-Lautrec, in whose work Picasso had shown an early interest.

Picasso appears to have stopped working on the large canvas in late July or early August 1907. Whether or not he considered it unfinished (or even unfinishable) remains open to debate. Several early documents suggest that he did indeed regard it as unresolved. Significantly, as both the painting's and his own fame grew to larger-than-life proportions, particularly after the Second World War, the artist began to dismiss this idea as inappropriate to the painting's magisterial status. Ultimately, it could be argued, it is precisely the abrupt stylistic contrasts and discontinuities within the painting that lend it its rawness and power.

When, however, Picasso first emerged from his self-imposed isolation to show his intimate friends the fruits of his labours, he was met for the most part with bafflement and embarrassed silence. Surprisingly, Fernande Olivier's memoirs have virtually nothing to say about the *Demoiselles*. Rancour at being cast into the role of whore (both inside and outside the painting), and at being demoted (as Françoise Gilot, a later mistress of Picasso, would memorably put it) from plinth to doormat, may well have been a major reason. A cryptic entry in Apollinaire's diary for 27 February 1907 reads: 'Evening, dinner with Picasso, saw his new painting… Wonderful language that no literature can express, for our words are already made. Alas.' Only later, with the benefit of hindsight, would Apollinaire more effusively describe the painting as a masterpiece that would 'free art from its shackles' and 'extend its frontiers', and Salmon hail it as 'the incandescent crater from which emerged the fire of present art'. Enthusiastic collectors of Picasso's earlier work, Gertrude and Leo Stein too were clearly nonplussed by the new painting. In later years, Leo Stein, less tactful, did not hesitate to call the painting a 'horrible mess'. Even Gertrude, more sympathetic than her brother to avant-garde experimentation, recalled in her *Autobiography of Alice B. Toklas*, published in 1933, that 'Against the wall was an enormous picture, a strange picture of light and dark colours, that is all I can say, of a group, an enormous group…all of it rather frightening'; only in her 1938 monograph on Picasso did she describe the work as 'a veritable cataclysm'.

▶ *Au Salon*
1879
Edgar Degas
MONOTYPE
MUSEE PICASSO, PARIS

Others, less close to the artist, clearly thought he had gone quite mad. Kahnweiler reported that 'The picture he had painted seemed to everyone something mad or monstrous. Braque, who had met Picasso through Apollinaire, had declared that it made him feel as if someone were drinking gasoline and spitting fire, and Derain told me that one day Picasso would be found hanging behind his big picture, so desperate did this enterprise appear.' Kahnweiler continued, 'I only remember that I must have told him immediately that I found his work admirable, for I was overwhelmed.' (However, this account, published in 1961, contradicts a similar text first published in 1920, in which Kahnweiler admits that he was unsure what to make of the painting.)

What exactly was it that even Picasso's closest associates found so difficult to come to terms with? André Salmon wrote that 'nudes appeared whose distortions – for which we were prepared by Picasso himself, by Matisse [page 183], Derain, Braque, van Dongen, and before them by Cézanne [page 182] and Gauguin [page 192]– are hardly surprising. It was the hideousness of the faces that horrified the half-converted.' And, indeed, as already mentioned, there was a plethora of work by avant-garde artists depicting naked women with varying degrees of simplification and distortion that, in their challenging references to a hallowed tradition of Western painting and their adoption of so-called 'primitive' stylistic devices, paved the way for Picasso's *Demoiselles*.

Paul Gauguin had been a pioneer in this respect. His interest in non-Western art not only embraced a variety of cultures but extended beyond the purely visual to his physical uprooting and adoption of a 'primitive' lifestyle in the South Seas. Unsurprisingly, there are at least two references in Picasso's painting to works by Gauguin: the profile head with frontal eye on the far left of the *Demoiselles* bears a strong resemblance to a similar head on the far left of Gauguin's *Spirit of the Dead Watching* of 1892. Both, of course, were inspired in turn by the example of ancient Egyptian art. In addition, the figure second from the left in the *Demoiselles* contains a reference not only to Michelangelo's *Dying Slave* in the Louvre, but also to a small terracotta sculpture by Gauguin entitled *Oviri* of *c.*1891–3. (Although early sketches reveal that it was originally envisaged as a seated figure, if turned on its side, the figure may well also allude to a whole tradition of female reclining nudes, which includes Manet's *Olympia*, of which Picasso had once made a parodic copy (page 121).)

In fact, the widespread tendency of artists in late nineteenth- and early twentieth-century Europe to turn to non-western artistic sources for inspiration has its origins in the early 1800s, with the emergence of groups of artists, such as the German Nazarenes, who consciously sought to emulate both the style and the way of life of late medieval and early Renaissance artists, whose 'primitivism' represented a superior alternative to the facile naturalism, materialism and moral decadence of modern civilization. (The English Pre-Raphaelite group, formed in 1848, shared similar sentiments.) For a long time, little distinction was made by Western artists and cultural commentators between the various types of so-called 'primitive' art: thus, Egyptian, Cambodian, African and Oceanic art were all subsumed under a single, distorting and ideologically suspect category. Most people were not interested in factual accuracy: details of context or chronology were considered unimportant so that, for instance, it was popularly – and erroneously – assumed, even in the early twentieth century, that most African carvings were at least as old as ancient Egyptian art. (Wilhelm Uhde, the German writer and art historian, described the *Demoiselles* to Kahnweiler as 'a picture…that looked Assyrian, something utterly strange'; and, following a visit to Picasso's studio, the English artist Augustus John recalled seeing 'an immense canvas bearing a number of figures based, it would seem, on a recent acquaintance with the monstrous images of Easter Island'.)

Picasso's first brush with 'primitive' art came in the form of carvings, produced

during the Iron Age on the Iberian peninsula, which the artist may well have first seen in Spain, but definitely saw in 1906 at an exhibition at the Louvre featuring newly excavated works from Osuna. The mask-like nature of the head in *Woman Combing Her Hair*, which was completed in Paris that autumn, and the increasing stylization and monumental sculptural qualities of the *Two Nudes* (opposite) painted at the close of 1906, testify to Picasso's interest in Iberian sculpture at this time. In general, however, ancient Iberian art was little known or appreciated at this juncture; indeed, of the Parisian avant-garde,

Picasso was the only one to have made use of it. The fact too that it represented his native country's only real contribution to ancient civilization would have added to its appeal.

As related on pages 57–8, in March 1907 Picasso acquired two small Iberian heads from a dubious individual called Géry Pieret, who had coolly removed them from the Louvre, where (symptomatically) they had been inaccurately identified and exhibited as Phoenician antiquities. Whatever the exact rights and wrongs of the incident, it is likely that Picasso would have justified his acceptance of the works in his own mind by arguing that it was the French archaeologists who were the real thieves, and that the Louvre was, in effect, a receiver of stolen goods. In any case, surely, he, as a Spaniard and an artist, had a far stronger claim to them than a French museum which took so little heed of them that nobody even noticed their disappearance?

In any event, the stylistic influence of these Iberian heads (page 194), which with their wide, simplified features, staring eyes and large, scroll-like ears were even more 'primitive' than the reliefs from Osuna that he had encountered earlier, on the two central figures of the *Demoiselles d'Avignon* (and in an earlier state of the painting, the other figures as well), is indisputable. For all these two figures' haunting, even disquieting qual-

ities, however, they do not range that far from the canon of Western female beauty. (Indeed, the pose and expression of the nude with the two raised arms may well contain a reference to Goya's famous *Nude Maja,* page 104.) If, as Salmon said, it was 'the hideousness of the faces that horrified the half-converted', it was almost certainly not these faces, but those flanking them (and above all, the two on the far right of the composition) to which he was referring – and in particular, one speculates, that of the lewdly squatting female, whose swivelled head brutally defies anatomical possibility. These heads, repainted in the summer of 1907, truly were without precedent in Western art.

Picasso's own pronouncements on the subject of African art (as on many other topics) were notoriously unreliable and inconsistent. In 1920, for example, he would memorably exclaim: 'African art? Never heard of it!' – a denial that only makes sense if one realizes the artist's impatience with what had become a superficial fashion, and the fact that in his own art he had returned to a form of neo-classicism. Interestingly, it was in 1939, at the time of the Spanish Civil War, that the left-wing Picasso chose publicly to deny all African influence on the *Demoiselles,* and to emphasize instead the importance to it of Iberian art. It is even possible that his downplaying at that period of El Greco's

▲ *Two Nudes*
1906
Pablo Picasso
OIL ON CANVAS
151.3 X 93 CM
MUSEUM OF MODERN
ART, NEW YORK

influence was related to the fact that General Franco had elevated the latter to cult status, and that the barbaric behaviour of Franco's African troops during the Civil War made Picasso reluctant to admit to African-inspired elements in his work.

In spite of the artist's protestations to the contrary, however, it is now quite clear that Picasso must have 'discovered'

been proved that those masks which bear the most striking resemblance to the fearsome heads of the three demoiselles – masks from the Etoumbi region of the then-French Congo (page 194), Dan masks from the Ivory Coast or Liberia, the Kifwebe masks of the Songye people and the Mbuya (sickness) masks of the Pende people of Zaire (page 194) – were almost certainly unknown to Picasso in 1907, since examples of their kind had not yet been imported into France. An additional consideration, often overlooked, is the nature of the changes that necessarily take place whenever three-dimensional objects are transposed to a two-dimensional surface. Similarly, while

it is clear that the dramatic colouring of certain Oceanic artefacts must have exerted an influence on Picasso at this juncture, it is almost impossible to pinpoint exactly which objects he must have been looking at.

Perhaps, in the end, we should accept the artist's word for it that African carvings were for him 'more witnesses than models'; that the influence of non-Western art was more generic than specific, more a question of perceived psychological affinities than of formal borrowings. In recent years, some academics have sought – with great earnestness, but not very convincingly – to read deeper significance into Picasso's use of African references in his work. Patricia Leighten, for example, has claimed that, on the one hand, he shared the avant-garde's admiration for Africa as the embodiment of dark, primeval energy, even savagery, and on the other, shared the abhorrence of many of his left-wing and anarchist friends for the horrors perpetrated by the French and Belgian colonial powers on native populations under their control. The latter may well be true; but this does not automatically transform the *Demoiselles* into an anti-colonialist manifesto. Leighten is also one of several scholars who have attempted to link issues of race with those of gender in their analyses of the painting. However ideologically well-intentioned, her

description of the painting in terms of 'the overlay of African masks – evocative of economic exploitation and forced labour – on white, female "slaves"', or Anna C. Chave's claim that 'a fear of loss of male hegemony together with a fear of the loss of hegemony of the West are at issue in *Les Demoiselles*', are surely rather far-fetched.

In the 1950s and '60s commentary on the *Demoiselles* focused almost exclusively on its role as the origin of Cubist formal experiments. Again and again, one hears how the inconsistent, multiple-viewpoint perspective, the fragmented, geometric forms and spatial ambiguity of the 1907 painting made Cubism possible. An article written by John Golding in 1958 was a voice in the wilderness: 'The *Demoiselles d'Avignon* is not, as has been so often said, the first Cubist painting. None of the fundamental qualities of Cubism are found in it. Detachment and intellectual control, objectivity combined with intimacy, an interest in establishing a balance between representation and an abstract pictorial structure – all these features are noticeably absent in the *Demoiselles*.' A comparison of the latter with a typical Analytical Cubist work, such as *Girl with a Mandolin (Fanny Tellier)* of 1910 (page 199), bears out the truth of Golding's statement. What is peculiar and noteworthy is that the differences between them should not have pro-

▲ *Large Nude*
1907–8
Georges Braque
OIL ON CANVAS
141.6 X 101.6 CM
GALERIE ALEX MAGUY,
PARIS

voked comment earlier. So tight, it seems, was the grip of a formalist approach to art history, in which style took precedence over subject matter, that the obvious was overlooked.

The first text unequivocally to draw attention away from formal matters back to iconography was a 1972 article entitled 'The Philosophical Brothel' by Leo Steinberg. (The title is one that Salmon once coined for the painting, probably inspired by the Marquis de Sade's notorious text *Philosophy in the Bedchamber*.) A cultural climate in

which feminism was on the rise and matters of sexuality and gender newly deemed of great significance undoubtedly paved the way for a widespread acceptance of such an approach. Certainly, analyses of the *Demoiselles d'Avignon* in terms of its subject matter (both conscious and unconscious) are now commonplace. Steinberg (rightly, I believe) claimed that 'so far from suppressing the subject, the mode of organization heightens its flagrant eroticism':

In this one work Picasso discovered that the demands of discontinuity could be met on multiple levels: by cleaving depicted flesh; by elision of limbs and abbreviation; by slashing the web of connecting space; by abrupt changes of vantage; and by a sudden stylistic shift at the climax. Finally, the insistent staccato of the presentation was found to intensify the picture's address and symbolic charge: the beholder, instead of observing a roomful of lazing whores, is targeted from all sides.

In this last sentence Steinberg is perhaps guilty of assuming that the 'beholder' is a heterosexual male who responds to the 'flagrant eroticism' of the work much as Steinberg himself does.

William Rubin has to some extent redressed the balance by suggesting that Steinberg stressed Eros at the expense of Thanatos, claiming that a deep-seated fear of women and their sexuality co-exists in the *Demoiselles* with a celebratory, life-affirming eroticism. He goes further, maintaining that a deep dread of sexually transmitted disease underlies the painting: in confirmation of this, he cites both the likelihood that Picasso had earlier contracted some form of venereal disease and the artist's encounter with the physical ravages wrought on the face by syphilis when he paid visits to the hospital of Santa Creu i de Sant Pau in Barcelona and the prison-hospital of Saint-Lazare in Paris, ostensibly to find models among the prostitutes there. Richardson confirms that Picasso did indeed contract a form of venereal disease in Barcelona in 1902, and may already have been infected the previous winter, and was using his search for models as a kind of cover-up. Rubin has even cited ghastly photographs of individuals suffering from syphilis as a possible source for the facial distortions in the *Demoiselles*. Whatever the exact truth of the matter, Picasso's dread of illness and disease is well documented, and lends weight to Rubin's hypothesis. The fact, moreover, that the Pende masks (page 194), to which the head of the crouching demoiselle bears such a striking (albeit fortuitous) resemblance, actually represented persons suffering from advanced stages of syphilis and other disfiguring diseases, may well be more than coincidental.

Carol Duncan, in a thought-provoking article of 1989 focusing on the

Museum of Modern Art in New York, has pointed out what ought to be obvious to any member of the gallery-going public: namely the extraordinary predominance in the history of modern art of female nudes. Why, she asks, 'has art history not accounted for this intense preoccupation with socially and sexually available female bodies? What if anything, do nudes and whores have to do with modern art's heroic renunciation of representation? And why is this imagery accorded such prestige and authority within art history – why is it associated with the highest artistic ambition?' Her answer to these questions will not please everybody: 'recurrent images of sexualized female bodies actively masculinize the museum as social environment. Silently and surreptitiously, they specify the museum's ritual of spiritual quest as a male quest, just as they mark the larger project of modern art as primarily a male endeavour.' The argument holds true not only for the *Demoiselles d'Avignon*, but equally for Manet's *Olympia* (page 97), and for American Abstract Expressionist artist Willem de Kooning's celebrated images of women from the 1950s and '60s, such as *The Visit* (page 200), where the splayed-out pose of the figure pays a direct homage to the right-hand whore in the *Demoiselles*. It also holds true for numerous other works by Picasso himself, chiefly from the mid-

▲ *Girl with Mandolin (Fanny Tellier)* 1910
Pablo Picasso
OIL ON CANVAS
100.3 X 73.6 CM
MUSEUM OF MODERN ART, NEW YORK

1920s onwards, in which, provoked by his amorous entanglements of the moment, his intensely ambivalent feelings about the opposite sex once again come to the fore. A major work such as the *Three Dancers* of 1925 (page 201) is a case in point.

Whatever else it is, Picasso's painting is unequivocally a brothel scene, and it hardly needs pointing out that it is in brothels that sexually transmitted diseases are most readily contracted. The choice of title was by no means Picasso's own: '*Les Demoiselles d'Avignon* – how that

▲ *The Visit*
1966–7
Willem de
Kooning
OIL ON CANVAS
150 X 120 CM
TATE, LONDON

more forthright (and implicitly risqué) allusion to girls rather than damsels.

When, in later years, he was asked if the painting was indeed named after the brothel on the Carrer d'Avinyó (Avignon Street) close to his parents' home in Barcelona (as he himself had apparently told Christian Zervos in the late 1930s), Picasso retorted: 'Would I be so pathetic as to seek inspiration…in a reality as literal…as a specific brothel in a specific city on a specific street?'

The worst thing is that when I am asked about this and say that it's not true, people go on maintaining that [the demoiselles] are girls from a brothel on the Carrer d'Avinyó. In fact, as everybody once knew, this story was invented by Max Jacob or André Salmon or some other friend in our group – it doesn't matter who – and it was a reference to a grandmother of Max who was from Avignon, where his mother also lived for a time… We said in jest that she owned a maison de passe [brothel] there. This was an invented story like so many others.

On another occasion, Picasso told Kahnweiler:

Avignon has always been for me a very familiar name, connected to my life. I was living around the corner from Avignon Street. It is there that I bought my paper, my watercolour supplies. And, as you

name annoys me,' the artist once told Kahnweiler. 'It was Salmon who invented it. As you well know, it was originally called *Le Bordel d'Avignon*.' (The fact that Apollinaire, another close friend, was busy writing aggressively pornographic texts, among them *Les Onze Mille Vierges*, in 1907, cannot be irrelevant.) When the painting was exhibited in public for the first time in 1916, Picasso was apparently furious with Salmon for foisting the *Demoiselles* title on to the painting, viewing it as a hypocritical capitulation to the prudishness of the public. He was, it seems, a little happier with the Spanish title *Las Chicas de Avignon*, and its French equivalent *Les Filles d'Avignon*, with its

*know, Max's [Max Jacob's] grandmother
was from Avignon. We joked about the
painting. One of the women was Max's
grandmother. One was Fernande, anoth-
er was Marie Laurencin [a painter and
Apollinaire's lover], all of them in a broth-
el in Avignon.*

Kahnweiler, in a letter of 1939, added
that Max Jacob had 'told Picasso that a
certain brothel at Avignon was a most
splendid place, with women, curtains,
flowers, fruits. So Picasso and his
friends spoke about the picture as being
"this place of carnal pleasure".' In fact,
Avignon, ever since the papacy was
exiled there in the fourteenth century,
enjoyed something of a reputation for
sexual immorality; that city was, more-
over, the familial home of the de Sades.
An amusing conflation of fact and fic-
tion can be found in an article entitled
'The Girls of Avignon' in a Swedish
newspaper of 1938:

*But let me not forget one of the main rea-
sons why I came to Avignon… Are the
young women of Avignon really as fright-
ful as the celebrated artist depicted them to
be? Do they really have such piggish snouts
and feet plagued with elephantiasis? If so,
it must be in the old neighbourhoods right
next to the Palace of the Popes. This is
where we find the reality without hygiene,
where the gutters stink along the narrow
streets, where there is no air to breathe in*

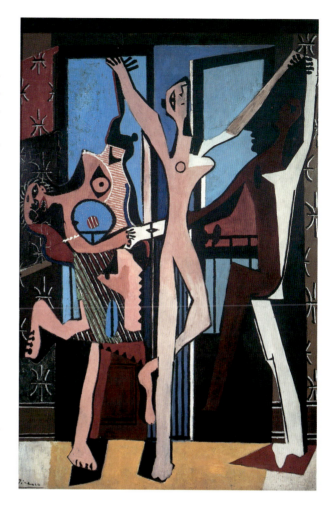

▲ *Three Dancers*
1925
Pablo Picasso
OIL ON CANVAS
215 X 142 CM
TATE, LONDON

*the awful hovels, where tuberculosis and
rickets are rampant. Is this not where
Picasso looked for his models?*

Another possible reference is to an
antechamber popularly known as the
Pont d'Avignon at the St-Lazare prison-
hospital in Paris. By contrast, just to
confuse the issue further, the Carrer
d'Avinyó in Barcelona was – and is – in
a respectable bourgeois neighbourhood.
It has even been suggested that a restau-

rant proprietor in that street dreamed up – or at least promoted – the spurious connection in order to boost his business.

For a painting almost universally celebrated as a major, indeed *the* major, milestone of modern art, it comes as a surprise to discover that its history up until 1939 was essentially a private one, in that it was seen, even in reproduction, only by relatively few people. It was first reproduced in 1910 as *Study by Picasso* in an American architectural magazine (the *Architectural Record*) in an article by Frank Gelett Burgess called 'The Wild Men of Paris', which grew out of his visits to a number of avant-garde artists' studios two years earlier. Its only definite public appearance occurred during the First World War in an exhibition organized by André Salmon entitled *L'Art moderne en France*. Salmon would later recall that 'in July 1916, M. Paul Poiret [the famous couturier] put his avenue d'Antin gallery at my disposal, with the cooperation of M. Barbazanges, to organize the Salon d'Antin, the only group exhibition available, since the start of the war, to the revolutionary artists'. The *Demoiselles d'Avignon* (thus named for the occasion, as described above) hung on a wall by itself. A review in *Le Cri de Paris* went as follows:

The Cubists are not waiting for the war to end to recommence hostilities against good sense. They are exhibiting at the Galerie Poiret naked women whose scattered parts are represented in all four corners of the canvas: here an eye, there an ear, over there a hand, a foot on top, a mouth below. M. Picasso, their leader, is possibly the least dishevelled of the lot. He has painted, or rather daubed, five women who are, if the truth be told, all hacked up, and yet their limbs somehow manage to hold together. They have, moreover, piggish faces with eyes wandering negligently above their ears.

An enthusiastic art-lover offered the artist 20,000 francs for this masterpiece. M. Picasso wanted more. The art-lover did not insist…

Who this art-lover was has never been discovered. On the whole, though, critical attention focused xenophobically (but not, perhaps, surprisingly, given the wartime context) on the predominance of foreign-born artists in an exhibition calling itself *L'Art moderne en France*.

The only other time that the *Demoiselles* may have been seen in public prior to 1939 was in 1918, in an exhibition dedicated to Picasso and Matisse at the Galerie Paul Guillaume in Paris. The evidence for this, however, remains inconclusive. In the meantime, in keeping with the growth of Picasso's reputation, a small but steady stream of articles appeared, which made reference to the painting. By the early 1920s a new

champion of the painting had arrived on the scene. This was the writer André Breton, soon to become known, indeed notorious, as leader (some would dub him 'pope') of the Surrealist movement; a reproduction of the *Demoiselles* would appear in the group's magazine *La Révolution surréaliste* in 1925. From mid-1921, Breton was also acting as librarian and artistic adviser to the wealthy couturier and art collector Jacques Doucet. Doucet, born in 1853, had already amassed a significant collection of eighteenth- and nineteenth-century French art; having disposed of the former before the First World War, he was now ready to take on the mantle of patron of contemporary art. He had first encountered Picasso's work in 1914, when he visited his studio; according to his companion on that occasion, he was 'at first very sceptical, feeling Picasso was not sincere, was fooling [the] public'. Picasso, however, was 'very courteous, patient and persuasive'. In 1916 Doucet bought two works by the artist: a small still life (a cup with black frame) and a Cubist harlequin; and as time went by, a cordial, even warm, relationship developed between the two men.

Breton would later claim that 'To convince him [Doucet] to buy a painting was a…laborious undertaking. Not only was it necessary to praise emphatically, and many times, its exceptional qualities, but also to continue thus to entreat him over the course of many letters. Needless to say, this very quickly turned into mere verbiage.' Yet Breton's passionate if idiosyncratic admiration for Picasso shines through the 'verbiage'. In December 1921, for example, he wrote to Doucet, expressing his regret that 'you have not acquired one of Picasso's major works (by this I mean something whose historical importance is absolutely undeniable, such as, for example, those *Demoiselles d'Avignon* which mark the origin of Cubism and which it would be a shame to see end up abroad)'.

Two years later Breton was still arguing the case for the purchase of the *Demoiselles*:

because through it one penetrates right into the core of Picasso's laboratory and because it is the crux of the drama, the centre of all the conflicts that Picasso has given rise to and that will last forever, in my opinion. It is a work which to my mind transcends painting: it is the theatre of everything that has happened in the last fifty years; it is the wall before which have passed Rimbaud, Lautréamont, Jarry, Apollinaire and all those we still love. If it were to disappear, it would take with it the largest part of our secret.

In early 1924, Doucet finally decided to take the plunge. He had last seen the

Demoiselles at the 1916 Salon d'Antin; astonishingly, he seems to have bought it without asking for it to be unrolled in Picasso's studio so that he could see it again. In 1961 Breton described the transaction as follows: 'I remember the day he bought the painting from Picasso, who, strange as it may seem, appeared to be intimidated by Doucet and even offered no resistance when the price was set at 25,000 francs: "Well, then, it's agreed, M. Picasso." Doucet then said: "You shall receive 2,000 francs per month, beginning next month, until the sum of 25,000 francs is reached."' In the end, it seems, Doucet paid not 25,000 but 30,000 francs. After being relined by a picture restorer named Chapuis, the painting was eventually delivered to Doucet's luxurious home at 46 avenue du Bois in the affluent Parisian suburb of Neuilly-sur-Seine in early December 1924. No record, however, exists of where the painting hung. A comment that Doucet is supposed to have made to Picasso – 'you see, M. Picasso, the subject is a little…well, peculiar, and I cannot in all decency show it in Mme Doucet's living room' – suggests that in the end no room was deemed suitable for it.

Picasso may well have been seduced into parting with the *Demoiselles* by Doucet's assurance, verging on a promise, that his collection would in due course go to the Louvre. The couturier's failure to keep to his word may be one reason why the artist, in anger, refused to sign the canvas. Alternatively, as Doucet wrote to the artist Picabia, Picasso may have withheld his signature 'because he claims to have given it to me as a gift; in saying let us look together for a place where the painting might end its days after me, I had the feeling that he was going to tell me that he would gladly see it by his side, but maybe that was just an impression'. Whatever the exact reasons, the relationship between the two men deteriorated, and Picasso never took up Doucet's invitation to view the painting in its new home.

On 12 December 1924 Breton wrote to Doucet to reassure him about his new purchase:

I cannot help but see in Les Demoiselles d'Avignon the most important event of the early twentieth century… It seems to me impossible to speak of this except in a mystical manner. The question of beauty only arises much later, and even then it is only fitting that it be broached with prudence. Les Demoiselles d'Avignon defies analysis, and the laws of its vast composition cannot in any way be formulated. For me, it is a pure symbol, like the Chaldean bull, an intense projection of this modern ideal, which we are only able to grasp piecemeal. Still, mystically speaking, after Picasso, goodbye to all the paintings of the past! …for me it is a sacred image.

In 1928 Jacques Doucet moved to an even more palatial residence in Neuilly at 33 rue Saint-James, in which the *Demoiselles* would occupy a conspicuous if incongruous position (right). François Chapon, author of a book on Doucet, provides a detailed description of its impressive surroundings:

One reached the studio by way of a staircase that the sculptor Csaky conceived according to the specific instructions of the master of the house. The steps of glazed silver enamel were flanked by a wrought-iron banister, the base of which was formed by a large peacock at rest; at the half-landing, a parrot adorned the beginning of the upper banister, in which were embedded here and there plates of black glass engraved with animal motifs. One thus came to the vestibule, and the main floor. Opposite the suite of the studio and the Oriental room, Les Demoiselles d'Avignon immediately caught one's eye.

Shortly before Doucet's death on 30 October 1929, A. Conger Goodyear, president of the Museum of Modern Art in New York, and César M. de Hauke of the Seligmann Gallery, both of whom would play an important part in the subsequent history of the *Demoiselles*, came to view his collection. It seems that Doucet had indeed expressed a wish to bequeath his fine collection to the Louvre. According to the art dealer René Gimpel,

▲ *Les Demoiselles d'Avignon* hanging in Jacques Doucet's Paris residence, late 1920s

the Louvre accepted his offer of *The Snake Charmer* by Le Douanier Rousseau, but 'turned down his Picasso… At the Louvre, at the Luxembourg, no-one in the official world wants to understand Picasso. He is a marked man.'

Following her husband's death, Madame Doucet retained possession of the *Demoiselles*, which, in a 1935 inventory of the collection compiled by the Seligmann Gallery in Paris, was given an estimated value of 120,000 francs. Alfred H. Barr, director of the New York Museum of Modern Art, arrived in Paris that same year to select works for a major

exhibition planned for 1936 entitled *Cubism and Abstract Art*, and visited Madame Doucet in the hope of securing the loan of the *Demoiselles* for that purpose. In the end, although the catalogue contained a reproduction of the work, he was to be disappointed. The Seligmann Gallery was clearly keen to acquire at least part of the Doucet collection; but the family was not yet ready to part with anything except the Rousseau painting and a circus sketch by Seurat that had specifically been bequeathed to the Louvre in Jacques Doucet's will. (Until recently it was thought that the *Demoiselles* was loaned to an exhibition at the Petit Palais in Paris entitled *Maîtres de l'art indépendant* in 1937; but it is now known that the work lent was a pastel related to the painting, from another private collection.)

By the late summer of 1937, Madame Doucet seems to have changed her mind about selling items from her collection. A handwritten receipt dated 15 September confirms that the *Demoiselles d'Avignon* was purchased from her by the Seligmann Gallery for 150,000 francs, together with five other works by Picasso (one of which Picasso himself would identify as actually being by Braque). Germain Seligmann has described how Picasso was invited by the gallery to view 'a very interesting group of your paintings from a well-known collection' before they were shipped across the Atlantic: 'I sent him a note saying that the paintings would be at my Paris galleries on a certain date, if he cared to call. Picasso was there almost before they were unloaded from the truck. He examined the *Demoiselles* with eagerness, remarked on its perfect condition and how well it had stood the test of time, both technically and as a key to the revolutionary movement it instituted.'

The ship carrying the paintings left Le Havre on 9 October 1937. About three weeks later, Jacques Seligmann and Co. Inc. proudly played host at its East Fifty-first Street gallery to an exhibition entitled *Twenty Years in the Evolution of Picasso 1903–1923*, comprised largely of works from the Doucet collection. The *Demoiselles d'Avignon*, still in the custom-made frame by Legrain commissioned by Doucet, was given pride of place on the walls and was described in the catalogue as second in size only to 'the recently completed canvas which he executed this year for the Spanish pavilion of the Paris Exposition' (namely, the equally important *Guernica*, which in 1939 would also travel to New York).

By 1937 Picasso's American reputation was well established, although, as the following review of the exhibition at the Seligmann Gallery makes clear, not all critics were quite sure what to make of him. This is Henry McBride writing in the *New York Sun* on 6 November:

'Here [at Seligmann's]…is – or possibly one should say "are" – *Les Demoiselles d'Avignon*, who danced upon the bridge in that celebrated city and got considerably shaken up by their experience, for they seem to be in pieces, and their visages flash at you from different planes, as though you were catching glimpses of them through a rapidly revolving kaleidoscope.'

The Museum of Modern Art (MoMA), founded in 1929 as one of the first institutions in the world devoted to contemporary art, was currently housed in temporary quarters at the Rockefeller Center, pending its re-opening in a brand new building at 11 West Fifty-third Street, in 1939. Minutes of a meeting of the Advisory Committee of MoMA, held on 9 November 1937, record the committee's decision to propose to the museum trustees that the *Demoiselles d'Avignon* be purchased for the permanent collection: 'It was pointed out…that it is important to have as many first-rate pictures as possible for the new building and that various museums are known and visited by thousands of people annually because of one or two objects. *The Demoiselles d'Avignon*, beginning, as it does, a whole new movement in painting, was considered by some members of the committee as the most important painting of the twentieth century.'

A meeting of the Board of Trustees concurred that the *Demoiselles* was indeed 'an epoch-making work, a turning-point in 20th-century art'. The painting was duly purchased from the Seligmann Gallery on 6 December 1937 for the sum of $28,000, but it took nearly two years to finalize the financial arrangements. The price paid was no small commitment for a museum which, at that juncture, had no acquisition fund. The official credit line, then as now, is that the work was 'Acquired through the Lillie P. Bliss Bequest'. In fact, $10,000 was contributed by two donors who, although they expressly wished to remain anonymous, were identified as Germain Seligmann and César de Hauke, while the outstanding $18,000 was raised by selling off an equestrian painting by Degas, which had earlier been donated by Lillie P. Bliss.

For the time being, the *Demoiselles* was stored at the Seligmann Gallery. It would finally arrive at the Museum of Modern Art on 24 April 1939, where it immediately became one of its star attractions. On the rare occasions it was lent to another institution, emotions ran high. In 1988, when it was loaned to the Musée Picasso, curator William Rubin apparently declared: 'If the plane crashes, I'll kill myself'; and when someone suggested it might be simpler for him to travel with the painting, he replied: 'Yes, then I won't have to choose the way to kill myself…'

JACKSON POLLOCK

AUTUMN RHYTHM 1950

The huge 'drip' paintings produced by Jackson Pollock between 1947 and 1950 attracted both praise and ridicule. Many people were drawn to the apparent simplicity and spontaneity of works such as *Autumn Rhythm*, hailing its maker as an all-American hero and admiring the painting's vast

scale, dramatic physicality and innovative technique. Others viewed Pollock's work with scorn, regarding him and all he stood for as a sham. That difference of opinion continues to this day.

▶ *Autumn Rhythm: Number 30, 1950*
1950
Jackson Pollock
OIL ON CANVAS
266.7 X 525.8 CM
METROPOLITAN MUSEUM OF ART, NEW YORK

'Every so often a painter has to destroy painting. Cézanne did it. Picasso did it with Cubism. Then Pollock did it. He busted our idea of a picture all to hell.' WILLEM DE KOONING, 1984

Jackson Pollock burst into the public eye on 8 August 1949 when a substantial and liberally illustrated article on him appeared in the pages of *Life* magazine (above) – circulation over five million – with the deliberately provocative subtitle 'Is he the greatest living painter in the United States?'. Although the text was by no means entirely flattering to the thirty-seven-year-old artist, he would hereafter become almost a household name. Certainly, the photographic portrait of him taken for the article by Arnold Newman, simultaneously casual and intense, cigarette nonchalantly hanging from his lips, did much to create his public persona. So persistent has this image of the artist proved that in 1975 a caricature could effortlessly make reference to it (opposite); and as recently as 1999, a 33 cent US postage stamp bore an artist's impression of that photograph, but (for the sake of modern sensibilities) with the dangling cigarette edited out. Pollock was only the second American artist to be thus honoured. The other, ironically, was the arch-realist and extremely popular painter Norman Rockwell, who in 1962 paid sardonic homage to Pollock in a tongue-in-cheek canvas entitled *Abstract and Concrete* (*The Connoisseur*) (page 212).

This 1949 image would later be reinforced by others, above all, perhaps, by the photograph taken in 1952 by Hans Namuth of a (once again) denim-clad Pollock sitting broodily on the running-

▲ The opening pages from an article on Pollock in *Life* magazine, 8 August 1949

board of his beat-up old truck. Ruggedly handsome, he bore more than a passing resemblance to the heavy-drinking, violent and inarticulate character of Stanley Kowalski in Tennessee Williams' 1947 play *A Streetcar Named Desire*. Williams, who had met Pollock three years earlier, may well have based his character at least in part on the artist; in any event, comparisons were frequently made between Pollock and Marlon Brando's rendering of Kowalski in the 1951 production of the play. Indeed, the writer John Gruen's description of his encounter with Pollock at the Cedar Tavern in Manhattan reads like an embarrassingly bad playscript:

I had been sitting by myself and noticed Jackson standing at the bar, drunk… He sat down across from me without speaking, took my hand in his and lifted it toward his eyes, as a palm reader would, looked at it for several long minutes and dropped it with some anger. Then he lifted his head and looked into my eyes. He said, 'You don't understand. You have never understood. No-one has ever understood.' With that he got up and lurched out of the bar.

When asked what he thought about Marlon Brando's biker gang in the film *The Wild Ones*, Pollock apparently replied: 'What do they know about being wild? I'm wild. There's wildness in me. There's wildness in my hands.' As

his friend Ted Dragon put it: 'He loved to be the macho kid. It was always the blue dungarees, work shirt, rough and tumble – anything to offset the idea of the effete artist, with flowing ties and the smock and the beret.' A much earlier, soft-focus photograph, taken in 1928, when he was a sixteen-year-old student at Manual Arts High School in Los Angeles, where Pollock does indeed look very much the long-haired bohemian, reveals the extent to which he later refashioned himself. The impact of his appearance and behaviour during his lifetime was dramatically reinforced by the manner of his death, in 1956 at the early age of forty-four, at the wheel in a drunken (and quite possibly suicidal) road accident, which also led to the death of one of his two female companions (neither of whom was his wife). Several lengthy biographies have been written about him, with telling titles such as *Jackson Pollock: An American Saga* and *To a Violent Grave*, and at least two films based on his life have been mooted. One, starring Robert de Niro and Barbra Streisand, was shelved; another, sim-

▼ *Jackson Pollock*
1975
David Levine
INK ON PAPERBOARD
34.9 X 27.9 CM
HIRSCHHORN MUSEUM AND SCULPTURE
GARDEN, WASHINGTON DC

THE LITTLE-KNOWN WORLD OF **OUR NEGRO ARISTOCRACY** | BACKSTAGE WITH *ACADEMY AWARD WINNER* **Shirley Jones**

POST *The Saturday Evening*

Jan. 13, 1962 20¢

Norman Rockwell

▲ *Abstract and Concrete (The Connoisseur)* 1962 Norman Rockwell *SATURDAY EVENING POST* COVER, 13 JANUARY 1962

ply entitled *Pollock*, and billed as a 'biographical drama', directed by and starring Ed Harris, came out in 2000.

The only two American artists prior to Pollock to have achieved a truly international reputation (more than half a century earlier) were the fashionable portrait painter John Singer Sargent and James McNeill Whistler, creator of atmospheric figure paintings and river scenes. In contrast to Pollock, however, who evidently took pride in his nationality, stating defiantly in a 1944 interview, 'I don't see why the problems of modern painting can't be solved as well here as elsewhere', and who was regard-

ed by many (including the British art historian Kenneth Clark) as 'the archetypal American painter', Sargent and Whistler prided themselves on their success in assimilating into European life and culture, and indeed spent most of their professional lives in Europe.

Until the Second World War, American culture was widely regarded, both within the USA and outside it, as parochial and/or derivative of European models. Only after 1945 was the growing economic and political power wielded by the United States accompanied by a growing self-confidence in artistic matters – so much so that during the Cold War period, Abstract Expressionism (of which Jackson Pollock was widely viewed as the most heroic exponent) was actively promoted abroad by the CIA, apparently in cahoots with the Museum of Modern Art in New York and other influential institutions. That artistic movement, with its emphasis on spontaneity and individual freedom of action, was easily made to fit the rhetoric that posited these qualities as quintessentially American, in stark contrast to the conformism and lack of individual freedom represented by Socialist Realism in the Eastern Bloc. In all this, Pollock and his art – aggressively masculine, unintellectual, untameable – suited the propagandists' purposes perfectly. Until relatively recently, the frequently made assertion that Abstract Expressionism represented

(in the words of one of the standard reference books on the subject) 'the triumph of American painting', which led to the demise of Paris and the ascendancy of New York as the centre of the avant-garde art world, went virtually unchallenged.

In actuality, there were two distinct trends within Abstract Expressionism. On the one hand, there was what is often called 'colour-field' painting, a quieter and more contemplative form of large-scale abstraction, characterized – as the name suggests – by broad expanses of colour and represented by artists such as Barnett Newman and Mark Rothko. On the other, there was what the critic Harold Rosenberg deftly dubbed 'action painting', characterized by the dynamic gesture and an emphasis on the act of creation, epitomized by Pollock but also practised by artists such as Franz Kline, Mark Tobey and Robert Motherwell. Practitioners of this kind of abstract art existed in Europe too, among them Hans Hartung, Georges Mathieu and Henri Michaux; yet – for reasons as much political as artistic – these artists were not perceived as breaking new ground in the way the Americans were.

Pollock's geographical origins also helped fuel the myth of the all-American cowboy hero. Born in the town of Cody, Wyoming, in 1912, the youngest of five sons, his childhood years were spent moving from one impoverished farmstead to another in Arizona and California. Surprisingly, perhaps, he was not the only member of the family to be artistically inclined: his eldest brother, Charles, paved the way by moving first to Los Angeles to study art, and then to New York City. Jackson joined him there in 1929, where he studied at the Art Students League under Thomas Hart Benton until 1931. Another brother, Sanford, also had artistic ambitions, but was prepared to sacrifice these to act as a support, both practical and moral, for Jackson. Even Benton, who seems to have taken the socially awkward and troubled young man under his wing, realized that he had little natural facility for art, and that for him everything would be a struggle. Benton was an erstwhile modernist, now turned fervent nationalist, whose work (page 214) celebrated the American way of life, both urban and rural. Most important for Pollock in the long term was his teacher's preoccupation with the rhythmic structures underlying all works of art, and his directing of his students to copy the works of artists conspicuous for the rhythmic qualities of their compositions, such as Rubens and El Greco (page 188). An early painting, such as *Going West* of *c.* 1934–8 (page 215), is in some measure influenced by Benton's example, but also pays homage in the swirling vortex of its forms to the nineteenth-century American painter Albert Pinkham Ryder ('the only American painter who interests

▶ *The City*
(New York Scene)
1920
Thomas Hart
Benton
OIL ON CANVAS
85.5 X 65 CM
THYSSEN-BORNEMISZA
FOUNDATION, MADRID

me', Pollock arrogantly claimed) and through him (if unwittingly) to the example of the English artist J. M. W. Turner. *The Flame* (page 216), which Pollock painted at around the same date, interest-

ingly anticipates his later work by taking the rhythmic qualities found in *Going West* almost to the point of abstraction.

Between 1935 and 1942, Pollock, like many other struggling – and established

▲ *Going West*
c. 1934–8
Jackson Pollock
OIL ON GESSO ON
FIBREBOARD
38.3 X 52.7 CM
NATIONAL MUSEUM
OF AMERICAN ART,
SMITHSONIAN
INSTITUTION,
WASHINGTON DC

– artists of all aesthetic persuasions, found employment in the government-sponsored Federal Art Project, which not only gave him a means of earning his living during the Depression, but provided a sense of artistic community and a stimulating environment in which to work. His paintings of this period reveal a rather self-conscious combination of several disparate and potent influences: most notably Picasso (to some extent, his work of the Cubist period, but above all works of the mid-1920s onwards, such as the *Three Dancers* (page 201); the Mexican muralists Orozco (page 217), Rivera and Siqueros; and Native American art (page 217). In 1941, Pollock would certainly have visited an important exhibition at the Museum of Modern Art entitled *Indian Art of the United States*, and seen Navajo medicine men execute their stylized and ritualistic figure paintings by spilling tinted sand directly on to the floor. The Mexican painter David Alfaro Siqueiros, in the workshops he held at Union Square in New York in 1936, apparently encouraged participants to explore the possibilities of allowing paint to drip, while Hans Hofmann, a German-born abstract artist who had studied in Paris in the early part of the century and then emigrated to the USA, where he became an influential teacher,

▲ *The Flame*
c. 1934–8
Jackson Pollock
OIL ON CANVAS
MOUNTED ON
FIBREBOARD
51.1 X 76.2 CM
MUSEUM OF MODERN
ART, NEW YORK

worked with the technique in the early 1940s. Another artist who, by the mid-1940s, was experimenting with a drip technique and, moreover, creating the kind of non-hierarchical, 'all-over' compositions that Pollock would soon make his own, was a now little-known American artist called Janet Sobel. Clement Greenberg later recalled that 'Pollock (and I myself) admired [Sobel's] pictures rather furtively' at the Art of This Century Gallery in 1944 (why the furtiveness, one wonders); 'the effect – and it was the first really "all-over" one that I had ever seen…– was strangely pleasing. Later on, Pollock admitted that these pictures had made an impression on him.' Yet Sobel, if mentioned at all in accounts of Pollock's development, is effectively dismissed as a mere housewife and/or amateur.

As the 1930s progressed, an increasing number of *émigré* artists arrived in New York, seeking refuge from the terrors of Nazi Europe, which increased the sense among the American avant-garde that a broader culture was now firmly within their reach. Among them were the eminent Surrealist artists André Masson, Matta (Roberto Matta Echaurren) and Max Ernst (page 220), who, together with Joan Miró (who remained in Europe), were to have a direct and profound influence upon the emerging Abstract Expressionists. The aspect of Surrealism that was to exert

the greatest attraction was its belief in the need to liberate the unconscious mind from rational control by any means available, which ranged from the taking of hallucinogenic drugs or starving yourself to the development of techniques, such as frottage (rubbing a rough surface like a wooden floorboard with a crayon or pencil) and decalcomania (the blotting of one painted surface against another), that exploited random effects, and the deployment of 'automatic' writing, a form of inspired doodling. In practice, it was artists such as the four mentioned earlier, much of whose work possessed an almost abstract calligraphic quality, rather than illusionistic artists, such as Salvador Dali (also in the USA at this point), whose work resembled (in his own words) 'hand-painted dream photographs', whom the young Americans deemed most relevant.

In 1942, Max Ernst (at that time married to the charismatic dealer Peggy Guggenheim) was experimenting with allowing paint to drip at random – yet another likely source of inspiration for Pollock in his famous 'drip' paintings of late 1946 onwards. However, Ernst's description of the process reveals two important differences in his approach, first its essential playfulness and second the fact that it was never regarded as an end in itself, but as a starting-point for further elaboration:

◀ Navajo Indian sand painting 1966
HORNIMAN MUSEUM, LONDON

It is a children's game. Attach an empty tin to a thread a metre or two long, punch a small hole in the bottom, fill the can with paint, liquid enough to flow freely. Let the can swing from the end of the thread over a piece of canvas resting on a flat surface, then change the direction of the can by movements of the hands, arms, shoulders and entire body. Surprising lines thus drip upon the canvas. The play of associations then begins.

▶ *Continued on page 220*

▲ *Gods of the Modern World* (panel 12 of 14) 1932–4
José Clemente Orozco
FRESCO
274 X 366 CM
BAKER LIBRARY, DARTMOUTH COLLEGE, HANOVER, NEW HAMPSHIRE

A CLOSER LOOK

AUTUMN RHYTHM JACKSON POLLOCK

Pollock's vigorous approach to painting involved standing over a huge piece of unstretched canvas and dripping paint on to its surface in a kind of ritual dance. The physicality of this approach prompted one critic to describe it as 'action painting', and others to take it as proof that the process could be as significant as the product.

Although Pollock's 'drip' paintings appear to be completely abstract and haphazard, a fine balance existed between randomness and control. Photographs taken of the artist at work on *Autumn Rhythm* show that he worked methodically from right to left, starting off by creating three schematic humanoid forms, which he then deliberately buried beneath a dense and complex network of lines and splats of paint.

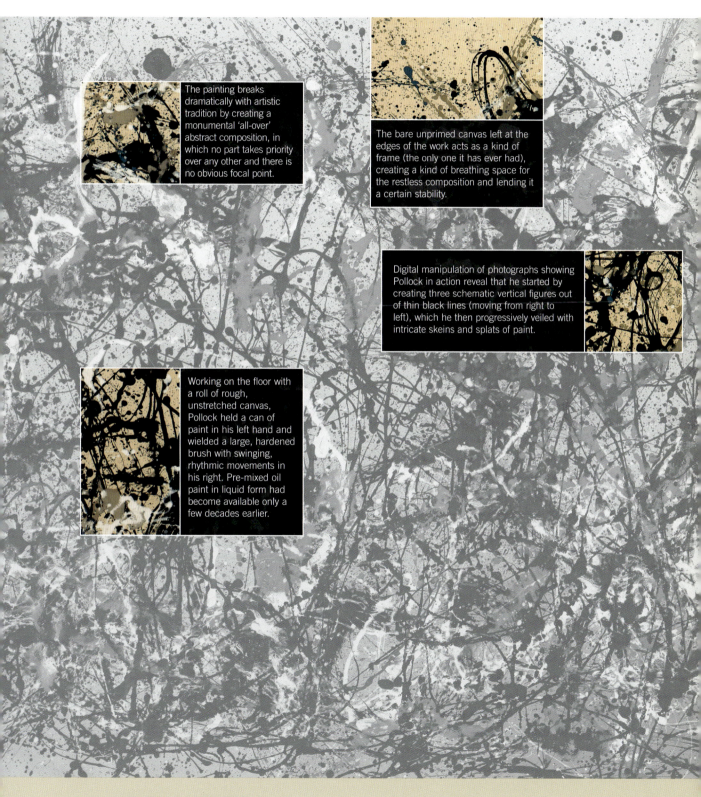

The painting breaks dramatically with artistic tradition by creating a monumental 'all-over' abstract composition, in which no part takes priority over any other and there is no obvious focal point.

The bare unprimed canvas left at the edges of the work acts as a kind of frame (the only one it has ever had), creating a kind of breathing space for the restless composition and lending it a certain stability.

Digital manipulation of photographs showing Pollock in action reveal that he started by creating three schematic vertical figures out of thin black lines (moving from right to left), which he then progressively veiled with intricate skeins and splats of paint.

Working on the floor with a roll of rough, unstretched canvas, Pollock held a can of paint in his left hand and wielded a large, hardened brush with swinging, rhythmic movements in his right. Pre-mixed oil paint in liquid form had become available only a few decades earlier.

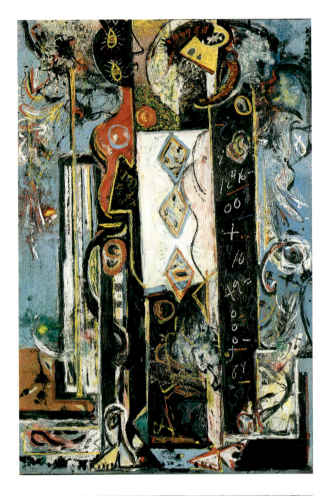

▶ One of the paintings produced by this method (lower left), with its sardonic title, *The Bewildered Planet*, vividly bears this out.

By 1942–3, canvases such as *Guardians of the Secret* and *Male and Female* (left) show that Pollock was beginning to forge a more distinctive style for himself, in which mythic forms, difficult to identify with any certainty but clearly indebted to Jungian concepts of the collective unconscious and the animus/ anima dichotomy, play a crucial role. (Pollock himself underwent Jungian analysis in the late 1930s and early '40s.) Under the influence of both Cubism and Surrealism, the distinction between figures and background, and between painting and drawing, became increasingly blurred. In 1943, Peggy Guggenheim included one of his recent paintings in a group show entitled *Spring Salon for Young Artists* at her newly established gallery in New York, Art of This Century. Pollock's contribution was noticed by no less an artist than the pioneering abstract painter Piet Mondrian, who described it as 'the most interesting work I've seen so far in America', and exhorted Guggenheim to 'watch this man'.

Acting on this, Guggenheim offered Pollock a generous contract, and gave him his first one-man show that very November, which immediately attracted the attention of influential critics such as Clement Greenberg. So sub-

stantial was the impact of his first solo exhibition that the Museum of Modern Art bought its first painting by Pollock (*The She-Wolf* of 1943) in early 1944. Guggenheim also commissioned him to produce a work to adorn the entrance hall of her town house. Now entitled *Mural*, this was the largest and most unequivocally abstract composition he had yet undertaken. The scale of this work alerted him to the possibility of creating a brand new format, somewhere between a traditional easel painting and a mural. In a 1947 fellowship application, he wrote: 'I believe the easel picture to be a dying form, and the tendency of modern feeling is towards the wall picture or mural. I believe the time is not yet ripe for a full transition from easel to mural. The pictures I contemplate painting would constitute a half-way state, an attempt to point out the direction of the future, without arriving there completely.' (His interest in mural painting would resurface in 1950, when, with the architect Peter Blake, he explored the idea of creating an 'ideal museum', in which his paintings would function as freestanding walls.) In the meantime, he continued to produce impressive works on a more modest scale in which figurative elements could still be detected.

Pollock married in October 1945, and a month or so later, with his wife,

the painter Lee Krasner, abandoned Manhattan for Long Island, in those days still essentially rural and unspoilt. They moved into a farmhouse with a large barn and about five acres of land in Springs, near East Hampton. Here, in a more serene frame of mind, his interest in nature reasserted itself, and gave rise to some of his most lyrical works. Although it retained recognizable figurative elements and was executed by traditional means, *Eyes in the Heat* of 1946 (above), with its dense skeins and webs of paint, in many respects anticipates the 'all-over' effect of his drip paintings, but in its strongly impastoed, slightly congested surface

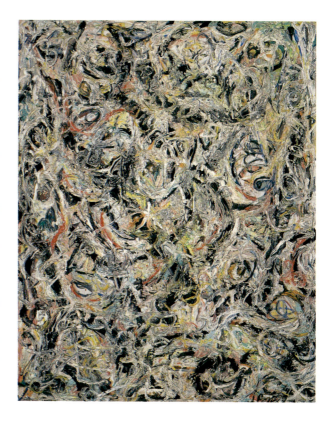

▲ *Eyes in the Heat* (from *Sounds in the Grass* series)
1946
Jackson Pollock
OIL ON CANVAS
137.2 X 109.2 CM
PEGGY GUGGENHEIM COLLECTION, VENICE/THE SOLOMON T. GUGGENHEIM MUSEUM, NEW YORK

◀ (opposite, top)
Male and Female
c. 1942
Jackson Pollock
OIL ON CANVAS
184.4 X 124.5 CM
PHILADELPHIA MUSEUM OF ART

◀ (opposite, bottom)
The Bewildered Planet
1942
Max Ernst
OIL ON CANVAS
101 X 140 CM
TEL AVIV MUSEUM OF ART

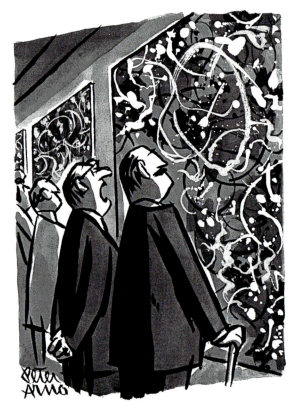

ous cartoonists' humour, both during his lifetime and after (left). The year 1950 is widely regarded as the 'heroic' year in which he produced his most completely resolved and 'classic' drip paintings – enormous canvases such as *Lavender Mist: Number 1, 1950* (opposite), *One: Number 31, 1950* and *Autumn Rhythm: Number 30, 1950*. This last painting, together with other works of 1950, was exhibited at the Betty Parsons Gallery in New York at the end of that year to considerable acclaim. (It would also feature in a show entitled *Fifteen Americans*, held at the Museum of Modern Art in 1952, and in an exhibition held in 1954 at the Sidney Janis Gallery entitled *Fifteen Years of Jackson Pollock*.) From 1948 onwards, the artist preferred to give his work numerical titles, and agreed to more conventionally descriptive ones only at the insistence of his dealers.

A couple of years before he died, Pollock covered his studio floor with masonite, as if to fossilize the traces of the most productive period of his life: in the eighteen months or so before his fatal accident, depressed and drinking heavily, he produced virtually nothing. After his death, Krasner moved into the barn (having previously had to make do with a room in the main farmhouse), but left her mark mainly on the walls. Shortly before her death in 1984, the original

also reveals the extent to which the drip technique would give him precisely the rhythmic freedom he now required.

By late 1946, traditional methods of applying paint to canvas no longer seemed adequate to Pollock. It was at this juncture that he began to drip and pour fluid enamel, aluminium and oil paints from sticks or hardened brushes over pieces of unsized, unprimed canvas (the kind of commercial duck used for ships and upholstery) tacked on to the studio floor, evolving the technique that would soon earn him fame, not to say notoriety, as 'Jack the Dripper', and ensure that he (and the critics who supported him) became the butt of numer-

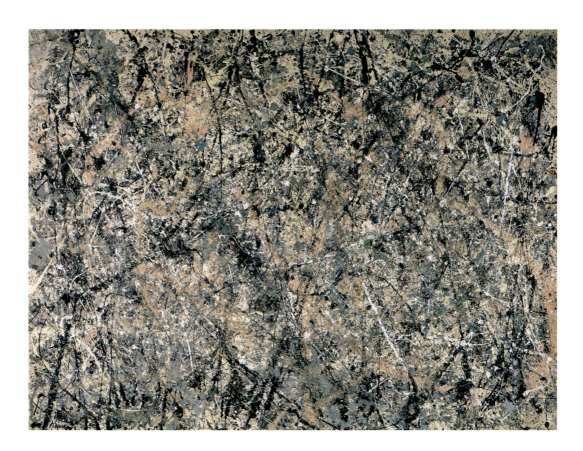

floor of the studio was re-excavated, and has duly been preserved for posterity. In 1999 the journalist Tim Marlow paid the studio a visit: 'It's only a shack, really, a small wooden barn which blocks the view from the modest farmhouse down to Accabonac Creek on the edge of East Hampton. But it's one of those mythologized places, like Picasso's studio at the Bateau Lavoir, in which the course of art history is deemed to have been changed. For this is the shack that Jack dripped in, now a study centre-cum-shrine.'

In 1950, a German *émigré* photographer called Hans Namuth approached Jackson Pollock with the request that he be allowed to photograph the painter at work. Although essentially an introverted and private man, Pollock agreed. (Lee Krasner later told Namuth that 'until that moment she had been the only person who ever watched him paint' but this was not strictly true, since two *Time-Life* photographers, Arnold Newman and Martha Holmes, had been granted the privilege in 1949.) Namuth later recalled his first visit to Springs as follows:

The large barn was filled with paintings. A dripping wet canvas covered the entire floor. Blinding shafts of sunlight hit the

▲ *Lavender Mist:
Number 1, 1950*
1950
Jackson Pollock
OIL, ENAMEL AND
ALUMINIUM PAINT ON
CANVAS
221 X 299.7 CM
NATIONAL GALLERY OF
ART, WASHINGTON DC

▲ Pollock photo-
graphed at work
on *Autumn
Rhythm*
1950
Hans Namuth
METROPOLITAN
MUSEUM OF ART,
NEW YORK

wet canvas, making its surface hard to see. There was complete silence. I looked aimlessly through the ground glass of my rolleiflex and began to take a few pictures. Pollock looked at the painting. [This was One: Number 31, 1950, which the artist had told him was already finished.] Then, unexpectedly, he picked up can and paintbrush and started to move around the canvas. It was as if he suddenly realized the painting was not finished. His movements, slow at first, gradually became faster and more dance-like as he flung black, white and rust-coloured paint on to the canvas… My photography session lasted as long as he kept painting, perhaps half an hour. In all that time, Pollock did not stop. How long could one keep up that level of physical activity? Finally, he said, 'This is it.'

Namuth would return many times between July and November 1950, producing not only a series of monochrome still photographs but also a short black and white film and a longer one in colour. (In his own words, 'To make a film was the next logical step. Pollock's method of painting suggested a moving picture – the dance around the canvas, the continuous movement, the drama.') Because of the low light levels in the studio, Namuth was obliged to use long exposures. The swiftness of the artist's movements meant that many of the photographs were therefore blurred.

Originally troubled by this, Namuth came to feel that the blurring actually enhanced the drama of the images. One of the paintings on which Pollock worked in his presence, and whose creation he recorded in a vivid series of black and white still photographs (left), was *Autumn Rhythm*, which would be acquired by the Metropolitan Museum of Art in New York in 1957, not long after Pollock's death, for the sum of $30,000. (Just a short time before this, the Museum of Modern Art had turned down the chance to buy it for a mere $6000.) In late 1957, the painting featured in the major retrospective of Pollock's work organized by the Museum of Modern Art, which travelled first to the São Paulo Bienal, and then to Rome, Basel, Amsterdam, Hamburg, Berlin, London and Paris, and did much to establish Pollock's international reputation.

The personal consequences of Namuth's intervention in Pollock's creative processes were to be disastrous. The story goes that no sooner had Namuth completed his project than Pollock took to the bottle again (after some two years of abstinence), drunkenly proclaiming how much of a 'fucking phony' the whole procedure had turned him into. One might argue, too, that the near-mythic image of the artist at work that Namuth conjured up ultimately took precedence in the popular

imagination over the paintings them-
selves. For all that, the photographic
record Namuth produced has proved
invaluable for a deeper understanding
of the way Pollock worked.

The photographs of the artist creating
Autumn Rhythm for the most part bear
out Pollock's slightly earlier description
of his working methods, published in
the winter of 1947–8:

*My painting does not come from the easel.
I hardly ever stretch my canvas before
painting. I prefer to tack the unstretched
canvas to the hard wall or the floor. I need
the resistance of a hard surface. On the
floor I am more at ease. I feel nearer, more
a part of the painting, since this way I can
walk around it, work from the four sides
and literally be in the painting. This is
akin to the method of the Indian sand
painters of the West. [In a 1950 interview
he would cite 'the Orientals' as an addi-
tional inspiration.]*

*I continue to get further away from the
usual painter's tools, such as easel, palette,
brushes, etc. I prefer sticks, trowels, knives
and dripping fluid paint or a heavy
impasto with sand, broken glass and other
foreign matter added.*

By 1950 he had in fact largely given up
incorporating 'foreign matter' into his
work, and although he used industrial
aluminium paints in some of the other
works he produced that year, *Autumn*
Rhythm was created using only oil
paint. (Pre-mixed oil paint in liquid
form had become available only a few
decades earlier.) The photographs con-
firm that Pollock did literally walk all
over the canvas, holding a can of paint
in his left hand and wielding a large
brush with swinging, rhythmic move-
ments in his right. More specifically,
they reveal that the artist started work-
ing at the right-hand edge of the can-
vas, drawing a complex configuration
of lines with a brush held anywhere
from a few inches to a few feet above
the canvas. As in many of his other
works of this period, he began working
exclusively with a thin, black, unin-
flected line, before moving on to the
second phase, accenting the composi-
tion with a series of long thick 'splats'.
It was only at this point that Pollock
moved on to begin work on the central
section of the canvas, on which he
sketched a second configuration, sepa-
rated from the first by at least 30 cm of
bare canvas. Repeating the procedure,
he then moved on to the left-hand
section.

The initial layout of the huge, scroll-
like composition suggests that Pollock
may well have had in mind (if only
semi-consciously) an essay published in
1926 by his former teacher Thomas
Hart Benton, entitled 'Mechanics of
Form Organization in Painting', and in
particular the following passage:

▶ Series of digitally enhanced photographs showing the progression of work on *Autumn Rhythm: Number 30, 1950*
Hans Namuth
METROPOLITAN MUSEUM OF ART, NEW YORK

There seems to be a need in following lateral extensions of rhythmic sequences for new and distinct readjustments of the eye's exploring activity every few intervals… There is no difficulty in following such compound vertical rhythms in an extended vertical progression, but so great is the difficulty in adapting the eye and brain to their lateral extension that there has developed a practice (perhaps there was never any other) of orientating laterally extended rhythms about several poles. Vision then encounters, as it shifts sideways, distinct rhythmical sets which are joined on their fringes.

Certainly, 'distinct rhythmical sets… joined on their fringes' accurately describes the early stages of what Pollock was now producing.

As Namuth constantly changed his position to keep up with Pollock's rapid

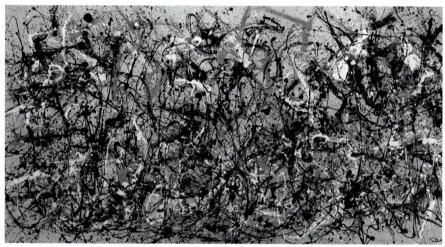

movements around the canvas, and was in any case (by his own admission) more interested in the artist than in the art, it has been difficult to ascertain the exact sequence of the photographs and to make out details of the composition. However, recent advances in digital imaging have made it possible to take a section of canvas that a photograph shows lying on the floor (and hence at an angle to the camera) and to flip it upwards into the picture plane, undoing the distortions of foreshortening. If, furthermore, several of these 'flattened' sections are combined, it becomes possible to create composite views of *Autumn Rhythm* which provide an overall (albeit not completely accurate) view of the painting at a given moment (opposite and above). Thus, a composite view assembled from four of Namuth's still photographs provides a fuzzy yet legible image of this early state

of the composition, revealing that what at a cursory glance seems a totally abstract form in the central section, is almost certainly a rudimentary, almost childlike human figure, constructed around a kind of wobbly circle (page 226, bottom). With the aid of Namuth's original photographs and the additional help of this digital process, it soon becomes evident that all three main underlying sections of the composition contain allusions to humanoid forms (not dissimilar, in fact, from those found in some of his works of the late 1940s). As Pollock continued to work on *Autumn Rhythm*, he evidently chose to bury these forms and to render the composition more homogeneous and abstract by means of a complex network of lines and splats overlaid on the original configurations. Broad strokes of tan and white were placed on top of earlier passages of black paint, breaking the lines of the original composition into discontinuous fragments. The further superimposition of countless narrow black lines, looping in all directions, added to the restlessness and apparent confusion of the completed work. In contrast to works such as *Lavender Mist* (page 223), however, the bare canvas plays an important role in providing stability and in creating a breathing-space around the edges of the composition. In keeping with their respective titles, the dense, delicate skeins of paint and almost pretty colour harmonies in *Lavender Mist* stand in contrast

to the more open, swirling forms and muted, less decorative colours of *Autumn Rhythm*. (Given the latter's title, it is hard not to catch a whiff of windswept days and gusting leaves.)

That figurative elements were never very far from Pollock's thoughts even in 1950 can further be deduced both from the progressive obscuring of those elements in his canvases of the mid- to late 1940s and from the fact that in 1951 he began once more to introduce recognizable imagery into his work (opposite). That Pollock understood the subversive significance of what he was doing is evident from a letter he wrote that summer: 'I've had a period of drawing on canvas in black with some of my early images coming thru [sic] – think the non-objectivists will find them disturbing – and the kids who think it's simple to splash a Pollock out.'

Some commentators on his work have claimed that it was gestural abstraction that came naturally to him, and that the figurative elements were more consciously introduced; others, that the very opposite is true. The insights provided by Namuth's photographs and the latest digital methods suggest that the latter group got it right, that for all the apparent spontaneity and lack of forethought in Pollock's creation of what have been called his 'great webs' of 1950, the figurative impulse was still dominant in him, and the abstract swathes of paint

▲ *Portrait and
a Dream*
1953
Jackson Pollock
OIL ON CANVAS
147.6 X 341.6 CM
DALLAS MUSEUM OF
ART

represented an act of will, a deliberate elimination of all traces of figuration. And, indeed, the notes taken by the journalist Dorothy Seiberling in preparation for her 1949 *Life* article, quote Pollock as saying: 'I try to stay away from any recognizable image; if it creeps in, I try to do away with it… I don't let the image carry the painting… It's extra cargo – and unnecessary.' But 'recognizable images are always there in the end'. Krasner too recalled how Pollock in the mid-1940s spoke of choosing to 'veil the image' – a remark that, until recently, was seen as irrelevant to the 1947–50 drip paintings.

In 1967, Clement Greenberg made the following astute observation:

The seeming haphazardness of Pollock's execution with its mazy trickling, dribbling, whipping, blotching, and staining of paint, appears to threaten to swallow up and extinguish every element of order. But this is more a matter of connotation than of actual effect. The strength of the art itself lies in the tension…between the connotations of haphazardness and the felt and actual aesthetic order, to which every detail of execution contributes.

To what extent he was in control of his media was clearly a sensitive issue for Pollock, who went to considerable pains to underplay the role of random effects in his work – in public defiance of those who claimed that his art involved no skill or discernment, and that 'a child of six could do it'. His voice-over for Namuth's 1951 film of the artist at work, for example, contained the following statement: 'I don't work from drawings or color sketches. My painting is direct… The method of painting is the natural growth out of a need. I want to express my feelings rather than illus-

trate them. Technique is just a means of arriving at a statement. When I am painting I have a general notion as to what I am about. I can control the flow of paint: there is no accident, just as there is no beginning and no end.' In 1950, he claimed in no uncertain terms: 'I don't use the accident – 'cause I deny the accident.' Less equivocal still was his telegraphed response to a headline about his work featured in *Time* magazine in 1950 that read 'Chaos, Damn It', to which he cabled back: NO CHAOS DAMN IT, DAMNED BUSY PAINTING.'

In reality, chance effects clearly did play a role in *Autumn Rhythm*, as in all Pollock's mature work. Indeed, the exploitation of chance by relinquishing conscious control had been one of the central tenets of the Surrealist concept of 'psychic automatism' which had led the American Abstract Expressionists to develop their own, related concept of 'plastic automatism'. The following, much-quoted description makes it clear that (like most artists) Pollock neither wished to be, nor was, fully in control of his creative processes: 'When I am in my painting, I'm not aware of what I am doing. It is only after a sort of "get acquainted" period that I see what I have been about. I have no fears about making changes, destroying the image etc., because the painting has a life of its own. I try to let it come through. It is only when I lose contact with the painting that the result is a mess. Otherwise there is pure harmony, an easy give and take, and the painting comes out well.'

The idea of art as an uninhibited outpouring of one's inner self seemed, moreover, to fit well with Pollock's psychic needs. 'Painting is self-discovery. Every good artist paints what he is,' he once declared. Clearly, painting was a crucial outlet for a man who, by his own admission, felt uneasy with words, writing to his mother that 'It is of the utmost difficulty that I am able to write – and then only miles from my want and feeling.' Revealingly, he liked to relate his painting method to a childhood memory of watching his father urinate on a rock, and frequently, moreover, made a public spectacle of his own urination (a tendency to which the 1975 cartoon, page 211, clearly alludes). The painter Franz Kline once described how Pollock, in the course of pouring wine at a restaurant, became 'so involved in watching the wine pour out of the bottle that he emptied the whole bottle. It covered the food, the table, everything… Like a child he thought it was a terrific idea – all that wine going all over.' Another, possibly apocryphal, story tells how in 1942, when Hans Hofmann invited Pollock to 'come and study with me from nature', he arrogantly retorted: 'I'm nature.'

It is striking how often critical responses to Pollock's classic drip paintings deploy sexually suggestive language. The English critic William Feaver (almost comically) described Pollock 'casting paint like seed…on to the canvas spread at his feet. This was no sissy… It was, demonstrably, the real thing…painting composed of …manly ejaculatory splat.' Even Hans Namuth's observation that 'It was a great drama, the flame of explosion when the paint hit the canvas; the dance-like movement; the eyes tormented before knowing where to strike next; the tension; then the explosion again' is redolent of male orgasmic sexuality. The idea that (in Auguste Renoir's crude phrase) the male artist 'paints with his prick', and that, conversely, the canvas represents the female principle, waiting passively to be possessed and conquered, is now

▼ *Noon*
1947
Lee Krasner
OIL ON LINEN
61.3 X 76.2 CM
COLLECTION OF ROY
ZUCKERBERG

▲ Fashion photograph, showing *Lavender Mist* in the background *VOGUE*, 1 MARCH 1951

complete contrast to Pollock's. (Her greater interest in intellectual matters is borne out by the following story: a former pupil of Hans Hofmann, she once 'brought [him] to see Pollock. Hofmann, being a teacher, spent all the time talking about art. Finally, Pollock couldn't stand it any longer and said, "Your theories don't interest me. Put up or shut up! Let's see your work."') They first met in the late 1930s, became lovers in the early '40s, and married in 1945. As so often happens in such relationships, the woman put her partner's ambitions first: in 1969 she told John Gruen that 'When we began going together, my own work became irrelevant. He was the important thing. I couldn't do enough for him.' Elaine de Kooning, artist-wife of Willem de Kooning, described Krasner as becoming 'kind of the opposite of competitive with Jackson. She wiped herself out.' Her career-long practice of obsessively reworking, cannibalizing and destroying her own work also stands in marked contrast to Pollock's greater assurance.

The work she produced in the 1940s, while closely related to Pollock's, is far more intimate and domestic in scale (page 231). Although the assumption is always that the male artist influenced the female, it should be remembered that Krasner was experimenting with pure abstraction well before her husband. Typically, though, she is credited mainly with being 'the woman behind

almost a cultural cliché. Andrew Perchuk, however, has argued that the aggressively 'macho' reading of Pollock's life and work stems from a particular set of historical circumstances, in which the USA in the immediate post-war period was undergoing a 'crisis in masculinity', prompted in part by its new status as a (feminized) consumer society, in part by the disturbing revelations contained in the Kinsey reports on male and female sexuality, and in part by the pressures of the Cold War mentality, characterized by fear and alienation.

It should come as little surprise, then, that Lee Krasner, the woman artist to whom Pollock was married for almost eleven years, fared badly in the relationship. Born Lenore Krassner into a Jewish immigrant family living in Brooklyn, her background and education stood in

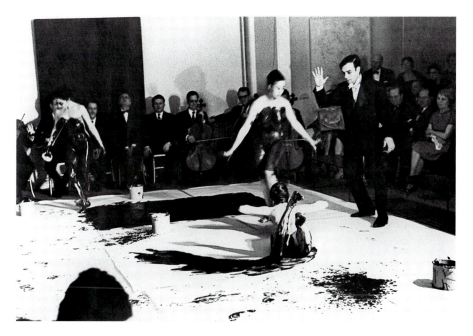

◀ *Anthropométries
de l'Epoque Bleue*
9 March 1960
Yves Klein
performance at the
Galerie
Internationale d'Art
Contemporain,
Paris

the man': Greenberg asserted that 'for his art she was all-important, absolutely', while the dealer John Bernard Myers concurred that 'There would never have been a Jackson Pollock without Lee Pollock and I put that on *every level*.' Ironically, those who try to deconstruct the myth surrounding Pollock lay much of the blame for its success at her door, accusing her of being pushy and over-manipulative both during his lifetime and after his death. Most revealingly of all, the architect Le Corbusier described Pollock as 'like a hunter who shoots without aiming. But his wife, she has talent – women always have too much talent.' Nor should one forget that her own professional career as a painter took an upward (albeit temporary) swing in the early 1950s, just as Pollock's was on the

decline – no doubt an extra source of tension in the relationship.

For all Pollock's own statements to the effect that he worked 'from within' to 'express his feelings' and 'an inner world', many members of the general public, I suspect, still harbour a suspicion that the famous drip paintings are really just decorative, little more than an elevated form of wallpaper. T-shirts, aprons – and yes, even wallpaper – sporting Pollock-inspired splatters bear this out. The writer Aldous Huxley expressed his own misgivings way back in 1948: 'It [Pollock's work] raises a question of why it stops when it does. The artist could go on forever. I don't know. It seems to be like a panel for wallpaper which is repeated indefinitely around the wall.' And as if confirming this, the 1 March 1951 issue of *Vogue*

contained photographs by Cecil Beaton of a glamorous fashion model posing in front of *Lavender Mist* and *Autumn Rhythm* (page 232).

Yet Pollock's impact on artists of his own and later generations has been immense. His fellow Abstract Expressionist Willem de Kooning famously exclaimed, 'Jackson's broken the ice,' later claiming that 'he busted our idea of a picture all to hell'. Ironically, de Kooning himself spawned more imitators than Pollock, as the abstract painter Al Held explained: 'de Kooning provided a language you could write your own sentences with. Pollock didn't do that.' But as another artist, Allan Kaprow, wrote: 'In him [Pollock] the statement and the ritual were so grand, so authoritative and all-encompassing in its scale and daring, that whatever our private convictions, we could not fail to be affected by its spirit.' In other words, it was less the specific look of the paintings (ironically, given their raw physicality) and more the sense of total liberation from traditional ways of making art that exerted such a profound influence. Above all, perhaps, it was the recognition that the *process* could be as significant as the finished product that threw open the doors to all manner of alternatives to paint on canvas: to conceptual art, where the idea behind the work took precedence over its embodiment; to

performance art in all its many manifestations, where the act became the art and the boundaries between theatre and the visual arts became blurred (page 233); and to body art, where the artist's body became the subject – and the medium – of the work. Even recent works that (often wittily) offer a critique of Pollock (page 235) are in a perverse way a form of homage.

These, then, are some of the reasons why Pollock's work of the late 1940s and, above all, the magisterial canvases of 1950 (of which *Autumn Rhythm* is a notable and much-cited example) came to acquire such authority among most of his peers and among the majority of serious art critics. To them one might add the paintings' ability to evoke, even apparently recreate, a sense of natural and cosmic forces without a beginning or an end; an impression of primal energy and improvisatory rhythmic power, akin to the Dixieland jazz that Pollock adored and, according to his wife, listened to *ad nauseam*. Wide open spaces were clearly important to him (settled on the East Coast, he would say, 'I have a definite feeling for the West: the vast horizontality of the land, for instance; here only the Atlantic Ocean gives you that'), while his early admiration for the work of Ryder and through him, a nineteenth-century Romantic tradition that celebrated the sublime in nature, suggests that something of those sentiments

was carried through into his mature work. Interestingly, an article published in 1999 in the scientific journal *Nature* describes how research physicists at the University of New South Wales in Sydney have scanned photographs of fifteen major works produced by Pollock between 1943 and 1952 into a computer programmed to identify the fractal patterns that underlie most natural phenomena deemed pleasing to humans. They have concluded that the paintings possess similar hidden patterns.

More cynically, one might posit the idea that far from being embodiments of the sublime, Pollock's abstract drip paintings are expressive primarily of inadequacy. A doctor friend of the artist went so far as to claim: 'I think Jackson was trying to utter something… There's an utterance there, but it's a lot like trying to understand brain-damaged adults or those with an autistic or dyslexic factor, or psychotics.' More charitably, they might be construed as representative of a peculiarly modern sense of inarticulacy and frustration. (The other possible sense of the term 'all-over' is rarely taken into account.) This is an idea confirmed by the painter George McNeil, who asserted: 'The freedom with which Pollock painted then, that was great. Everybody was changed by

his work…he was able to paint his frustrations – his work came from this.' Is it possible that in the end, part of the power of these paintings is born of defiance – and thus partakes of the sublime after all?

Perhaps, as the critic Max Kozloff declared, Pollock 'represented our time. Or rather, the time became aware of a vital part of itself through him.'

▲ *Action Photo
(After Hans
Namuth)*
1997
Vik Muniz
CIBACHROME
PHOTOGRAPH OF SOFT
TOFFEE APPLIED TO
ENLARGED PHOTOGRAPH
BY NAMUTH FILM
PRIVATE COLLECTION

FURTHER READING

LEONARDO DA VINCI: *MONA LISA*

Marani, Pietro C., *Leonardo da Vinci: The Complete Paintings,* Harry N. Abrams, New York, 2000. Although costly, this is a beautifully produced volume, and is virtually the only scholarly book currently in print to focus on the paintings.

McMullen, Roy, *The Mona Lisa: The Picture and the Myth*, Macmillan, London, 1976. Still the standard work on the subject, this is readable, thought-provoking and extremely informative.

Nuland, Sherwyn, *Leonardo da Vinci*, Orion, London, 2000. A useful, up-to-date biography.

Reit, Seymour V., *The Day They Stole the Mona Lisa*, Robert Hale, London, 1981. This racy and purportedly accurate account proves that truth can indeed be stranger than fiction.

MICHELANGELO BUONARROTI: *DAVID*

Hibbard, Howard, *Michelangelo*, Westview Press, Oxford, 1985. This is still the standard biographical text.

Hughes, Anthony, *Michelangelo*, Phaidon Press, London, 1997. A good general introduction to this artist.

Murray, Linda, *Michelangelo*, Thames & Hudson, London, 1980, reprinted 1992. A sound general introduction.

GOYA: *THE THIRD OF MAY 1808*

Licht, Fred, *Goya and the Origins of the Modern Temper in Art*, John Murray, London, 1980. See chapters 7 & 8.

Symmons, Sarah, *Goya*, Phaidon Press, London, 1998. A good general introduction to this artist.

Thomas, Hugh, *Goya: The Third of May 1808*, Allen Lane/The Penguin Press, London, 1972. Like the books by Reff and Heller, this forms part of the excellent, if now somewhat out-of-date, 'Art in Context' series.

Williams, Gwyn A., *Goya and the Impossible Revolution*, Penguin Books, Harmondsworth, 1979. Useful for its focus on the political context of Goya's work.

EDOUARD MANET: *OLYMPIA*

Clark, T. J., *The Painting of Modern Life: Paris in the Art of Manet and His Followers*, Thames & Hudson, London, 1999. See chapter on 'Olympia's Choice'.

Hanson, Anne C., *Manet and the Modern Tradition*, Yale University Press, New Haven & London, 1977. See chapter on 'The Nude'.

Krell, Alan, *Manet*, Thames & Hudson, London, 1996. A good general introduction to the artist.

Lipton, Eunice, *Alias Olympia: A Woman's Search for Manet's Notorious Model and Her Own Desire*, Cornell University Press, Ithaca, 1999. As the title suggests, this is a highly personal and rather idiosyncratic account, but interesting nevertheless.

Reff, Theodore, *Manet: Olympia*, Allen Lane/Penguin Books, London, 1976.

VINCENT VAN GOGH: *SUNFLOWERS*

Mancoff, Debra N., *Van Gogh's Flowers*, Frances Lincoln, London, 1999.

McQuillan, Melissa, *Van Gogh*, Thames & Hudson, London, 1997. A sound, basic introduction to the artist.

Van Gogh's Sunflowers, Christie's sale catalogue, London, 30 March 1987.

De Leeuw, Ronald, ed., *The Letters of Vincent van Gogh*, Allen Lane, London, 1996.

EDVARD MUNCH: *THE SCREAM*

Heller, Reinhold, *Munch: The Scream*, Allen Lane/Penguin Books, London, 1973.

Hodin, J.P., *Edvard Munch*, Thames & Hudson, London, 1996.

Wood, Mara-Helen, ed., *Edvard Munch: The Frieze of Life*, National Gallery, London, 1992-3.

PABLO PICASSO: *LES DEMOISELLES D'AVIGNON*

Chave, Anna C., 'New Encounters with *Les Demoiselles d'Avignon*: Gender, Race and the Origins of Cubism', *Art Bulletin*, issue 76, pp 596-611, 1994.

Cousins, J., Rubin, W. & Seckel, H., *Les Demoiselles d'Avignon, Studies in Modern Art 3* (2 volumes), Museum of Modern Art, New York, 1994. This is likely to remain the most exhaustive, if not definitive, publication on the subject for a long time.

Leighten, Patricia D., 'The White Peril and l'art nègre: Picasso, Primitivism and Anticolonialism', *Art Bulletin*, issue 72, pp 609-30, 1990.

Richardson, John, *A Life of Picasso* (2 volumes), Jonathan Cape, London, 1991, 1996. See volume 1, pp 463-75, and volume 2, pp 3-45.

Rubin, William, 'Picasso' in *Primitivism in Modern Art: Affinity of the Tribal and the Modern*, volume 1, Museum of Modern Art, New York, 1984.

JACKSON POLLOCK: *AUTUMN RHYTHM*

Amfam, David, *Abstract Expressionism*, Thames & Hudson, London, 1990.

Chave, Anna C., 'Pollock and Krasner: Script and Postscript' in *Frascina, Franci*s, ed. Pollock, and *After: The Critical Debate*, Routledge, London, 2000.

Naifeh, Steven & Smith, Gregory White, *Jackson Pollock: An American Saga*, Clarkson N. Potter Inc., New York, 1989. A lengthy, more or less reliable biography.

Varnedoe, Kirk (with Karmel, Pepe), *Jackson Pollock*, Museum of Modern Art, New York, 1999. A massive and authoritative publication, this contains numerous photographs by Hans Namuth, and valuable new insights into the evolution of *Autumn Rhythm*.

Wagner, Anne M., 'Fictions: Krasner's Presence, Pollock's Absence' in Chadwick, Whitney, *Significant Others*, Thames & Hudson, London, 1993.